FEEDBACK

TELEVISION AGAINST DEMOCRACY

DAVID JOSELIT

The MIT Press
Cambridge, Massachusetts
London, England

MIT Press books may be purchased at special quantity discounts for business or sales promotional use. For information, please email special_sales@mitpress.mit.edu or write to Special Sales Department, The MIT Press, 55 Hayward Street, Cambridge, MA 02142.

This book was set in Caecelia by Graphic Composition, Inc. Printed and bound in the United States of America.

Library of Congress Cataloging-in-Publication Data

Joselit, David.
 Feedback : television against democracy / David Joselit.
 p. cm.
 Includes bibliographical references and index.
 ISBN-13: 978-0-262-10120-2 (hardcover : alk. paper)
 1. Television broadcasting—Social aspects—United States.
2. Television and politics—United States.
3. Television and art—United States. I. Title.
PN1992.6.J675 2007
302.23'45—dc22
 2006030096

10 9 8 7 6 5 4 3 2 1

for Steve Incontro

Contents

Acknowledgments

Feedback has developed over several years with the help and inspiration of a rich community of scholars, artists, and friends. While I was a curator at the Institute of Contemporary Art in Boston in the 1980s, David Ross and Bob Riley introduced me to video and media art, and as a member of the faculty of the University of California–Irvine's Ph.D. program in visual studies from 1995 to 2003, I began to recognize the role of television in postwar culture. At Irvine I was particularly inspired by lively conversations and collaborations with Sally Stein, Anne Friedberg, and Jim Herbert. In the course of research, I benefited enormously from the generous assistance of Rebecca Cleman and Josh Kline at Electronic Arts Intermix; John Hanhardt of the Guggenheim Museum; Matt Wribican at the Andy Warhol Museum archives; Callie Angell, author of the catalogue raisonné of Warhol's films; John Rajchman at Columbia University; Jonah Raskin at Sonoma State University; Ted Ryan at the Coca-Cola archives; and the artists Vito Acconci, Joan Jonas, Frank Gillette, Ira Schneider, and Michael Shamberg. I am particularly grateful to the participants of the seminar "Medium and Media" at UCI and Yale, and to Sheila Murphy, with whom I did some joint research on Warhol while she was at UCI. Jay Curley, my research assistant during the most intensive period of work on *Feedback,* was indispensable. His intelligence and skill in organizing far-flung bodies of material and his incredible diligence in pursuing illustrations were inspiring. John Hanhardt, Caitlin Jones, Amanda Parmer, Leslie Nolen, Jon Huffman, and Yoko Kanayama provided extra help with photo research.

My work on *Feedback* has been generously supported by a grant from the Howard Foundation; a residency at the Clark Art Institute, where particular thanks are due to Michael Ann Holly and Mariët Westermann; and a sabbatical granted by Yale University, due in great part to the efforts of Ned Cooke and Emily Bakemeier. Portions of this book have been published in different versions in *Art Journal, Artforum, Grey Room,* and *October,* and I am grateful to the editors of these publications. The many people who have supported this project in formal and informal ways include Henry Abelove, Alex Alberro, Nora Alter, George Baker, Eric Banks, Yve-Alain Bois, Kaucyila Brooke, Lynne Cooke, Douglas Crimp, Tom Crow, Thomas Eggerer, Laura Engelstein, Briony Fer, Russell

Ferguson, Hal Foster, Tamar Garb, Romy Golan, Maria Gough, Tim Griffin, Serge Guilbaut, Karin Higa, Gareth James, Amelia Jones, Branden Joseph, Janet Kaplan, Norman Kleeblatt, Miwon Kwon, Ewa Lajer-Burcharth, Carrie Lambert-Beatty, Karen Lang, Simon Leung, Neil Levine, Michael Lobel, Barbara London, Catherine Lord, Reinhold Martin, Christine Mehring, Stephen Melville, Richard Meyer, Matthias Michalka, Helen Molesworth, Laurie Monahan, Keith Moxey, Alex Nemerov, Mignon Nixon, Kerry Oliver-Smith, Alex Potts, Peter Prescott, Joel Sanders, Albert Sbordone, Vanessa Schwartz, Felicity Scott, Patrick Sinclair, Noa Steimatsky, Elisabeth Sussman, Nancy Troy, Katie Trumpener, Cécile Whiting, and Christopher Wood. At the MIT Press, Roger Conover's engagement and support, including his invention of this book's subtitle, have been invaluable, and Marc Lowenthal has been a pleasure to work with.

A special thanks is due to three dear friends—Pam Lee, Geoff Kaplan, and Steven Nelson—who, over the long course of this project, have kept me honest and kept me laughing. I thank my mother and sister, Jill Joselit and Amy Goldberg, for their patience and love, and I regret that my father Lawry Joselit is not here to celebrate with us. This book is dedicated to my partner, Steve Incontro, for his support and for everything else.

Introduction: Television against Democracy

> Art history as the enumeration of individual images ended with the direct
> introduction of light as the principal agent in the creation of images
> which have become infinitely multiple, complex and all-pervading.
> The comet is Light.
> **William Burroughs**

Television tames the comet by turning light into private property; it
haunts art history as the commercial doppelgänger of art's experimental
advance toward information since the mid 1950s.[1] Art stands against tele-
vision as figure stands against ground, and television, in its privatization
of public speech and its strict control over access to broadcasting, stands
against democracy. In the age of television, politics is conducted through
media-generated icons designed to manufacture consent. As a visual
medium, democracy stands against art as figure stands against ground.
No less an authority on politics than Hannah Arendt acknowledged this
condition in her response to the 1971 publication of the "Pentagon Pa-
pers," a report commissioned by Defense Secretary Robert McNamara on
decision making in Vietnam. With her customary shrewdness and preci-
sion, Arendt recognized that what mattered to the Johnson administra-
tion was not actual victory in Vietnam, but the *image* of victory:

> The ultimate aim was neither power nor profit. Nor was it even
> influence in the world in order to serve particular, tangible interests
> for the sake of which prestige, an image of the "greatest power in
> the world," was needed and purposefully used. The goal was now
> the image itself, as is manifest in the very language of the problem-
> solvers, with their "scenarios" and "audiences," borrowed from the
> theater. . . .
>
> Image-making as global policy—not world conquest, but victory in
> the battle "to win the people's minds"—is indeed something new in
> the huge arsenal of human follies recorded in history.[2]

In describing a politics of "the image itself," *Feedback* indicates how art
history and visual culture might participate in its procedures. Television

is *Feedback*'s object not only because TV is that site where politics and representation most spectacularly intersect "to win the people's minds," but also because television is a major impediment to democracy in the United States. Its profoundly centralized and prohibitively capitalized flows of information *represent* community as it prevents the formation of collective blocs. While ostensibly public and even universal, television is impossible to enter for virtually every citizen. *Feedback* enumerates a spectrum of visual tactics, developed by artists and activists in the age of network television, for breaking into this floating world and launching counterpublics from within it.

To this purpose, *Feedback* pursues three interrelated goals. First, it offers an apparatical analysis of the television system during its initial or "network" era in the United States—that period beginning with the widespread dissemination of TV in the early 1950s and ending with the consolidation of cable as a rival delivery system in the late 1970s.[3] My discussion is confined to the United States because American television pioneered the kind of commercial network that is now common in much of the world, and because its history is intimately related to that of video art. Second, *Feedback* attempts to define the problems and opportunities involved in conducting politics *through images* as opposed to the persistent if misguided conviction that public discourse consists primarily of rational linguistic debate.[4] I will carefully consider how media icons are produced, how they create publics, and how such images can be challenged. Finally, *Feedback* seeks to challenge current methodologies in art history that, in histories of twentieth-century art, continue to be guided by fantasies of revolution and subversion whose blatant impracticality renders them either cynically opportunistic or childishly naive. In this book, I will practice a kind of *eco-formalism* whose object is interrelated image ecologies rather than individual artworks. Instead of drawing a strict distinction between commercial practices of video (television) and supposedly noncommercial ones (art and activism), I will chart their differential capitalization as well as the benefits and perils of entering their integrated ecology from different points (as artist, producer, or guerrilla). In doing so, I explore three alternate metaphors for assessing the effects

of image-events: *feedback,* which may denote either rational interchange or destabilizing feedback noise; *the viral,* as a parasitic and catastrophic mode of image circulation that can invade and transform systems; and *the avatar,* as a prosthetic icon available to anyone, regardless of their nominal identity.

Feedback is an art-historical study whose archive is not an artist's oeuvre, a style, a theme, or even a medium. Instead, it recounts certain events in the video ecology of midcentury America that disrupted or reconfigured television's closed circuit. Despite their difference from conventional artworks, I have submitted these image-events to the same procedures of formal analysis that structure art history. The trope of figure-ground reversal, for instance, migrates from its roots in abstract painting to assess acts of representation in a variety of media, including the medium of politics. In a televisual world, where art stands against television and television stands against democracy, art history has the capacity to become a political science. I offer this book as one step in that direction.

1 OPEN CIRCUITS

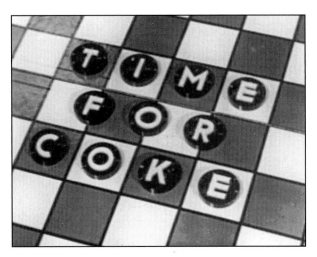

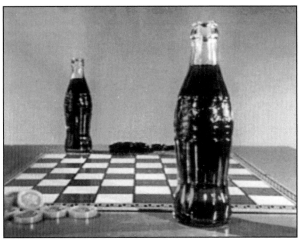

FIGURE **1.1**

Time for Coke—Checkers. Stop-action television advertisement, 1953. Courtesy of the Coca-Cola Company.

I

In the absence of players, checkers move themselves around a board. When the game is over, eleven pieces return to the grid, each inscribed with a letter, to spell out the legend "Time for Coke." In response to this call from their fellow things, two Coca-Cola bottles slide up to the board obligingly. Elsewhere, sixteen Lucky Strike cigarettes enjoy a barn dance with no smoker in sight. Their caller sings out to them, "Grand right and left around you go, Lucky Strike means fine tobacc-o!" And in an act of sinister onanism, an anthropomorphic can of Raid pushes its own button to emit a lethal cloud of insect repellent. In the early days of television, stop-motion photography and animation freed objects from their human masters. Life was breathed into things.[1]

The paradigm of information society is the network: an ever-expanding web of data resurfacing the globe. Networks are configurations without distinct edges, but not without intelligible form; they resolve into kaleidoscopic patterns of extension and intensification.[2] The paradigm of consumer society is the commodity: an objectified figure of desire. Commodities appear as points of arrest in networks, where the commutability of money, desire, and information is momentarily halted. What remains evanescent and mobile in the network is ostensibly stilled in commodities. And yet, as the history of television advertising demonstrates, the opposite is equally true: commodities are animated while networks are captured in a box.[3] As the point of contact between networks and commodities, TV establishes an alternating current by which things expand into information as information contracts into things. The resulting privatization of public channels of communication constitutes a genuine Orwellian dystopia, and yet the potential power of information's circulation, as many artists and activists have demonstrated, can never be entirely contained. The closed circuit of commercial television may be broken or distorted, if only temporarily. Indeed, one of the fundamental innovations of post–World War II art has been its invention of noncommercial applications for the same convertible model of objectivity that structures TV. This is apparent in movements as diverse as pop and conceptual art, or land and performance art, where information is folded into or expands out from the contours of things. The goal of *Feedback* is to trace such instances of disruption within the commodity-network system and in the practice of art.

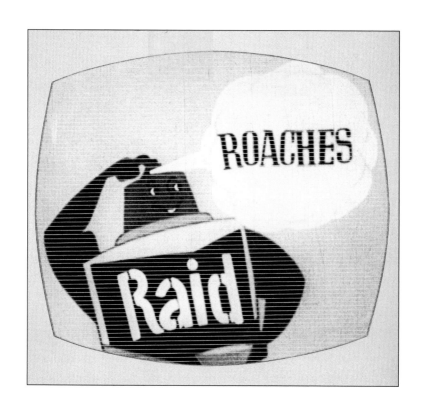

FIGURE **1.2**
Killer Raid. Television advertisement, 1956.
Courtesy S. C. Johnson & Son, Inc.

Outside the realm of television studies, and equally far from the disciplinary centers of art history, a variety of theorists engaged with poststructuralism and postmodernism have posited a model of "distributed" or "networked" subjectivity,[4] of which television's objectivity is the perfect complement. In these theories, mobility is built into persons and things: the teleology of "reification" so often proclaimed by Frankfurt School acolytes as a state of absolute stasis is rethought as a succession of relocations that, if not abolishing commodification altogether, may release some of its potential energy.[5] Paul Virilio, for instance, has pointed to the qualities of motion or speed as spatial and social positivities. One of his terms for such new objects of analysis is the "trajective": "Between the subjective and the objective it seems we have no room for the 'trajective', that being of movement from there to there, from one to the other, without which we will never achieve a profound understanding of the various regimes of perception of the world."[6] The "trajective" erodes distinctions between people and objects in favor of a situational theory of action. It identifies the kind of motion that television attempts to tame in both its animation of things and its channeling of networks. In a consumer world where things habitually stand for ideals, such acts of relocation are not merely superficial, but may have real social effect. If a commodity's meaning results from its *circulation,* it is possible to develop a politics whose goal is not to abolish or "critique" commodification (objectives that are utopian and inefficacious by turn) but rather to reroute the trajectories of things. As that site where the mobility of commodities is narrowly channeled in the service of sales— where Coke bottles or cigarettes come to life in order to seduce viewers— television is both the largest arena for and the greatest impediment to proliferating the pathways of things. But the channeled mobility of televised commodities cannot entirely neutralize the underlying potential of trajective action. In its high-stakes gamble to incite, while seeking to control the motion of things, TV is playing with fire. It is the goal of this book to visualize television's unconscious: to find the genuinely trajective within TV's pacified theater of things.

To know television, then, requires a careful description of the articulation it engineers between networks, in which the trajective principle can never be fully stilled, and commodities. The contradiction fundamental to this relation is perhaps unwittingly manifested on the cover of a little book published in 1958 by the *New York Times* radio and television editor Jack Gould.[7] *All About Radio and Television* was intended to explain TV to children, in part by encouraging boys and girls to learn the science behind

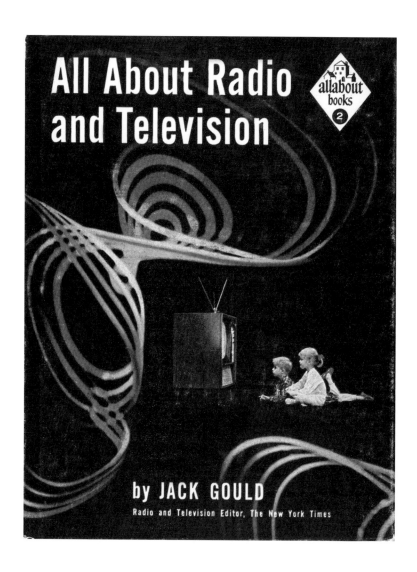

FIGURE **1.3**
Front cover of *All About Radio and Television,* by Jack Gould
(New York: Random House, 1958).

the medium by creating primitive receivers in their own basements and rec rooms. In addition to providing clear technical information, Gould assisted in the ideological promotion of TV in chapters with titles such as "Television Is Fun" and "Why We Have Television Networks." In other words, Gould's account of television is both conventional and affirmative, which only makes the representational crisis encoded on the face of his book more remarkable. The cover centers on a television set seen from the side. To the right are two little blond viewers in their pajamas, presumably siblings, who watch the illuminated screen raptly, one seated and the other lying on his stomach, head lifted at attention. This domestic scene takes place in a void—the uniform black of the cover allows for no spatial orientation whatsoever. But framing the floating vignette are two twisting configurations of rainbow-colored electromagnetic waves. Here the gap between the television commodity, represented photographically, and the network, represented in abstract wave patterns, is almost traumatic, as though some monstrous science fiction force had invaded the children's cozy domestic world.[8] The cover of *All About Radio and Television* insinuates a startling fact: the network and the commodity, though structurally linked in the ways I have suggested, are profoundly dissimilar and even antagonistic. This contradiction, if unexpected, makes perfect sense, for while the commodity requires the network in order to move it from place to place—from the appliance store to the living room, for instance—the mobility of the network, as the trajective principle, is always a potential threat to the stability of commodities.

The agonistic relationship between commodity and network encoded in the cover illustration of Gould's book is imaginatively reconciled in two artist's projects of the 1960s: Nam June Paik's "prepared TVs" of 1963 and Andy Warhol's 1968 commercial for the Schrafft's restaurant chain. In a 1963 exhibition in the Galerie Parnass in Wuppertal, "Exposition of Music—Electronic Television," Paik included several black-and-white television sets that had been altered in various ways. According to Edith Decker-Phillips, all of these TVs were tuned to the same program, but all were submitted to various sorts of interventions, which fell roughly into three categories: signals were bent into abstract patterns through changes in internal circuitry; external media like radio or audiotape were linked to the television signal to disrupt it; and TVs were altered so that visitors could manipulate the image on the screen by, for instance, speaking into a microphone.[9] In his typical antic prose, Paik himself pointed to two important qualities of these works in an essay titled "Afterlude to the

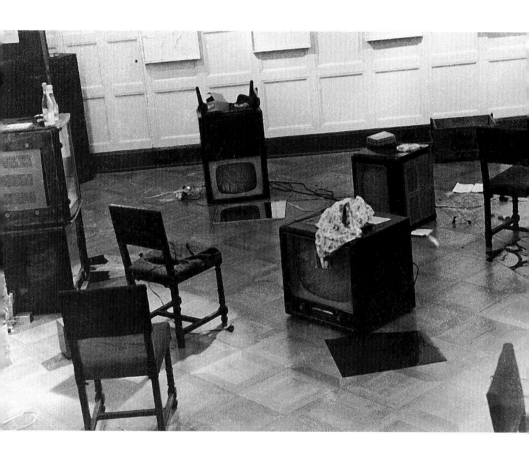

FIGURE **1.4**
Nam June Paik, installation view of "Exposition of Music—Electronic
Television," Galerie Parnass, Wuppertal, March 11–20, 1963. Photo:
Rolf Jährling. Courtesy Nam June Paik Studios, Inc.

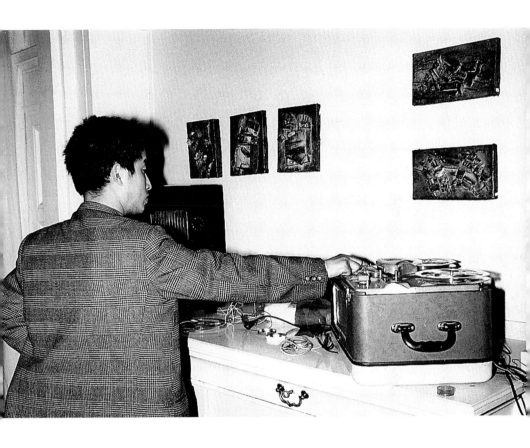

FIGURE **1.5**
Nam June Paik at "Exposition of Music—Electronic Television,"
Galerie Parnass, Wuppertal, March 11–20, 1963.
Photo: Rolf Jährling. Courtesy Nam June Paik Studios, Inc.

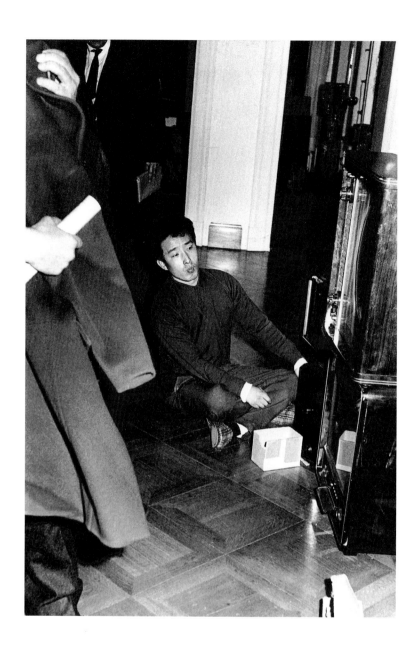

Exposition of Experimental Television," written in 1963 but published a year later. First, the artist emphasizes the uniqueness of each of his "prepared TVs": "13 sets suffered 13 sorts of variation in their VIDEO-HORIZONTAL-VERTICAL units. I am proud to be able to say that all 13 sets actually changed their inner circuits. No Two sets had the same kind of technical operation. Not one is the simple blur, which occurs, when you turn the vertical and horizontal control-button at home."[10] Paik takes pains to insist that his amendments should not be mistaken as a mere form of *adjustment* within existing technical standards ("Not one [of the altered signals] is the simple blur which occurs, when you turn the vertical and horizontal control-button at home"). Instead, his altered televisions constitute a thoroughgoing transformation of the apparatus from the inside out. Whereas the cover of Gould's book establishes an opposition between the network and the receiver, in Paik's exhibition the receiver is manipulated in order to make the network manifest itself as precisely the array of curvilinear waves that swirl around the domestic TV in the illustration for *All About Radio and Television*. Here, however, the "unrepresentable" network is framed, if not domesticated, within the contours of the television set. Ironically, it is only by distorting the broadcast signal (every TV in "Exposition of Experimental Television" was tuned to the same program) that the material nature of its medium is made to appear. If, as Paik declares colorfully, "There are as many sorts of TV circuits, as French cheese-sorts,"[11] this means that the television apparatus we take for granted is in fact only one of many possible manifestations of a particular technology.

Paik is known for his eccentric and sometimes tongue-in-cheek applications of Zen philosophy to electronic culture. In the essay I have already quoted he offers a definition of—or tactic for attaining—the religious-philosophical category of the "eternal" in terms of multiplicity: "To perceive SIMULTANEOUSLY the parallel flows of many independent movements."[12] And indeed, taken together, the singularities of the thirteen television receivers in Wuppertal function as such an ensemble of "parallel flows."[13] They evoke an alternate vision of the television network whose purpose is to reeducate perception: "The simultaneous perception of the parallel flows of 13 independent TV movements *can* perhaps realize this old dream of mystics, although the problem is left unresolved, whether this is possible with our normal physiognommy [sic]."[14] In contrast to the standard structure of the network as a centralized source of information that is uniformly broadcast to a multitude of individual receivers, Paik customized a microcosmic network in which each TV receiver would

FIGURE **1.7**
Andy Warhol, *Underground Sundae*, 1968. Videotape. © The Andy Warhol
Foundation for the Visual Arts/Artists Rights Society (ARS), New York.

decode the signal in its own way. The resulting plurality of data streams effectively mapped Raymond Williams's famous formulation of television as "flow."[15] In the "Exposition of Experimental Television," Paik conjured an entire menu of programming—all of the "French cheese-sorts"—simultaneously, as though the contents of a broadcast day had been juxtaposed in *space* rather than remaining separated within their own divisions of *time*. In this ensemble, the TV and the network were not allowed to remain separate as they had been in the cover illustration of Gould's book. Rather, the "dematerialized" mobility of the network was stabilized as an object of spectatorship. The wave migrated to the screen as an image.

In an obscure and now apparently lost videotape of 1968,[16] Andy Warhol accomplished an operation complementary to Paik's in his "Exposition of Music—Electronic Television." In this work Warhol dissolved the commodity itself into the pulsating waves of the network just as Paik had previously captured them in the technical apparatus of the TV receiver. Equally notorious for his underground films and his willingness to undertake commercial projects, Warhol was asked by the F. William Free & Company advertising agency to help revitalize the image the Schrafft's restaurant chain with a commercial for a new product: the Underground Sundae. Although "superstars" Joe D'Allesandro and Viva were invited to participate in the videotaping session, it was the sundae itself that emerged as the "star" when the human actors were eventually cut out.[17] The best existing account of the work was published in a 1968 article in the *National Observer*:

> The screen fills with a magenta blob, which a viewer suddenly realizes is the cherry atop a chocolate sundae. Shimmering first in puce, then fluttering in chartreuse, the colors of the background and the sundae evolve through many colors of the rainbow. Studio noises can be heard. The sundae vibrates to coughs on the sound track. "Andy Warhol for a Schrafft's?" asks the offscreen voice of a lady. Answers an announcer: "A little change is good for everybody."[18]

With his usual curt pithiness, Warhol was quoted in the *New York Times Magazine* as saying, "It's, uh, all about a cherry. A maraschino cherry. You know, on top of a chocolate sundae. . . ."[19] While the commercial's psychedelic management of color accorded well with the countercultural look that Schrafft's was after, Warhol's own expressed interest lay in the

mechanics of video and television. Despite advertising executive William Free's suggestion that the commercial should resemble Warhol's early black-and-white underground films, the artist himself had other ideas. As the *National Observer* reported:

> Explains a Warhol associate who helped create the one-minute commercial from a day of taping: "We wanted to use the electronic effects of the medium for decorative design. We made 18 tries, fiddling with bad settings on purpose to work toward a certain effect, like the changes in color you get when you dial a color TV incorrectly." Mr. Warhol added another idea: "We wanted to show all the mistakes they do in commercials."[20]

In an article published in *Playboy*, Warhol again stated his fascination with the malleability of video. As the author Paul Carroll reports, "His recent widely discussed commercial for Schrafft's restaurant chain was a long, voluptuous panning shot of a chocolate sundae, with 'all the mistakes TV can make kept in,' the artist explained. 'It's blurry, shady, out of focus.'"[21]

Like Paik, then, Warhol purposely evoked television's "unconscious": namely, its constitution from immaterial electromagnetic waves. But here, the commodity itself—the sundae—is remade, not out of ice cream, sauce, and a maraschino cherry, but from the texture of television itself, or as Warhol put it, from "all the mistakes TV can make." In their different ways, Paik and Warhol transgressed the dichotomy illustrated on the cover of Gould's book. Even if the TV critic could not acknowledge the inextricability of objects and the information networks in which they circulate, the artists saw this connection clearly. They reasserted the trajective principle by dissolving things into networks, allowing the inherent motion of the television signal to remake commodities as dynamic textures that, in Paik's case, were sometimes susceptible to the viewer's manipulation. Gould's cover and the two artists' experiments thus mark the limits of television's articulation of commodity and network: on the one hand, things are kept separate from electromagnetic waves in a clear statement of commodification's strict delimitation of objects, and on the other they fuse, causing a surge of trajective energy. The topography of commercial television exists between these possibilities.

II

Objects become commodities through exchange,[22] and exchange is always partially if not wholly a visual transaction. Since the first coin that bore a likeness of an emperor or king, value has been expressed through images, but in modern economies, where consumer demand must be incited to unprecedented levels in order to keep pace with technologically enhanced production capacities, the value of a product's image has increased exponentially. As pop art demonstrated in the 1960s, a commodity's informational cloak—as communicated in advertising and packaging—is not simply an appliqué but a constitutive feature: its personality, as it were. It is this public face, and not a commodity's use value (which is often indistinguishable from that of its rivals), that sells. This imperative for objects to signify within a competitive marketplace is the primary historical prerequisite for the emergence of visual information networks like television. Indeed, as William Boddy recounts in his excellent history of television in the 1950s, the apparatus was conceived from the outset as a closed circuit, folding network into commodity and vice versa: "Those most involved in planning television's commercial development—the electronics manufacturers and the commercial broadcasters—defined television simultaneously as itself a consumer product for the home and as an audio-visual showroom for advertisers' consumer goods."[23] In other words, in television, commodity and network—while opposed to one another in the ways I have suggested—are locked into a single symbiotic system. The history of television in the United States is the history of how this system unfolded in four interrelated relationships, each of which requires explication.

1. The network is a function of the commodity. Television existed as a technology before it was clear how it might be marketed as a product. It was not until after World War II that large manufacturers of electronics like RCA gained the capacity to produce televisions widely. As Boddy tells it: "The premier issue of *Television* [magazine] in the spring of 1944 noted that the huge defense expenditures of World War II had pushed production in the radio manufacturing industry up 1200 to 1500 percent since April 1942. *Television* continued: 'The question now arises what to do with these facilities after the war, for the demands of aural radio alone will not

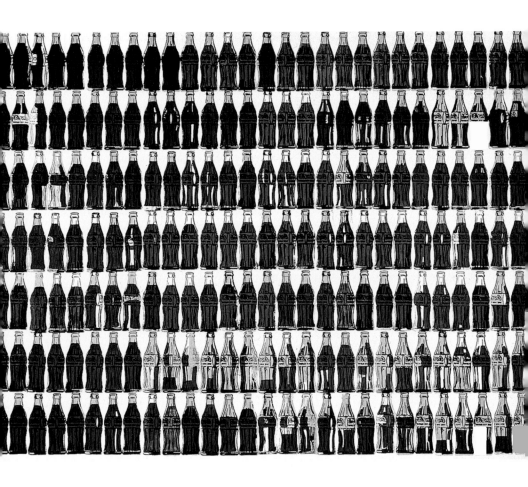

FIGURE **1.8**
Andy Warhol, *210 Coca-Cola Bottles*, 1962. Synthetic polymer paint and
silkscreen ink on canvas, 82½ × 105". © The Andy Warhol Foundation for
the Visual Arts/Artists Rights Society (ARS), New York. Photo: The Andy
Warhol Foundation, Inc./Art Resource, New York.

be sufficient to keep many of them going. *Only television offers the promise of sufficient business.'"*[24] In other words, the initial pressure to disseminate TV came from the need to put wartime manufacturing capacities to peacetime use. The cold war was also a war for the hearts and souls of new and more consumers, and one of its prime "weapons" was the television set. Established radio networks, particularly NBC and CBS, were positioned to provide programming, but this programming had developed as an ad hoc mosaic of entertainment products provided by advertising agencies.

Already in 1940, in a book titled *Television Broadcasting: Production, Economics, Technique,* Lenox Lohr recognized that the imperative to sell television sets on the one hand and to develop broadcasting on the other described what he called a closed circuit:

> The rate of progress will depend on how rapidly solutions to the economic problems are found. Moderate-cost receivers of high quality and reliability are the first consideration. These will be influenced by the growth of a nationwide market due to the installation of many transmitters and a public demand excited by program standards sufficiently fine to warrant the cost of the instruments. The excellence of the programming and the number of hours of service per week, then become the questions of major consideration. As both of these are approached, mass circulation will be obtained sufficiently large to justify the expenditure of the advertiser's dollar, giving the broadcaster additional money to put on more and better programs, hence further promoting the sale of sets and accelerating their mass production. Thus the circuit is closed.[25]

The original feedback loop within commercial television is thus the one established between the network and the commodity, which are locked together in a perpetual cycle of mutual enabling.

2. The commodity is a function of the network. If networks were established to sell a particular kind of commodity—the television set—they in turn emerge as an elaborate system for selling virtually any other type of product. At the outset, a large proportion of television programs were provided by advertising agencies themselves. Even after this system became impractical, and programs began to be developed by networks, studios, and independent production companies, the values and structure of television entertainment were closely aligned to the commercial messages that underwrote them financially. Programming was essential to the

overall sales effort, in that it represented and thereby promoted the *lifestyle* appropriate to consumer life. Each particular act of marketing encoded in a commercial message therefore took place within a more thoroughgoing, if also more indirect, environment of persuasion. As the motivational research pioneer Ernest Dichter declared in 1960, TV programming, along with other mass media, served as an intensive educational program for consolidating a new consumerist middle class: "Young wives and even older women who were reared on a lower social stratum learn their etiquette, dinner recipes, clothes, conduct and, especially, the products that are to symbolize their class membership, from radio and TV programs, women's pages in newspapers, magazine articles, and newspaper advertisements, rather than from relatives, friends, or professional advisers."[26] Dichter was one of the primary engineers of such a "consumer class," but his perspective is by no means uncommon. As Boddy recounts, television executives were hypervigilant in maintaining a consistency in values between TV programming and a sponsor's products.

Direct messages through program content are only part of television's persuasive lexicon. The *structure* of TV programs is equally devoted to valorizing commodities. First, television narratives are intensely formulaic: conflicts are established and resolved in tidy units, punctuated by commercial breaks. The viewer is trained to believe that crises may be solved; complexity and ambivalence are swept away in the syncopated rhythm of trauma and its assuagement. In and of itself, this notion of the "quick fix" dovetails nicely with the promise of relief encoded in various products for sale, but the association is also relentlessly driven home through the appearance of commercials as a kind of entr'acte, punctuating the program's successive dramatic movements. Again, Dichter is an unapologetic spokesman for the power of objects. In developing the notion of a "tension differential," he proposes a model not only for commercials but for the programs themselves:

> When a single man wishes to be married, when a housewife wants a career, when a member of the middle class dedicates himself to becoming a member of the upper classes—whenever a person in one socioeconomic category aspires to a different category, a "tension differential" is developed within him and this leads to frustration and action. Where a product promises to help a group overcome this tension, achieve its level of aspiration in whatever area it may fall, that product has a chance of success.[27]

Another name for Dichter's "tension differential" is *desire,* and indeed, the structure of TV produces a constant oscillation between the evocation of desire and its easy, if only always temporary, resolution.

A second structural quality of TV that enables consumption is its assiduous representation of social problems as individual problems that may be addressed through the acquisition of an appropriate product. Virtually every early commentator on television emphasizes the psychological nature of its programming. Unlike film, which is characterized by the projection of a large-scale photographic image, the small screen tends toward the kind of dramatic intimacy epitomized by the close-up. As Dichter suggests in his commentary on the relationship between consumption and class, television programming privileges individual modes of identification over collective or group identities. This is essential to a consumer ethos premised on the efficacy and pleasure attributed to individual acts of consumption. A third structural parameter of television drama is its reliance on highly charged symbolic tableaux to convey both narrative and ideological messages. It is worth quoting at length from Gilbert Seldes's *Writing for Television* of 1952, in order to capture the self-conscious relish with which objects are made to signify in television narratives:

> To communicate motives by images and action is difficult; to communicate mood no less so, and the temptation is always great to invent a gimmick like a prop—a flower, a cigarette case, a guttering candle—to do the work for us. They are useful, but dangerous. Put a vase of gladioli in the foreground of your picture and the audience knows a woman has been around; let two stalks break and sag, her absence is felt. At the end of six months of broken gladioli, an inventive director will have overblown roses, their petals falling, and a good director will think of an unfinished tapestry or whatever hasn't been used before. These symbolic props are good because they speak through the eye of the beholder to his subconscious, it takes no brainwork to understand them, and the audience, catching the meaning of the symbol, is pleased with its own acumen. The writer and director are pleased because they have saved time, and the producer is pleased because a piece of zebra-striped cloth and a napkin in a water goblet have created a night club for him, saving a lot of space and a lot of money.[28]

Seldes's description of the TV prop as a loaded quantum of narrative meaning might just as easily describe the persuasive rhetoric of the advertisement: "These symbolic props are good because they speak through the eye of the beholder to the subconscious, it takes no brainwork to understand them." In other words, the program is a training ground for the sort of object-centered perception that is essential to a commercial's success. Television's narratives converge in the commodity.

3. The network is itself a commodity. Broadcast television is premised on the parcelization of a public asset: the airwaves. The Federal Communications Commission (FCC) licenses the use of particular frequencies to individual privately owned stations that in turn must periodically demonstrate their responsiveness to a public good. In the early days of TV, the FCC's policies were crafted with at least two goals in mind: the fair distribution of stations among American cities and towns, and the avoidance of signal overlap and interference. Given the limited range of broadcast frequencies and the high demand for new stations early in the medium's history, these opposing goals led to a temporary freeze in the processing of licenses in 1948. The intricate history of FCC policy is not, however, at issue here. What is significant for our purposes is television's location on a borderline between the exigencies of corporate expansion on the one hand and the establishment of a national public sphere on the other. As television critic Charles Siepmann wrote in 1950, "consideration is being given to ways and means of making television's highways as extensive as those of our road system."[29] Like the highway system of the 1950s, whose construction constituted a major stimulus to the postwar economy, the development of a televisual infrastructure was viewed as both a national amenity and a corporate boon. Access to the public was itself fashioned as a kind of commodity.

The network emerged as a commodity in another sense as well. In the early years of broadcasting, the established networks adapted procedures they had followed in the heyday of radio whereby programming was largely developed by advertising agencies or by local stations. As the scope of television expanded, this model became impractical due in part to the much higher costs of TV production. Studios and independent production companies took over, but, as William Boddy has demonstrated, networks began to understand that they needed to think of their entire schedule as a consistent entity. Boddy quotes CBS president Frank Stanton in a 1956 statement: "A network is an organic thing—that is, it is very much alive. It has to be considered as an entity. The dangers of consider-

ing it only as a set of disrelated parts . . . are most considerable."[30] From the perspective of its executives, a network was an "organic" whole, a commodity in itself. In the absence of a coherent identity and artistic strategy, networks worried that they would lose viewers to rivals or to other sources of entertainment. As Boddy recounts, the consolidation of network control over the business of TV was one of the great struggles within the medium during the 1950s. The bundle of programs that is the public face of a network thus emerged as itself an object of exchange.

4. The audience is a commodity. The relationship between American television and its viewers is fundamentally commercial. As a recent textbook puts it: "Broadcasters sell audiences. Despite some appearances to the contrary, that is the single most important activity of the business. Virtually all other actions are undertaken in support of that function."[31] Programming functions as a lure, capturing audiences in order to sell them. As a 1951 promotional booklet published by NBC recommended, businesses should measure their advertising investment "by the criterion of extra customers per dollar."[32] Initially, television adopted radio's model of sponsorship, in which an entire program was underwritten (and often produced) by a corporation whose goal was to increase generalized good will toward its brand. By the late 1950s, largely due to the high cost of television production, so-called magazine or spot advertising, which allowed several companies to underwrite a single program, began to predominate. As Karen S. Buzzard has argued in her history of the ratings industry, this shift in sponsorship corresponded to a change in the average commercial's objective from soliciting good will for a corporate benefactor to fostering identification with particular products. As a result of this shift, advertisers began to regard their audiences less as undifferentiated masses and more as a spectrum of distinct sectors defined by their consumption patterns.[33] But measuring these audiences presented a serious challenge. Television is the first major public medium experienced in private: there are no ticket sales to keep track of, no crowds to count, just anonymous viewers, each in his own home. How can one sell a community that fails to cohere in space?

An NBC study titled "How Television Changes Strangers into Customers" (1955) disavows this dilemma by representing the relationship between advertiser and viewer in the interpersonal terms of an unfolding friendship. "The Power of Television," according to authors Willard R. Simmons and Thomas E. Coffin, "*advances viewers along every step in the creation of customers for a brand. It turns strangers into acquaintances . . . acquaintances*

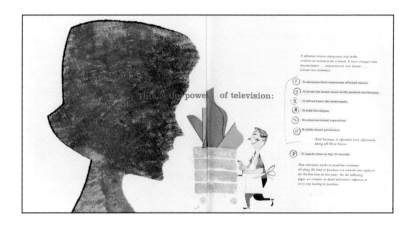

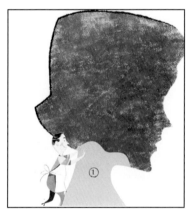

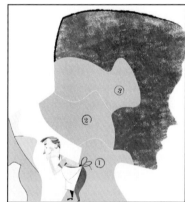

FIGURE **1.9**
Illustrations from "How Television
Changes Strangers into Cus-
tomers," an NBC study, 1955.
Courtesy NBC Universal, Inc.

into friends . . . friends into customers."[34] Acquaintanceship is established through awareness of a trademark, while friendship begins when the viewer develops a preference for a particular product. In everyday life, affection may lead to physical intimacy, and this, the authors insinuate, is equally true of the romance between people and things: "We've seen how television converts strangers into acquaintances . . . acquaintances into friends . . . how TV applies its massive strength at every stage from 'awareness' to 'preference.' Inevitably, these TV pressures explode into sales."[35] A sequence of cartoons illustrating "How Television Changes Strangers into Customers" complements the ejaculatory metaphor that concludes this passage. In these drawings, a tiny male worker fills in the colossal blank profile of a woman with seven puzzle pieces, each corresponding to a stage in television's conquest. When the portrait is complete, this visual allegory suggests, the viewer will be possessed body and soul. But the seduction of people by products is only half of television's transaction: viewers must in turn be rendered saleable. This is indirectly acknowledged in an appendix devoted to outlining the study's scientific method. Here, the authors explain how reluctant subjects were convinced to grant interviews: "The impersonal and anonymous nature of the information was emphasized and, when necessary, respondents were shown IBM cards to illustrate that the information given became, in the final analysis, merely a 'statistic.'"[36] The sober voice of the social scientist delivers the punch line to the adman's excited pitch: in the television romance, viewers go from strangers to acquaintances to friends to customers (lovers?) and finally to statistics. This is how the buyer is sold.

The ratings industry, dominated by A. C. Nielsen Co., provided the mechanism by which viewers were transformed into statistics. This task was difficult and contradictory: on the one hand Nielsen, like its competitors, aimed at understanding individual consumer desire, but on the other it sought to produce scientifically valid statistics on national viewership. To encompass both qualitative and quantitative analysis, a dual method was developed: individual questionnaires that could cull anecdotal evidence, and the Audimeter, a device installed in a representative sample of American households to automatically measure their viewing habits.[37] The Audimeter, purchased by Nielsen in 1936 from its MIT inventors, held microfilm cartridges that recorded when a television set was on, and to what channel it was tuned. As a 1963 article on television ratings recounts, the Audimeter's feedback loop performed an unintentionally comical ritual of human commodification:

The duty of a Nielsen TV householder as a representative of 50,000 TV households is to report. Every two weeks he is supposed to remove the microfilm magazine—prestamped and preaddressed—and mail it to Nielsen's Chicago headquarters, where the results are tabulated.

Removing the microfilm magazine actuates a coin slide which promptly rewards the TV householder with two quarters for services rendered. As an added inducement to stay in the sample, a premium scheme—similar to trading stamps—offers him such gifts as toasters and electric blankets.[38]

The householder is paid (if only fifty cents) to become a statistic, and she can earn credits for appliances, as though the dancing commodities on the screen had fallen onto the living room floor along with her two quarters.

Becoming a statistic is not just a commercial transaction, but a political one. In the same 1963 article, Nielsen is quoted as saying: "The audience has a right to vote. Reduced to its essentials, the act of tuning to a program is a vote. Whenever broadcasters, advertisers or agencies invest in research to count those votes—to strive in a troubled world to find out the type of entertainment people want—I think, frankly, that these companies deserve to be commended, not castigated."[39] Nielsen's defensive statement responds to hearings of the House Commerce Committee in 1963 in which the ratings industry was criticized for exercising undue influence on what networks were willing to broadcast on the nominally public airwaves. His cold war righteousness in equating a program preference with a vote is chilling, but hardly surprising. The ratings business is founded on a statistical rather than a democratic form of "representation" in which each possessor of an Audimeter "represents 50,000 TV households." Whether or not such choices should be called voting, the behavior of sample families determined what the most powerful public medium in the United States would broadcast. The commodification of audiences is not merely an aspect of consumption—it marks television's transformations of democratic publics into statistically defined markets.

o o o

In his brilliant 1982 essay "The Fact of Television," Stanley Cavell defines the material basis of television as *"a current of simultaneous event reception,"*

whose mode of perception is *monitoring*.[40] Cavell argues that even in the absence of live transmission, which was in fact short-lived in American television, the medium's structure as an array of perpetually interrupted narratives inherently lends it the effect of liveness: "Switching (and I mean here not primarily switching within a narrative but switching from, say, a narrative to one or another breaks, for a station or for a sponsor, and back again) is as indicative of live as . . . monitoring is."[41] Cavell might have added channel surfing to his enumeration of TV's broken narratives, but noting this omission only strengthens his case. What is profoundly moving in his account is the acknowledgment that television is a mode of witnessing, and what is witnessed (the "current of simultaneous events") is often frankly *uneventful*: "if the event is something the television screen likes to monitor, so, it appears, is the opposite, the *uneventful*, the repeated, the repetitive, the utterly familiar. The familiar repetitions of the shows of talk—centrally including here situation comedies—are accordingly company because of their embodiment of the uneventful, the ordinary."[42] The point of Cavell's essay is to consider why the enormously popular medium of television has met with such silence and embarrassment from intellectuals, among others. His conclusion that the medium offers "company," linking the members of an atomized populace to one another in a virtual world, is as stunningly obvious as it is persuasive.

Where I disagree with the philosopher is in his account of the psychological motive for this witnessing: "My hypothesis is that the fear of television—the fear large or pervasive enough to account for the fear of television—is the fear that what it monitors is the growing uninhabitability of the world, the irreversible pollution of the earth, a fear displaced from the world onto its monitor."[43] On the contrary, I believe that the "embarrassing" event television endlessly monitors is its own primal scene: the dilation of commodities into networks and networks into commodities. What we, as viewers, monitor is the transformation of things into animate beings and the channeling of narratives into points of purchase. The drama of television is always the birth and rebirth of the commodity (corresponding, perhaps, to what Foucault called the death of man).[44] The televisual miracle is that we grow to love our discipline as consumers, and to mistake the lively world of things as a social, even a democratic, world in which we "vote" our preferences by buying them. The melancholy side of televisual monitoring is the reversal of roles it perpetually replays: the commodity's animation leads to human stasis, to viewers sitting quietly in darkened rooms everywhere.[45]

III

The space is dark and cacophonous: the video glow pulses and blinks across monitors of all descriptions. Large-screen TVs to install in family rooms, tiny white boxes to tuck into the corners of kitchen counters. The bread-and-butter televisions destined for any room in the house, all sorted by size and name: Panasonic, Sony, Zenith, Aiwa, JVC, Hitachi. And each is turned on. Sometimes they're all tuned to the same channel, giving symphonic proportions to whatever talk show, sitcom, or police drama is playing at the moment. Sometimes an intricate pattern emerges where different stacks or rows of TVs display alternate programs, weaving new images from existing networks. But everywhere in the United States these places—the places where televisions are sold—are the same. And each manifests a paradox: the spectacle that sells a TV is external to it. The television receives: it gives access to an information network whose sublime immensity could never be loaded into the family car and driven home.

The television showroom is not just a salesroom, but a theater of contradiction. Here, banks of monitors constitute a noisy disavowal of the individual commodity's inadequacy, for if the nature of desire insures that no object may ever satisfy the fantasies it provokes, then the television set, whose "essence" is external to it, is the perfect figure of this false promise. When a purchaser buys a Sony or a Panasonic, what she *desires* is the gorgeous mosaic that plays across its screen, but what she *gets* is only a *receiver*. And like that buyer, who is a *human receiver,* the TV may either come to life (turn on) or withdraw (turn off). This simple capacity of the television, as a commodity, to connect to or disconnect from surrounding networks qualifies it as a "distributed" or "networked" object analogous to the distributed *subjectivity* of the cyborg. According to thinkers ranging from Marshall McLuhan to Donna Haraway,[46] cyborgian perception patches technological prostheses into a body's organic sensorium, causing consciousness to extend beyond the human envelope. Some have called this condition "posthuman" and characterized its subjectivity as distributed, like a network, across different organic and manmade sense organs.[47] In its inextricable connection to a network, television is the preeminent model of the distributed *object.* Whereas cyborgs extend consciousness outward, television gathers networks into itself.

A distributed subject is a circuit composed of organic and technological sensors whose effect is consciousness; a distributed object is a circuit of inorganic "receivers" and informational networks whose product is the fetish. One might argue that the whole history of modernism has been a response to the short-circuiting of humans and objects in which bodies and things have grown into one another as cyborgs and fetishes. If we take the circuit as a model of both subjectivity and objectivity in the mid and late twentieth century, then a pressing formal question arises: What kind of object (or subject) is a circuit? In one sense, the answer is simple: television is the paradigmatic closed circuit. Formally, it arises from two mechanisms: *scanning,* which characterizes television's reproductive technology, and *feedback,* which describes its broadcast structure. Not coincidentally, these two kinds of motion also correspond to the two initial tropes of video art: the distorted broadcast signal as first produced by Nam June Paik, and interactive closed-circuit installations by artists ranging from Frank Gillette and Ira Schneider to Bruce Nauman. These structures also embody a politico-formal problem because motion is so narrowly channeled in them that its ostensible dynamism results in virtual stasis: scan lines *reconstitute* images while the feedback loop *recycles* them. Closed circuits discipline public speech—they carry innumerable utterances but ultimately allow little variation in what can be said. A public can be addressed (or constituted) only if a statement's content is structured according to the discursive laws of the commercial network within which it circulates[48] (ranging from Hollywood film, which is highly capitalized and widely popular, to the art world, which is less capitalized and more "elite").

In this regard, the ranks of monitors arrayed in electronics stores, whose constant frenetic motion is doubly stabilized—physically within the grid, and economically through the price matrix of exchange—offer a ready-made metaphor of television's neutralization of the trajective principle. The television showroom is capitalism's spontaneous embodiment of the closed circuit. It accurately, if unconsciously, renders movement as stasis. Unlike those who have given vulgar accounts of fetishization (and its close cognate, *reification*), thinkers like Homi Bhabha have theorized the fetish as stasis-in-motion. Bhabha regards the fetish not as a stopgap, but as a locus of opposing tendencies held in suspension, just as in physics ostensibly solid matter is composed of particles in constant movement. In his account of colonial subjectivity, the stereotype is closely aligned with the fetish, and both are characterized by their provocation of opposing move-

ments of desire. For while the fetish is meant to disavow anxiety, it induces as a by-product the very desires it is meant to bind. Bhabba writes:

> The scene of fetishism functions . . . as, at once, a reactivation of the material of original fantasy—the anxiety of castration and sexual difference—as well as a normalization of that difference and disturbance in terms of the fetish object as the substitute for the mother's penis.

> . . . The stereotype is not a simplification because it is a false representation of a given reality. It is a simplification because it is an arrested, fixated form of representation.

> . . . For the stereotype impedes the circulation and articulation of the signifier of "race" as anything other than its *fixity* as racism.[49]

Bhabha's account, which recognizes both mobility *and* fixity in the stereotype/fetish, seems paradoxical, and yet the television showroom embodies this form precisely by staging an encounter of extreme mobility with extreme fixity.

Whereas Bhabha evokes the fetish as a "fixated form of representation," the anthropologist Arjun Appadurai has called for a historiography (or ethnology) of the commodity fetish that breaks open closed circuits at the moment of consumption. To put it simply, when people take home a television from the electronics store, they may use it in any number of ways, "licit" or not. Just like art objects, commodities are wildly variable, ranging from diamond necklaces to pork futures: Wall Street has invented financial instruments so abstract that conceptual art's powers of "dematerialization" seem tame by comparison. In order to embrace this multiplicity, Appadurai has theorized commodification as a threshold rather than a state of being; it is a sojourn, not a prison sentence. For him, the social act of exchange is what constitutes a commodity, and since a single object may undergo several such transactions in the course of its existence, its meaning inheres not in its material being but in its "social life": "We have to follow the things themselves, for their meanings are inscribed in their forms, their uses, their trajectories. It is only through the analysis of these trajectories that we can interpret the human transactions and calculations that enliven things. Thus, even though from a *theoretical* point of view human actors encode things with significance, from

a *methodological* point of view it is the things-in-motion that illuminate their human and social context."[50] In defining objects in terms of their mobility, Bhabha and Appadurai give texture to Virilio's notion of the trajective. Things, they assert, acquire meaning through the *trajectories* they trace. As television demonstrates, the immobility of fetishes is not accomplished by stopping their motion altogether, but rather by channeling movement into closed circuits. Appadurai's analysis suggests a different sort of praxis (one strongly implied by Bhabha as well), in which the fetish may be liberated by breaking open its closed circuit. Instead of seeking to subvert fetishization or reification wholesale as so much recent art criticism alleges to do, we can more modestly (and yet how much more effectively!) endeavor to set objects on different paths.

Video art is one dimension of television's "social life." Indeed, the TV showroom's "symbolic form,"[51] in which geometrically ordered banks of monitors are the ground for a looser mesh of electronic information, is not limited to the blandishments of the electronics store: the same form emerges both in video art and the television control room.[52] Starting in the late 1960s, artists such as Frank Gillette, Ira Schneider, and Les Levine made works in which ranks of monitors attached to a closed-circuit video camera would mix commercial broadcasting with video relays of spectators on time delay. Michael Asher wittily called attention to the analogy between such video works and commercial TV control rooms (typically furnished with grids of monitors, each with a camera feed) in a 1976 project where the "backstage" interactions of control room technicians in a Portland TV station were meant to be broadcast live as programming.[53] In the mid 1970s, Nam June Paik began to arrange ranks of monitors not in grids, but as simulated landscapes: expanses of sky, water and earth, all composed of electronic components. In different ways, the interactivity of the control room and the evocation of a media landscape mark the reworking of closed circuits into complex ecologies receptive to new media trajectories.

One of the objectives of this book is to describe such media ecologies, or "mediascapes,"[54] but in order to do so a new kind of criticism is necessary. Such a criticism must take Fredric Jameson's model of cognitive mapping as its inspiration[55] rather than the exorbitant and even hypocritical claims for subversion that characterize so much of the critical and academic reception of post–World War II American art. I take it as axiomatic that there is no longer a position outside capitalism in the United States,

and that under such conditions, facile revolutionary claims for art (not to mention television) are little more than posing. I wish to take seriously Appadurai's statement that "from a *methodological* point of view it is the things-in-motion that illuminate their human and social context." To that purpose, in the following chapters I propose to seize upon the televisual figures of scanning and feedback not only as forms but as methodologies. Television will be both object of study and interpretive framework. *Feedback* is the product of this short-circuiting.

Within the humanities, studies in visual culture have arisen as one type of response to the challenge of tracking the "social life of things." Recent scholarship in this field has been structured along four axes: method, archive, technology, and reception. Methodologically, visual culture is said to mimic, even to envy, the science of anthropology, whose object is not limited to the artist's production but rather embraces the rituals, practices, and visual artifacts of an entire culture.[56] This shift in object of study is closely related to an expansion of aesthetic archives beyond the oeuvre of individual fine artists to encompass works of corporate commercial art ranging from film to comics and advertisements. Much work in visual culture is premised on a theory of history in which new media (successively, photography, film, radio, television, and the Internet) are shown to produce new modes of visuality. This emphasis on technologies of vision has helped to consolidate lively studies of spectatorship in which meaning is associated as much with the consumption as with the production of aesthetic works. Indeed, visual culture marks a widespread shift from studies of producers (artists, architects, or designers) to studies of consumers (publics, audiences, fans). But as Thomas Crow and others have argued,[57] except perhaps in their magnitude none of these shifts associated with visual culture is absolutely new. There is a change in emphasis, away from formal analysis, the artist's oeuvre, traditional media, and artistic production, and toward cultural or discourse analysis, commercial artifacts, new technologies, and aesthetic consumption. In other words, visual culture and art history mutually serve as each other's Other within a constituent dichotomy whose division of the field is retained even as polarities of value are reversed.[58] In my view, the more pressing issue is the dividing line itself—by now astoundingly artificial—that is drawn and redrawn not only between art history and visual culture, but between commercial and fine arts. Simply put, visual culture often amounts to little more than the art history of commercial art. The adjacency and slippages between commercial and fine arts are certainly

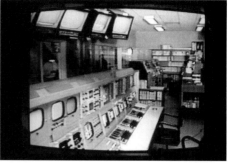 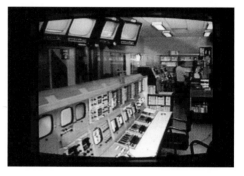

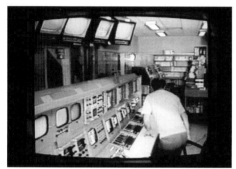

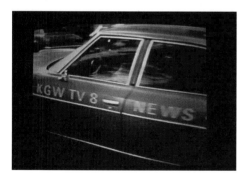

FIGURE **1.10**
Michael Asher, "no title" (12 stills from the 30-minute live television program which was Asher's contribution for the "Via Los Angeles" exhibition, Portland Center for the Visual Arts, Portland, Oregon), 1976. Live television. Courtesy of the artist.

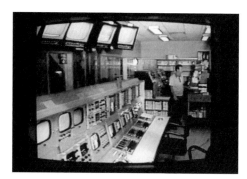
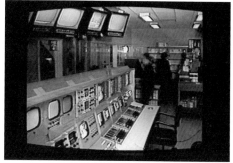

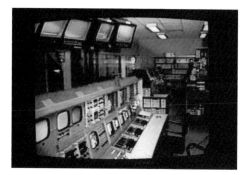
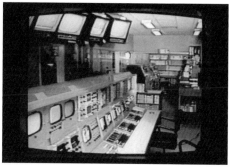

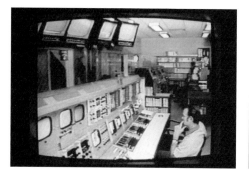

This work made
possible through the
cooperation of
KGW-TV 8, Portland.
The National Endowment
for the Arts. The
Metropolitan Arts
Commission and the
Oregon Arts Commission

nothing new (think, for instance, of medieval guilds or the commercial dimension of the great European academies that directly preceded modernism), but they do attain a different scale in the late twentieth century. During this period, American politics and public speech entered the realm of the visual to an unprecedented degree, while the visual itself was aggressively commercialized and massively capitalized through, among other things, the rise and ubiquitous dissemination of television.

The rubric that lends itself to transgressing the line between commercial and fine art is therefore not the contest between art history and visual culture, but rather a parallel (though not identical) relation between *medium*, typically associated with the fine arts, and *media*, a term commonly associated with commercial modes of communication like television and film.[59] I prefer this parsing of the field because it allows a shift in the articulation of difference in cultural production away from distinctions among established material substrates (mediums in the colloquial sense) such as painting, sculpture, and photography, and toward the mapping of an uneven spectrum of cultural and capital investments made *across* an ecology of interrelated forms (which might encompass television, video art, and the media appropriations of political activists). At first glance, the terms *medium* and *media* seem dramatically distinct from one another. After all, *medium* is associated with the most conservative modernist professions of essentialism, now inextricably linked to the name Clement Greenberg. But in its more nuanced theorizations, the question of medium has had extraordinary resilience in studies of twentieth-century art, encompassing not only modernism but also many if not most theories of postmodernism. One prominent intersection of these perspectives occurs in *"A Voyage on the North Sea": Art in the Age of the Post-Medium Condition*, in which Rosalind Krauss defines medium as a recursive structure—"a structure, that is, some of the elements of which will produce the rules that generate the structure itself."[60] Krauss demonstrates that the process-oriented sculpture of Richard Serra, for instance, is consistent with the internal divisions of a *media* apparatus such as cinema, whose *medium* is distributed across projector and screen (with the audience lodged in between). She writes: "Serra experienced and articulated the medium in which he saw himself to be working as aggregative and thus distinct from the material properties of a merely physical objectlike support; and, nonetheless, he viewed himself as modernist. The example of independent, structuralist film—itself a matter of a composite support, yet nonetheless modernist—confirmed him in this."[61] In other

words, Krauss positions film, one of the core practices of *media,* as a model for the recuperation of a modernist reading of *medium.*

Such a paradoxical identification between medium and media characterizes the canonical theoretical tropes of *postmodernism* as well. Though posing as an exit from modern medium-specificity, the various allegorical readings of postmodern art developed in the early 1980s by critics such as Craig Owens, Douglas Crimp, and Benjamin Buchloh are structurally analogous to Krauss's model of modernist recursiveness. Craig Owens's account of allegory is exemplary. Building on a variety of thinkers, and especially Walter Benjamin, Owens developed a pithy model of postmodern allegory in a two-part essay published in successive numbers of the journal *October* in 1980. Early on in the text he offers a fundamental definition: "Let us say for the moment that allegory occurs whenever one text is doubled by another."[62] Allegory, then, is the doubling—indeed, the multiplication—of "texts" within and around a work of literature or art. Such doubling (or multiplication) is precisely a recursive act transposed to a semiotic register. This concept was developed to analyze the recursive nature of so-called appropriation art in which, for instance, a rephotographed *picture* (or sign) "by" Walker Evans serves as the ground for "another" picture or sign—the reproduction presented as a "Sherrie Levine"—which is visually identical but conceptually distinct and even contradictory. If here the emphasis on self-referentiality is more textual, psychological, or apparatical than that associated with, for instance, the essentialist and optical reduction of painting to the fundamental characteristics of its medium, this difference is of the order of individual aesthetic utterances rather than a shift in the rules of their code, which remains fundamentally recursive. At stake here is not so much the nature of a medium (say, the difference between a painting and a "picture," in the terms of Crimp's famous essay),[63] but the epistemological structure of aesthetics in the mid twentieth century, which has been diagnosed as fundamentally recursive by both the most important artists of the period and their most brilliant critics and historians.

For commercial media like television, Marshall McLuhan's notion of the "ratio" offers a closer conceptual fit than the modernist model of recursivity. As McLuhan famously declared, "the 'content' of any medium is always another medium,"[64] and therefore the structure of media is the relation (ratio) between them: "For in operating on society with a new technology, it is not the incised area that is most affected. The area of

FIGURE **1.11**
Sherrie Levine, *After Walker Evans #3*, 1981. Gelatin-silver print, 8 × 10".
© Walker Evans Archive, The Metropolitan Museum of Art. Courtesy Paula
Cooper Gallery, New York.

impact and incision is numb. It is the entire system that is changed. The effect of radio is visual, the effect of the photo is auditory. Each new impact shifts the ratios among all the senses."[65] As a supplement to his concept of the ratio among senses and among media, McLuhan understood new technologies as extensions of the sensory apparatus of individual human beings—as a *ratio* between a biological entity and a mechanical apparatus, which he pessimistically referred to as "auto amputation."[66] Whereas recursivity defines *medium* as a closed circuit established between a material apparatus and its aesthetic products, McLuhan allows us to understand *media* as an open circuit or sprung coil whose fundamental form is the ratio, or relation between media and among humans and technologies. With a nod toward the midcentury sociologist David Riesman, we might conclude that mediums are inner-directed and media are outer-directed,[67] but in terms of their material substrate (video for instance), there need not be any difference between them at all. As David Antin proclaims about video art, "it is with television that we have to begin to consider video, because if anything has defined the formal and technical properties of the video medium, it is the television industry."[68] The difference, then, between medium and media lies not in a material substrate like painting, sculpture, or video, but in the public addressed and the capitalization necessary to reach—or more accurately, to *constitute*—such a public. Antin's point is that video art directs the same technical possibilities accessible to television to a differently positioned audience and institutional frame. I do not mean to offer a simplistic value judgment like "artworks are elitist and television is populist." Rather, I wish to assert that what establishes difference *among* media (if we dispense with the term *medium* altogether, and thereby negate the misleading association between it and Greenbergian modernism) is the type and magnitude of social and economic investment made in a particular form.

And yet neither of the critical categories I have proposed thus far—recursivity and ratio—is capable of theorizing such investment. In combination they may delineate the contours of a new critical territory that spans the commercial and the avant-garde, the outer- and the inner-directed, but they cannot fully map the topographical features of this terrain: the peaks and valleys of intensification, consolidation, or blockage that arise from the asymmetrical investment of capital in form. While the Deleuzian concepts of territorialization and deterritorialization are widely in use, a critical vocabulary for diagnosing their *forms* is distinctly underdeveloped. We need to understand how media are channeled and pooled,

directed and diverted. In this regard, the work of the sociologist Talcott Parsons may serve well. Over his long career, Parsons explored the question of media in social rather than visual terms. For him, *money* served as the primary model of the medium, which he understood as exhibiting four fundamental qualities: (1) a symbolic character, "which was stated by the classical economists for money in the proposition that it had value in exchange, but not value in use";[69] (2) specificity of meaning, in the sense that the medium may function in some but not all instances of exchange; (3) circulability, in that money migrates among many people and through many transactions; and (4) the absence of a zero-sum quality. This last concept is the most obscure with regard to the understanding of media in the arts and humanities, but perhaps for that very reason it is the most promising. Parsons explains: "Most political scientists dealing with political power had explicitly stated or tacitly assumed that it was a zero-sum phenomenon, that is, that an increase in the amount of power held by one group in a system *ipso facto* entailed a corresponding decrease in the amount held by others. This patently was not the case with money because of the phenomenon—well known to economists—of credit creation."[70] What is significant in Parsons's theory is his understanding that media—as in the exemplary case of money—are subject to accumulation, and through the logic of credit they engage in speculation. In other words, like the cybernetic concept of noise, whose degradation of intelligible pattern interrupts the smooth relay of a message, medium-as-accumulation diverts communication. But this diversion is hardly "arbitrary" in the way that semiotic theorizations within art history have analyzed the arbitrariness of the sign. On the contrary, investment is highly motivated by the desire to consolidate money, power, and influence. As Parsons puts it:

> In the case of money the classical instance is the creation of new money in the form of credit by banks. . . .

> We would contend that the—or one—political analogue of the banking function in the lending context is to be found in that of political leadership. Political leadership will make promises, fulfillment of which is dependent on the implied consent of the constituencies of the political leaders who have given them a grant of power under institutionalized authority, most obviously in cases of election to office. Once in office, however, such power holders may introduce extended plans which can be implemented only through new political power. . . . We think that this is a process which is

rather strictly analogous to that of credit creation on the part of bank executives.[71]

For Parsons, power, like money, is conceived as a *social medium*. Given the contemporaneous emergence of credit cards and television in the United States, it is tempting to regard them as "new media" in that each introduces a novel means of financial speculation (and consequently, the accumulation of power).[72] As the purveyor of advertising on an unprecedented scale, television addressed the glut of consumer products in postwar America by relentlessly glamorizing these objects in its narrative programming, directly inciting viewers to purchase them through its advertising. Meanwhile, credit cards helped to "solve" the complementary problem of overconsumption—that buyers may lack ready funds to consummate their exorbitantly inflamed desires.[73] Indeed, Daniel Boorstin has linked the emergence of credit cards in the mid twentieth century both to the consolidation of national markets and to the attenuation of objects that may result from possessing and consuming things before they are fully paid for—an aspect of what he evocatively calls the "thinner life of things."[74] For Boorstin, then, the dematerialization of objects is not in conflict with, or in a position of unambiguous resistance to, massive capitalization and consumption—rather, it emerges as one of its effects. Encoded in his phrase—the "thinner life of things"—is my motivation for introducing Parsons's concept of media as economic accumulation, for Boorstin asserts that the nature of objects is transformed through the financial arrangements that underwrite them.

Thus far, I have delineated three aspects of media: their recursive structure as manifested in the closed circuit; their ecological position as defined by the relation—or *ratio*—among an entire spectrum of existing media; and finally their speculative concentration in which form is conditioned through social and financial investment. A concept of media adequate to the postwar televisual era must encompass these three dimensions. I propose that *feedback* provides such a synthetic category. It is worth quoting the cybernetics pioneer Norbert Wiener on feedback:

> It is my thesis that the physical functioning of the living individual and the operation of some of the newer communication machines are precisely parallel in their analogous attempts to control entropy through feedback. Both of them have sensory receptors as one stage in their cycle of operation: that is, in both of them there exists

a special apparatus for collecting information from the outer world at low energy levels, and for making it available in the operation of the individual or of the machine. In both cases these external messages are not taken *neat,* but through the internal transforming powers of the apparatus, whether it be alive or dead. The information is then turned into a new form available for the further stages of performance. In both the animal and the machine this performance is made to be effective on the outer world. In both of them, their *performed* action on the outer world, and not merely their *intended* action, is reported back to the central regulatory apparatus.[75]

Wiener's understanding of feedback combines inner-directed and outer-directed flows of information. The machine (animate or inanimate) regulates its internal functioning through the incorporation of messages drawn from outside. Moreover, this *outside* is encountered as a distinct actuality beyond the control of the subject-machine: this is what is meant by Wiener's distinction between *performed* and *intended* action. Gregory Bateson defines information as a difference that makes a difference[76]—in other words, like McLuhan, he conceives of communication as a *ratio.* But in feedback, the ratio is folded back into the recursive circuit that it helps to regulate. *Feedback* is the figure of the actual interaction of medium and media. Moreover, it is in the difference Wiener acknowledges between a *performed* and an *intended* action, as these terms are used in the colloquial sense, that the third aspect of medium I have addressed—its speculative nature—inheres, since the internal functioning of form within Wiener's subject-machine is always in response to external stimuli, which are themselves determined by the broad field of social investment. The *performative* returns media to the world of money and power.

The channeled motion of television—the alternating current it establishes between commodity and network and its infinite repetition of the commodity's primal scene as the foundation of American sociality—can only be understood within the media ecology I have described. It is in such a context that the closed circuit of television (and the system of commodity circulation it serves and exemplifies) may be correctly perceived as a function of *investment* whose objective is to narrowly channel the trajectories of things in order to extract massive profits from them. Neither the modernist aesthetic tactic of revolution nor the poststructuralist technique of subversion (which in any event are two sides of the same coin) is adequate to address the closed circuits that fashion our pub-

lic worlds—unless one is prepared to wage actual political revolution and to pay its price of massive violence (something that those with "subversive" on their lips might well remember). This book proposes another route. If meaning inheres not in things but in their "social lives," the duty of the historian is to describe and theorize how objects might circulate differently, taking as inspiration the impossible trajectories invented by artists and the short-lived ruptures of political intervention. *Feedback* traces the efforts of artists and activists to produce aberrant or utopian pathways across the locked-down terrain of television. It seeks to open circuits.

FIGURE **2.1**
Nam June Paik, *TV Garden,* 1974 (1982 version). Single-channel
video installation with live plants and monitors; color and sound;
dimensions variable. Photo: Peter Moore. Courtesy Nam June Paik
Studios, Inc.

I

In the age of television, art inhabits a mediascape whose contours are established by the social life of things.[1] It is here that commodities (including artworks) find their natural habitat, their "second nature."[2] As Susan Sontag suggests in her 1977 book *On Photography*, such ecological conditions call for an ecological response: "Images are more real than anyone could have supposed. And just because they are an unlimited resource, one that cannot be exhausted by consumerist waste, there is all the more reason to apply the conservationist remedy. If there can be a better way for the real world to include the one of images, it will require an ecology not only of real things but of images as well."[3] Sontag's ecological metaphor suggests that discrete images should give way to whole ecologies as the fundamental unit of formal analysis. Such an *eco-formalism* would allow historians to organize visual data differently, tracing images as events within integrated systems. But as inspiring as Sontag's general proposal is, her specific prescription—"the conservationist remedy"—is troubling. To conserve forests, rivers, or endangered species is to preserve limited and exhaustible resources, but to conserve *images,* "an unlimited resource," leads ultimately either to censorship or to museification, both of which were common during the latter half of the twentieth century.[4] Image *conservation,* then, appears inherently conservative.

Nam June Paik shared Sontag's ecological perspective, but he advocated image proliferation rather than conservation. In his evaluation of video's social effects, Paik suggested that public television programming (including video art made for broadcast) could be an alternative to other, more wasteful forms of financial expenditure. He drew no *cordon sanitaire* around images, but rather positioned their premier delivery system, television, as a catalyst that might help "correct" an entire economy. By increasing the flow of images, harmful investments of other sorts might be minimized:

> When PBS spends $100,000 on the production of a television play (to be enjoyed by millions of people), the energy consumption is no bigger than that of a $100,000 private plane for the pleasure of a single sportsman. Yet both areas of activity contribute equally to the Gross National Product. Rather than blindly idolizing the GNP,

we should divide it into two categories, one with a high energy/ecology factor, the other with a low one. By promoting the second category, we combine our concerns for a high growth of the economy, for energy self-sufficiency of the oil-importing countries, and for environmental protection. We must not only be guided by the estimated sum total of the GNP or by estimated per capita income, but must also take the energy/ecology factor into consideration as a long-term indicator of individual wealth as well as the wealth of the nation.[5]

In the course of his long career, Paik worked closely with the visionary producer Fred Barzyk at WGBH, the public television station in Boston, and advised the Rockefeller Foundation on its philanthropic policies regarding new developments in television and video. Here he demonstrates a subtle understanding of the calculus of media, investment, and community.[6] In establishing a connection between public television and the "wealth of the nation," his goal was to "open circuits"[7] by demonstrating how the proliferation and diversification of images could benefit an entire interrelated ecology.

In an interview published in 1973, Paik discussed the advent of videocassettes in the following terms:

> The cassette will diversify the video culture. Now there is only one television structure in the United States, one-way communication from three major networks. You get their kind of television, or you must cut it off. But in the future world, you will have cable TV, video cassettes, and picture phones. You will also have video tranquilizers, like my Synthesizer Machine. If the video structure is diversified, one of the first results will be less pollution. It will be a major solution to the ecology crisis. Why move, why drive somewhere in your car, if you can do everything right at home?[8]

Like McLuhan, for whom the impact of a new medium is registered through its reframing of adjacent media ("The effect of radio is visual, the effect of the photo is auditory"),[9] Paik diagnoses the significance of videocassettes in terms of a heterogeneous energetic ecology that links the diversification of television to a reduction in air pollution. Whether he is right or wrong in his prognostications is not my primary concern (though he accurately captures the ethos of telecommuting thirty years in advance). What is significant

FIGURE **2.2**
The Paik-Abe Video Synthesizer, developed by Nam June Paik and
Shuya Abe in 1969; shown here is the 1972 model, made for
WNET/Thirteen, New York. Courtesy Nam June Paik Studios, Inc.

in the two passages I have quoted is that images are not consigned to the position of "reflecting" or "interpreting" social conditions, but rather operate as full-fledged agents in a heterogeneous but integrated financial ecology. For Paik, even venerable statistical markers like the GNP must be submitted to cultural parsing. In his account, the introduction of a new technology such as the videocassette, or a new technique of image production like his Video Synthesizer, developed in collaboration with the engineer Shuya Abe and funded by WGBH, may adjust the balance of an entire media system. Paik indicates a role for art (or any other representational activity) that is at once more modest and more efficacious than revolution or subversion. The artwork functions as a catalyst[10] that may reconfigure a system subtly or even catastrophically, and consequently the historian's job is not only to study the production of art, or even to understand how social forces percolate through it, but also to describe the effects of such catalytic events on an entire image ecology.

Paik's strategy for redressing the "one-way communication from three major networks" was multipronged: he helped to develop philanthropic policies regarding video and he participated in the most important effort by public television to produce artists' works, but his fundamental contribution was the invention of formal models for disrupting image ecologies. He devised two especially productive "eco-forms" that transpose the utopian proposals of his writings to the laboratory setting of the gallery or public television broadcast.[11] One of these is the arrangement of environmentally scaled banks of monitors programmed with ever-changing video mosaics. By making tapes that juxtaposed such dissimilar components as appropriated advertisements and original interviews, and by combining monitors of many sizes and shapes into room-scale ensembles, these installations served as actual models of a diversified television ecology.[12] Paik's second strategy was to develop malignant procedures by which a video signal was distorted or degraded into mere "noise." In his *Electronic Opera #1* (1969),[13] for instance, which was part of WGBH's first broadcast of artist's television, *The Medium Is the Medium,* scan lines are bent with magnets so that the faces of Richard Nixon and John Mitchell fold into themselves as though these notorious politicians were swirling down an electronic toilet. These twin tactics of diversification and distortion embody a kind of event that, in a 1969 essay titled "Pathologies of Epistemology," the cultural theorist Gregory Bateson calls "self-correctiveness . . . in the direction of runaway,"[14] and which I will call *viral* aesthetics.[15]

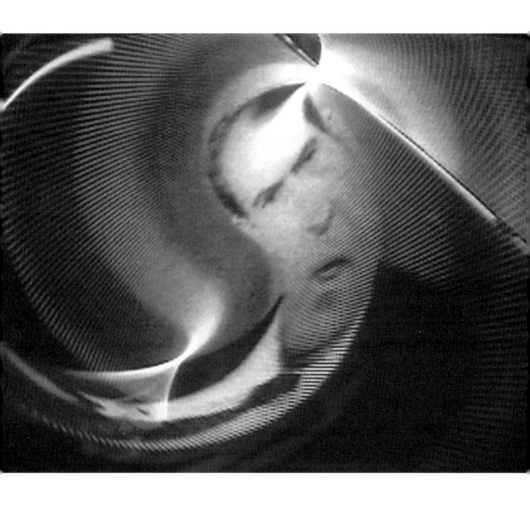

FIGURE **2.3**
Nam June Paik, *Electronic Opera #1*, 1969. Video still.
Courtesy Electronic Arts Intermix (EAI), New York.

If, as I argued in chapter 1, a progressive politics regarding images in general and television in particular must involve imagining new trajectories for things—by endowing them with dynamic new social lives—then the virus, as a deviant vector, may offer a useful paradigm. When viruses enter an ecological system, like a body, they block existing channels and open new ones. The viral does not "overturn" its host but infects it, as in Paik's famous synthesizer developed with Abe, where broadcast signals are deliriously degraded or distorted. Paik's aesthetics may be considered viral because they exhibit the virus's qualities of runaway reproduction (as in his installations) and parasitism (in hijacking the ordinary broadcast signal). In medicine the virus is transpersonal, moving from host to host as though through a human medium, whereas in artworks like Paik's the viral image is transobjective: its motion fatally blurs the distinction between commodity and network that defines the televisual ecology. As a parasite that scrambles a genetic or computer code, the virus offers a model for how commodities and networks might actively disrupt or reconfigure one another—it constitutes a systemic invasion where the absence of individual intention (the virus cannot "think," but can only act) does not preclude productive or even political effects. In Paik's macroscopic analysis, for instance, the videocassette refigures the circulation of TV throughout its entire ecology. On the level of the individual artwork, Paik's manipulation of television's scan lines disrupts the nature of objectivity at its very roots by infecting commodities with unstable motion, thus reintroducing the trajective principle of the network into the ostensible stability of the commodity.

Such a destabilization of the detente between commodity and network, which is fundamental to commercial television, places Paik's viral aesthetics squarely in the tradition of the readymade. As an artist, but also as an activist, Paik recognized that to remake the television system would require inventing a new kind of objectivity. As the primary tradition of the twentieth century in which commodities are resituated within networks (and thus endowed with new social lives), readymades could answer this requirement. In a statement of 1984 Paik retrospectively offers an account of the reinvigoration of the readymade through video:

> After Marcel Duchamp and John Cage, there were not many ways to go. Jasper Johns was a genius. Everybody was making collages using ready-made objects, but Johns painted a painting of a ready-made

with his hand, injecting himself too. He made a slight variation. His Ballantine beer cans were cast and not actual Ballantine beer. He wasn't painting actual cans. That was one way at the time to escape from the impossible Duchamp cult of the ready-made. For me, I thought when I went to reality, I would use my brain and go deeper. I would study how it was made and I discovered it was made of electrons and protons. It made sense to me that I might as well use electrons and protons directly. Then I can have the reality of ready-mades, spiritual reality and scientific reality.[16]

According to this declaration, the aesthetic problem Paik set for himself was to engage with the tradition of the readymade without falling into academicism, or what he calls "the impossible Duchamp cult." He identifies two options for accomplishing this: Jasper Johns's technique of "painting" readymades, and his own practice of working with particles— electrons and protons—that are transobjective. Each of these approaches demonstrates that the significance of the readymade has nothing to do with the pictorialism of the *objet trouvé*—with "making collages using ready-made objects." Paik understood that the radicality of Duchamp's invention lay not in incorporating mass-produced things in art, but rather in producing a paradoxical object locked in a perpetual oscillation between its status as a thing and its status as a sign—or, stated differently, in heightening the epistemic crisis between commodities and networks.

According to this interpretation, Duchamp's readymades were properly viral from the start, for they were constituted through the refiguration of an object—the scrambling of its DNA, as it were—by endowing it with a new inscription. As Duchamp writes in one of his notes for the *Large Glass*:

Specifications for "Readymades".

by planning for a moment to come (on such a day, such a date such a minute), "*to inscribe* a readymade"—The readymade can later be looked for.—(with all kinds of delays)

The important thing then is just this matter of timing, this snapshot effect, like a speech delivered on no matter what occasion but *at such and such an hour.* It is a kind of rendezvous.[17]

It is the inscription—whether rendered as an actual text applied to the readymade physically, or projected onto it virtually as a title—that makes the snow shovel in Duchamp's *In Advance of the Broken Arm* (1915), for instance, not a snow shovel but a work of art. And this slippage between object and inscription establishes theoretically the future relationship between the commodity and network that television would dilate into a full-blown public sphere. Paik's fascination with the readymade tradition thus reaches beyond his personal use of mass-produced objects like TV sets. He recognized that television, as the chiasmus of commodity and network, results from capitalizing on the destabilized relation between objects and their textual frames that Duchamp had already demonstrated aesthetically in the second decade of the twentieth century. Television is the rightful heir of the readymade.

It was William Burroughs who recognized that language—the "medium" both of inscription and informational networks—should be considered viral. As Burroughs declares in *The Ticket That Exploded,* first published in 1962:

> From symbiosis to parasitism is a short step. The word is now a virus. The flu virus may once have been a healthy lung cell. It is now a parasitic organism that invades and damages the lungs. The word may once have been a healthy neural cell. It is now a parasitic organism that invades and damages the central nervous system. Modern man has lost the option of silence. Try halting your subvocal speech. Try to achieve even ten seconds of inner silence. You will encounter a resisting organism that *forces you to talk.* That organism is the word. In the beginning was the word.[18]

For Burroughs (as, differently, for poststructuralism), language *infects* the speaker, rather than originating from inside her or him. In his elaboration of this metaphor (or, perhaps, actuality), he associates the viral word with psychological patterning on the one hand, and with the potential for breaking apart such patterns (what he sometimes calls the "Reactive Mind") on the other. In its power to manipulate minds, the word functions analogously to the media—a point that Burroughs makes explicitly in his 1970 text *Electronic Revolution.* In this work, as in *The Ticket That Exploded* that preceded it, he recommends using audio *playback*—a kind of "runaway self-correctiveness" closely related to the emerging strategies of video art—as a political tool.[19] Burroughs's experiments with tape recorders[20] are an important complement to his cut-up techniques of literary

FIGURE **2.4**
Marcel Duchamp, *In Advance of the Broken Arm* (snow shovel),
1945 (replica of the lost original of 1915). Wood and galvanized
iron snow shovel, 48 × 18 × 4". Yale University Art Gallery, Gift of
Katherine S. Dreier to the Collection Société Anonyme. © 2006
Artists Rights Society (ARS), New York/ADAGP, Paris/Succession
Marcel Duchamp.

THE DEATH OF MRS D

composition, both of which were intended to "rub out the word" as an oppressive force.[21] In *Electronic Revolution* he writes:

> The control of the mass media depends on laying down lines of association. When the lines are cut the associational connections are broken. . . .

> You can cut the mutter line of the mass media and put the altered mutter line out in the streets with a tape recorder. . . . Mutter line of the EVENING NEWS, TV. Fix yourself on millions of people all watching Jesse James or the Virginian at the same time. International mutter line of the weekly news magazine always dated a week ahead. . . .

> So stir in news stories, TV plays, stock market quotations, adverts and put the altered mutter line out into the streets.[22]

Burroughs understood playback as a kind of *political* virus. He recommends, for instance, "you want to start a riot put your machines in the street with riot recordings move fast enough you can stay just ahead of the riot surf boarding we call it. . . ."[23]

In Burroughs's viral aesthetics, the manipulation of language is powerfully catalytic: the presumed transparency of words to "their" meanings is destroyed, just as in Duchamp's readymades the correspondence between objects and their function is disarticulated completely. Burroughs saw more clearly than Duchamp that this slippage could present an explicitly political opportunity—to induce riots, for example, through the deployment of tape-recorded language as a biological weapon. In the work of Johns, whom Paik identifies as an intermediate figure between Duchamp and himself, this displacement from signifying to acting (which is one of the fundamental characteristics of viral aesthetics) resides in objects themselves.

If Duchamp untied the signifier from the signified, Johns explored a *syntactic* condition of objects in which the viewer experiences a declension of things. In two paintings titled *Device,* for instance, where rulers are attached to the edges of a painterly field and manipulated as compasses to imprint blurred semicircles on a ground of expressionist brushstrokes, the readymade functions simultaneously as picture, object, painterly mark, and "brush." In a sketchbook note written sometime around 1967,

FIGURE **2.6**
Jasper Johns, *Device,* 1962. Oil on canvas with wood, 40 × 30".
The Baltimore Museum of Art: Purchased with funds provided by The
Dexter M. Ferry, Jr., Trustee Corporation Fund, and by Edith Ferry
Hooper, BMA 1976.1 © Jasper Johns/Licensed by VAGA, New York.

Johns indicates that such object declensions may have had, for him, an analogy to language: "Linguistically, perhaps, the verb is important. But what about such a case in painting?"[24] To make an object (naturally assumed to be a kind of "noun") into a verb requires a field of action. Consequently, Johns's syntactical manipulation of readymades within the discourse of painting should be regarded not as a neo-avant-garde regression, but as a historically astute recognition that unless the readymade is kept in motion, its initial shock value will quickly fade. Duchamp himself understood the susceptibility of readymades to recuperation, and he labored to anticipate and outflank their neutralization by carefully limiting his output. Later, he wittily restaged and reissued some of them, like *Fountain* (1917), in order to maintain the instability between thing and concept that accompanied their initial presentations—in other words, by making physical objects into verbs.[25] Johns's innovation lies in causing such permutations of things to occur on the unified plane of painting.

If a viral aesthetics orchestrates the mutual perversion of commodities and networks, Johns's work is viral in the sense that he introduces the singularity and immanence of use—or action—into the abstract code of language. In pursuing their "social lives," things interrupt codes. This, I think, is what Johns is getting at when around 1960 he wrote in a sketchbook:

> Focus—
>
> Include one's looking
>
> " " "seeing"
>
> " " using
>
> It & its use &
>
> its action.
>
> As it is, was, might be.
>
> (each as a single tense, all as one)[26]

Here again, a linguistic term helps to illuminate the painter's tactics: in this text, Johns imagines a method of combining objects (and perceptions)

in which "each [functions] as a single tense, all as one." The verb's temporal moods coexist, as in the *Device* paintings where the ruler itself might be considered in the present tense, whereas the marks it has made on the canvas are in the past. As Paik shrewdly observed, Johns "painted a painting of a ready-made with his hand," and in so doing introduced both action (the verb) and, in his choice of motifs, a kind of tense as well. His penchant for molds and stencils in works such as *Target with Plaster Casts* (1955) or *Gray Alphabets* (1956) emphasizes the painterly mark's passage through a readymade threshold: the contours of an organ pressed into a mold function as a "mark," while stencils discipline brushstrokes in paintings composed of letters and numbers.

Paik also identified Johns's "genius" with a strategy of "injecting himself too." It is through his "hand" that the ruler meets the canvas, the cast meets the organ, or the stencil meets the stroke. But in such works, the artist's "hand" doesn't serve as the guarantor of authentic emotion as it had in the paintings of abstract expressionists like Jackson Pollock, where gesture was understood as the medium of the unconscious; instead, it is an organic agent of highly coded action. Whereas Johns's viral transobjectivity still requires the motility of a body, Paik's viralism seeks a different level. As we have seen, his practice of the readymade is composed of subobjective—as opposed to subjective—units: "For me, I thought when I went to reality, I would use my brain and go deeper. I would study how it was made and I discovered it was made of electrons and protons. It made sense to me that I might as well use electrons and protons directly. Then I can have the reality of ready-mades, spiritual reality and scientific reality."[27] Paik manipulated readymade "electrons and protons directly" in what he called his "dancing pattern," whose antigravitational gyrations result from the liberation of a TV receiver's signal. The artist dates the dancing pattern to his 1968 exhibition, "Electronic Art II," at the Galeria Bonino in New York: "I made it from internal modulation of three audio signals. I feed the audio signals into the set and they make variable patterns, particularly on color sets. I think my two technical breakthroughs were placing magnets on black-and-white sets and the dancing color pattern."[28]

By transmogrifying the commercial speech of broadcast TV, Paik's "technical breakthroughs" complete the elision of commodity and network that Duchamp had initiated with the readymade. In the dancing pattern, network *is* commodity (i.e., broadcast TV), and the trajective principle has

thoroughly remade the object. There is no difference in the "electrons and protons" that constitute the one and the other, so the shift between them lies entirely in their *rearrangement*. Paik's "electronic painting" is thus both parasitic and systemic. Rather than functioning as a singular index of the artist's gesture, his "mark" is manifested as the disruption of the receiver's normal operation. Television images are composed of fields of interlaced scan lines: the pictures to be broadcast are broken down into elements, or pixels, that are transmitted as electrical waves to a receiver in which they are reconstituted through the action of electron guns whose high-speed motion across and down the screen activates discrete phosphors. In amending the television receiver, Paik refigured television's ecology of image production: his "medium" became the patterns of scanning itself. As he explains in a 1967 essay: "The main reason for the quick success of my electronic art was . . . my efforts on the creation of unusual scanning patterns." And later in the same essay, he links such manipulations directly to the logic of the viral: "Among vast application of this method in art, science, and technology, one interesting example would be the imitation of the statistical movements of virus, bacteria, fishes, and mass people etc."[29]

In a 1975 interview, Paik declared, "Marcel Duchamp did everything except video. He made a large front door and a very small exit. That exit is video. It's by it that you can exit Marcel Duchamp."[30] If, as Paik provocatively suggests, video is the heir of the readymade, it carries the tradition forward by dissolving the distinction between commodity and inscription that had formed the conceptual ground against which a readymade could signify. Indeed, Paik's "dancing pattern" is literally *groundless,* composed, as the artist put it, of "nongravity motion."[31] Viral aesthetics is precisely such a scrambling of figure and ground—it is an infection of gestalt relationships whose symptom is feedback noise. But the antigravitational mark that arises when a television's circuits are rearranged represents only one pole of Paik's viralism: the other banishes gravity through infection of the body by media. In a series of famous collaborations with Paik, the cellist Charlotte Moorman "wore" television sets (as video bras) or "played" them (as a video cello). Her body became the ground for an infinite regress of images, sometimes images *of herself playing her instrument.* As Gregory Battcock wrote of TV *Cello* (1971), "It was an extraordinary conception and a theoretical masterpiece, because instead of 'being on television,' the televisions were, in fact, on Charlotte Moorman."[32] In other words, the embrace of the audience within a media circuit is explored as the reversal (or more accurately the degradation) of figure-ground relationships

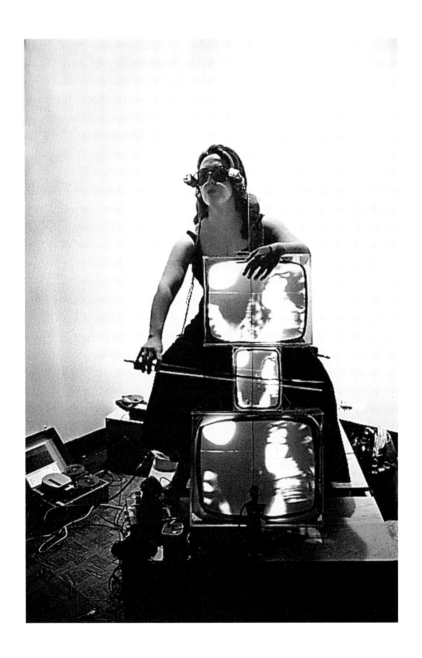

2.8
Jud Yalkut and Nam June Paik, *TV Cello Premiere*, 1971. Performer:
Charlotte Moorman. Video still. Courtesy Electronic Arts Intermix
(EAI), New York.

between a body and its representations. Indeed, in some of his strangest proposals, Paik imagined eroticism as the means of collapsing such differences. In a 1965 letter to Billy Klüver, he wrote:

> Someday [a] more elaborate scanning system and something similar to matrix circuit and rectangle modulations system in color TV will enable us to send much more information at single carrier band, f.i. audio, video, pulse, temperature, moisture, pressure of your body combined. If combined with robot made of rubber, form expandable-shrinkable cathode-ray tube, and if it is "une petite robotine"

> please, tele-fuck!

> with your lover in RIO[33]

Long before AIDS, Paik, like Burroughs, understood information as a sexually transmitted disease. The viral erodes the gestalt between body and machine. Or, as the artist declared in 1975: "What was most interesting was the intercourse [les rapports] between the body of Charlotte Moorman and the TV set. When two Americans like Moorman and TV make love together, one can't miss that."[34] Nor is such viral degradation simply metaphorical. As Donna Haraway has argued, the rise of the immune system as a medical object in the course of the twentieth century was premised on a new understanding of subjectivity:

> My thesis is that the immune system is an elaborate icon for principal systems of symbolic and material "difference" in late capitalism. Pre-eminently a twentieth-century object, the immune system is a map drawn to guide recognition and misrecognition of self and other in the dialectics of western biopolitics. That is, the immune system is a plan for meaningful action to construct and maintain the boundaries for what may count as self and other in the crucial realms of the normal and the pathological.[35]

Just as psychological and cultural models of difference introduced questions of gender, race, and ethnicity into studies of human sociality, medicine began to situate difference at the cellular level. Here, the boundary between self and nonself is no longer marked by the skin, but distributed throughout the body as decentralized encounters between antigens (viral and bacterial avatars of the nonself) and the immune system's complement of T-cells, B-cells and macrophages.

In Paik's viral art, bodies and objects are absorbed into scan lines only to be rewritten as pure abstract patterns.[36] The genealogy that began with Duchamp's unlinking of signifier and signified and proceeded to Johns's syntactic declension of objects is rendered in Paik's work as a truly mutational form of the readymade in which it is the code itself, in the guise of a commercial television network, that is reinscribed. Pattern meets pattern in an art of interference. Paik's manipulation of scan lines performs a truly viral paradox: it proliferates images while obliterating commodities. It releases the trajective force of information networks that, in the commercial television industry, are closely channeled. But can such ecological readjustment be considered as a *historical* event? The favored tropes of twentieth-century art—revolution and subversion—are both linear and irreversible. What is the temporality of the scanned pattern? A passage from George Kubler's *The Shape of Time* suggests a possible answer: "Now and in the past, most of the time the majority of people live by borrowed ideas and upon traditional accumulations, yet at every moment the fabric is being undone and a new one is woven to replace the old, while from time to time the whole pattern shakes and quivers, settling into new shapes and figures. These processes of change are all mysterious uncharted regions where the traveler soon loses direction and stumbles in darkness."[37] Kubler imagines history as a scanned image whose apparent stasis is in constant motion—a fabric that at every moment is being undone and replenished.[38] *Scanning* thus suggests an alternate model of historical events that eschews teleological narratives. Following Kubler, there are two actions for the historian or critic to look for: the resurgence of pattern (in a mode analogous to Judith Butler's theorization of subjectivity as a repeat performance)[39] and the "shake" or "quiver" between successive patterns—what I have called interference. Such a history would not dwell on revolution or subversion, but rather would locate what Duchamp might call "delays,"[40] or what information theorists call "noise." The purpose of viral aesthetics is to interrupt the smooth reproduction of pattern in order to induce shake, quiver, or noise. The objective of an art history devoted to scanning is to stabilize such evanescent moments in order to mine their significance, as both politics and form. In the next section I will attempt an eco-formalist analysis by tracking Paik's aesthetic formula— the simultaneous proliferation of images and obliteration of objects—in the American experience of psychedelia. In this social movement, which was equally a media phenomenon, the "dancing pattern" moved from the screen into the world, in a heroic if doomed effort to obliterate not just individual objects but the entirety of American consumer culture.

FIGURE **2.9**

"Changes" (the Houseboat Summit), from *San Francisco Oracle* (February 1967). Courtesy of Regent Press, Oakland, publishers of *San Francisco Oracle, Facsimile Edition: The Psychedelic Newspaper of the Haight-Ashbury, 1966–1968.*

II

With the skill of an advertising executive, the LSD visionary Timothy Leary
helped structure the aspirations of a generation with his quasi-televisual
mantra: "Turn On, Tune In, Drop Out." Like many popular slogans, Leary's
phrase captures a real historical longing while remaining decidedly vague.
It does, however, beg a question central to the hippie counterculture:
What kind of politics may proceed from individual acts of liberation? The
difficulties of reconciling personal revolt and political revolution were
not lost on Leary and his cohort—they were the topic of the Houseboat
Summit, a conversation among four prominent countercultural
figures— Leary, the Zen scholar Alan Watts, and poets Gary Snyder and
Allen Ginsberg—published in the *San Francisco Oracle* in February 1967.
The colloquium reflected back on San Francisco's Human Be-In, held in
January of that year as a "gathering of the tribes" in Golden Gate Park.
The Be-In served as both a foretaste and a siren call for the upcoming
Summer of Love, during which psychedelic culture came into full public
view in San Francisco.[41] The summit opens with Alan Watts stating the
dilemma directly: "Look then, we're going to discuss where it's going . . .
the whole problem of whether to drop out or take over."[42] Throughout the
long conversation, Ginsberg in particular, who had recently spent time
with Mario Savio of the Free Speech Movement in Berkeley, challenges
Leary to define what he means by "dropping out." Leary, whom I suspect
may have been practicing what he preached that particular night, never
answers directly. What becomes clear in the course of the conversation,
however, is a sharp division between traditional opposition politics asso-
ciated with student radicals in the Free Speech and antiwar movements
and a politics of representation, in which the production of a spectacular
subcultural lifestyle served as the most efficacious response to consumer
society. Over the course of the summit, Leary states this distinction clearly:

> Mass movements make no sense to me, and I want no part of mass
> movements. I think this is the error that the leftist activists are
> making. I see them as young men with menopausal minds [sic].
>
> They are repeating the same dreary quarrels and conflicts for power
> of the thirties and the forties, of the trade union movement, of

FIGURE **2.10**
Time magazine cover, July 7, 1967. © 1967 Time Inc. Reprinted by
permission. Time Inc./Time & Life Pictures/Getty Images.

Trotskyism and so forth. I think they should be sanctified, drop out, find their own center, turn on, and above all avoid mass movements, mass leadership mass followers. . . .

. . . You see the only way to stop the war in Vietnam is for a hundred high school kids to quit school tomorrow. Don't picket, don't get involved in it at all . . . because they're watching.[43]

This last admonition—"they're watching"—may sound paranoid, but in fact it was accurate. The world *was* watching the Haight-Ashbury neighborhood of San Francisco and its inhabitants with frank enthusiasm. In one of the most prominent and notorious examples of this media blitz, hippies made the cover of *Time* magazine early in the summer of 1967— a form of coverage widely credited with increasing the migration of kids to San Francisco.

o o o

Although Leary, as part of his program of dropping out, assumed a compensatory "dropping in" to the media spotlight (which he himself enjoyed inordinately throughout his life), other theorists of the acid counterculture were more skeptical of such attention. As one example, the Diggers—a group I will have more to say about later—staged the "Death of Hippie, Son of Mass Media" on October 6, 1967. A broadside accompanying this funeral procession down Haight Street colorfully articulates its objectives:

MEDIA CREATED THE HIPPIE WITH YOUR HUNGRY CONSENT. BE SOMEBODY. CAREERS ARE TO BE HAD FOR THE ENTERPRISING HIPPIE. The media cast nets, create bags for the identity-hungry to climb in. Your face on TV, your style immortalized without soul in the captions of the [San Francisco] Chronicle. NBC says you exist, ergo I am. . . . The victim immortalized. Black power, its transcendent threat of white massacre the creation of media-whore obsequious bowers to the public mind which they recreate because they too have nothing to create and the reflections run in perpetual anal circuits and the FREE MAN vomits his images and laughs in the clouds because he is the great evader, the animal who haunts the jungles of image and sees no shadow, only the hunter's gun and knows sahib is too slow and he flexes his strong loins of FREE and is gone again from the nets.[44]

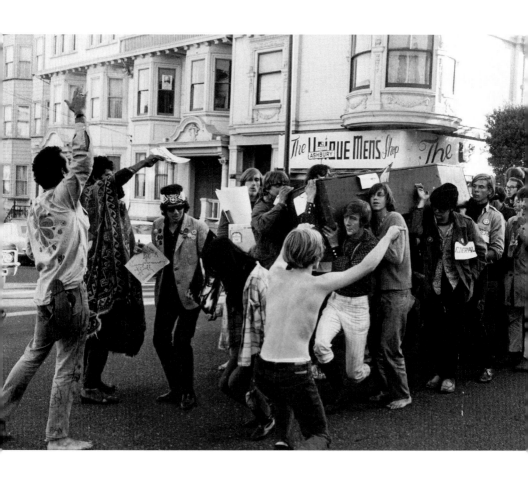

FIGURE **2.11**
Diggers, "Death of Hippie, Son of Mass Media," mock funeral in
the Haight-Ashbury district, San Francisco, October 6, 1967.
Photo: Popperfoto/Classicstock.com.

The two versions of the countercultural program I have cited are thus in direct opposition: for Leary, the hippie produces an emblem of revolt carried by the media that is capable of changing the minds of the public; for the Digger, in a disconcerting projection of colonial discourse, the FREE MAN "haunts the jungles of image and sees no shadow."[45] One side seeks publicity while the other avoids it, but both agree that *the problem of countercultural revolt is inseparable from a politics of media representation*. For each, dissent is conducted largely, if not entirely, as performance.

There is much at stake in seeking to establish a genealogy for such visual politics in the twentieth century, and yet despite offering a wealth of examples and techniques for conducting activist visual analysis, the discipline of art history has been underutilized for this purpose. Too often, works of art are valued exclusively for what they mean (including what historical conditions they may "reflect") as opposed to what they *do*. T. J. Clark's readings in *Farewell to an Idea* are a prominent exception. At one point in discussing El Lissitzky's propaganda board at Vitebsk, a rare instance in which modernist abstraction accomplished an explicitly political task, Clark pauses to reflect rhetorically on a definition of revolution in relation to representation:

> If the attempt to map Bolshevik categories and prescriptions onto the world was more and more transparently impossible, then put the blame on the mapping. Do not map the world, transfigure it. That is what El Lissitzky's propaganda board promises to do. Take the mood of euphoria and desperation, and finally synthesize the two terms. "At long last create a situation from which all turning back is impossible." Create at the level of language. Make a revolution of the sign.[46]

The historical nuances of Lissitzky's revolutionary project are not my concern here. Rather, I wish to reflect on Clark's concept of "a revolution of the sign." On the face of it, linking revolution and signification is conventional avant-garde procedure, but the author's choice of preposition makes a world of difference. Clark is not primarily concerned with revolution *in the sign,* which we may interpret as an aesthetic mode of semiotic play circumscribed by the conventional practices of a singular medium like painting or sculpture—a perspective that might be characterized as "vulgar formalism." Instead, he posits a revolution *of the sign,* suggesting that the artist's project is not limited to the semiotic interrogation of a

medium, but rather functions as a response to, or even a resolution of, a politically induced crisis within a society's representational systems. Specifically, Clark notes a "general collapse of 'confidence in the sign'"[47] in the Soviet state around 1920 that arose in part from a crisis outside of art—the runaway inflation of paper money. Like a catalyst, Lissitzky's abstraction thus enters a heterogeneous ecology of images where political revolution and monetary crisis may be correlated with a thoroughgoing need to reinvent form.

Whereas Lissitzky and his modernist fellow travelers could utilize painting as a field relatively untouched by capitalist markets in which to work through semiotic crisis, by the late 1950s and certainly by the 1960s, commodities had become the premier representational unit in the United States (and to differing degrees in much of the developed world). Pop art and assemblage are powerful means of substantiating this axiomatic alliance between the commercialized object and the sign, whether a brand like Coca-Cola serves as an ideograph in an Andy Warhol painting, carrying as much national meaning as a flag, or discarded commodities are "repurposed" semiotically in an Edward Kienholz sculpture. In every case, commercial objects are manipulated as a lexicon of meanings, *as a kind of language*. And as Herbert Marcuse has argued, such signification is not superficial, but like "natural language" plays a fundamental role in psychic structures. As he writes in his 1969 *Essay on Liberation*:

> A society constantly re-creates . . . patterns of behavior and aspiration as part of the "nature" of its people, and unless the revolt reaches into this "second" nature, into these ingrown patterns, social change will remain "incomplete," even self-defeating.

> The so-called consumer economy and the politics of corporate capitalism have created a second nature of man which ties him libidinally and aggressively to the commodity form. The need for possessing, consuming, handling, and constantly renewing the gadgets . . . has become a "biological" need in the sense just defined. The second nature of man thus militates against any change that would disrupt and perhaps even abolish this dependence of man on a market ever more densely filled with merchandise— abolish his existence as a consumer consuming himself in buying and selling.[48]

By asserting that the ecology of commodities in consumer society is a "second nature," Marcuse delineates a fundamental problem for any postwar American politics. If the commodity form has succeeded in structuring both politics and consciousness, then any effort to circumvent or destroy it must occur on the ground of commodity exchange, a realm usually held to be distinct from traditional activism. Inevitably, television, as that public sphere appropriate to the commodity, and indeed produced *from* it and *for* it, must be a privileged site for such activism—possibly even its only location. As Paik wrote presciently in 1968, "If revolution meant for Russians of 1920 electrification then the revolution in 1960 means electronification . . . mind to mind. . . ."[49]

Many activist tactics directed at the commodity were developed during the 1960s, ranging from the looting that took place in the 1965 Watts riots in Los Angeles—which the situationists famously understood as a kind of liberation of consumer desire among those who had been economically excluded from it[50]—to the acid subculture, in which objects are literally dissolved into psychedelic pulsation. Marcuse's own prescription, interestingly enough, is to develop a politics of aesthetics in which the invention of new forms of living are directed at loosening the commodity's hold on experience. In this view art becomes a laboratory for life, although necessarily a limited one. Such a renovation of modes of living situated outside of the commodity matrix was, of course, precisely the program of the hippies and the acid subculture that they invented. The Diggers, a largely anonymous group in the Haight-Ashbury whose membership and praxis grew out of the street theater of the San Francisco Mime Troupe, offer a particularly productive model of activism because of their two-pronged assault on the commodity—as an object both of exchange and of psychic identification.[51] The Diggers attempted to resolve the dilemma set forth at the Houseboat Summit by making a politics that was both image-oriented and *communal,* not focused on particular individuals as was Leary's LSD evangelism or, slightly later, Abbie Hoffman's publicity grabs as a Yippie.

The Diggers' activities were based on the concept of "Free." They came into being in 1966 by delivering Free Food every day at 4 p.m. to anyone who needed it in the Panhandle, a spur of Golden Gate Park near Haight-Ashbury, and later they organized Free stores where goods were offered without cost. Notorious for burning money, the Diggers established for themselves an impossible economy: they would not participate in conventional modes of exchange and often (though not always)

refused gifts of money from affluent fellow travelers. However, they did need to acquire by some means the goods and foodstuffs necessary to provide their free services. Sometimes they obtained these items through in-kind donations and sometimes through theft (at least according to Digger Emmett Grogan's autobiography).[52] The Diggers were also gifted writers of manifestos, distributed as broadsides on the street. What I wish to highlight in their praxis are the connections they established between three different registers of "Free" that are often maintained as separate: (1) free of cost, (2) personally liberated, and (3) freedom of form. Following Marcuse, a genuine revolution would have to address all of these registers simultaneously, building bridges somehow between the economic, the psychological, and the aesthetic. Leary understood this when he endorsed the personal act of dropping out as an object lesson to a watching world, but as the Diggers' "Death of Hippie," action and manifesto asserted, the danger of such spectacularization was what Thomas Frank has identified as the commodification of "cool,"[53] or what the Diggers themselves referred to as "bags for the identity-hungry to climb into." In place of unwittingly or, worse, purposely lending oneself to media stereotype, the Diggers proposed the condition of what they called the "life-actor"—a term that came naturally to them, given their origins in guerrilla street theater. In "Trip without a Ticket," a manifesto originally published in the winter of 1966–1967, the Diggers described the life-actor in terms of a kind of viral agency: "No one can control the single circuit-breaking moment that charges games with critical reality. If the glass is cut, if the cushioned distance of media is removed, the patients may never respond as normals again. They will become life-actors."[54]

As I see it, the "life-actor" is that person who has been liberated from what Marcuse calls the "second nature" of desire for and psychic identification with the commodity form. The Diggers make this connection explicitly when they interpret the significance of their free store in the following terms: "So a store of goods or clinic or restaurant that is free becomes a social art form. Ticketless theater. Out of money and control. . . . Diggers assume free stores to liberate human nature."[55] And finally this link between abolishing a capitalist mode of exchange and freeing human nature is associated with the transformation of consciousness, or "deconditioning," that LSD enables: "Pop Art mirrored the social skin. Happenings X-rayed the bones. Street events are social acid heightening consciousness of what is real on the street."[56] LSD or, more specifically, what the Diggers evocatively call "social acid" is precisely a mode of abolishing the com-

modity as a stable form at the very core of consciousness—this is the implication of the Diggers' genealogy of art, moving from pop, which addresses commercial surfaces, to Happenings, which probe an interior state of mind through the external manipulation of objects, and finally to social acid, which remakes the very core of subjectivity *from the inside.*

The visual experience of acid, as represented by both early trippers and the inventors of a full-blown sixties psychedelic visuality, is characterized by the dissolution of objects into waves or pulsations. Already in *The Doors of Perception* of 1954, Aldous Huxley had emphasized this experience. Using art as a model of psychedelic experience, Huxley describes how it felt to encounter ordinary things under the influence of LSD:

> Table, chair and desk came together in a composition that was like something by Braque or Juan Gris, a still life recognizably related to the objective world, but rendered without depth, without any attempt at photographic realism. . . . But as I looked, this purely aesthetic, Cubist's-eye view gave place to what I can only describe as the sacramental vision of reality. . . . The legs, for example, of that chair. . . . I spent several minutes—or was it several centuries?—not merely gazing at those bamboo legs, but actually *being* them—or rather being myself in them; or, to be still more accurate (for "I" was not involved in the case, nor in a certain sense were "they") being my Not-self in the Not-self which was the chair.[57]

This passage captures an ecstatic fusion of object and person into a "Not-self" that is neither one nor the other. The influence of Buddhist thought is unmistakable in Huxley's account, but so is the particular lesson that LSD had to teach those seeking a realm beyond the commodity form. In such perceptual "re-patterning" lies an answer to Marcuse's dilemma: things (and persons) should dissolve into a continuous field of pulsation, of sensory stimulus that need never be channeled into the stable reservoirs of matter that are a prerequisite of commodification. In other words, the trajective principle of the network, as a free pattern of information, should be liberated from the commodity.

The visual culture of psychedelia was devoted to dissolving objects into networks of optical pulsion, as in psychedelic posters composed of sinuous nests of lines, dissolving forms, and eye-popping juxtapositions of complementary colors. Interestingly, these visual tactics closely resemble

FIGURE **2.12**
Dr. Timothy Leary Ph.D., L.S.D. Record cover, 1965. Courtesy of
The Bancroft Library, University of California, Berkeley.

FIGURE **2.13**
Nam June Paik, *Magnet TV*, 1965. 17" black and white television set with magnet, 28⅜ × 19¼ × 24½". Whitney Museum of American Art, New York; Purchase, with funds from Dieter Rosenkranz. Photo: Peter Moore. Courtesy Nam June Paik Studios, Inc.

Paik's "dancing pattern." I am convinced that this morphological similarity is no coincidence. Paik associated his early television works with a kind of Zen abolition of the object, and the transformation he makes to the endless stream of animated commodities broadcast on TV is analogous to what Huxley describes as the effects of acid on his perception of the ordinary table or chair. Television, as the public sphere of commodities, as well as other media like film and audio playback, persistently structure accounts of psychedelic consciousness. Not only may Leary's slogan, "Turn On, Tune In, Drop Out," sound like an admonition to become a kind of hip couch potato, but in his guide to acid trips, *The Psychedelic Experience,* coauthored with Ralph Metzner and Richard Alpert, Leary used the metaphor of TV no less than three times as a way of describing LSD hallucination. At one point, the tripper's experience is recounted as follows:

> He experiences direct sensation. The raw "is-ness." He sees, not objects, but patterns of light waves. He hears, not "music" or "meaningful" sound, but acoustic waves. He is struck with the sudden revelation that all sensation and perception are based on wave vibrations. That the world around him which heretofore had an illusory solidity, is nothing more than a play of physical waves. That he is involved in a cosmic television show which has no more substantiality that [sic] the images on his TV picture tube.[58]

Leary's account of seeing "not objects, but patterns of light waves" is strikingly close to Paik's "dancing patterns." In fact, during the mid and late 1960s, new modes of consciousness, both within and outside the acid subculture, were consistently envisioned by means of expanded media.[59] Leary himself organized a series of multimedia events in the late 1960s intended to visualize a paradigmatic acid trip for a "straight" and curious audience. But film typically functioned as the preferred mode of visualization. I wish to identify three models for such *mediated* transformations in consciousness. Two of these emerge from the acid subculture itself, and in each of them, the dematerialization of objects has as its corollary the construction of new forms of spectatorship and community.

The first model emerges from the activities of Ken Kesey, who, as the second eminent prophet of acid in the United States, served in every way as an alternative to Leary. Kesey and his ragged band of Pranksters, with whom he lived and experimented, established a close association between the trip and the movie. At his ranch in La Honda, California, where various

free-form social experiments took place, media feedback loops were established on the grounds as well as in the house. As Tom Wolfe describes it in *The Electric Kool-Aid Acid Test*, Kesey's ranch became the site for the kind of audio-playback experiments that Burroughs had proposed in *The Ticket That Exploded:*

> Kesey had all sorts of recording apparatus around, tape recorders, motion-picture cameras and projectors. . . . Kesey was trying to develop various forms of spontaneous expression. They would do something like . . . all lie on the floor and start rapping back and forth and Kesey puts a tape-recorder microphone up each sleeve and passes his hands through the air and over their heads, like a sorcerer making signs, and their voices cut in and out as the microphones sail over.[60]

During the Pranksters' notorious 1964 bus ride across country, the *trip,* understood as both a journey inward via LSD and a road trip in the Beat tradition, was closely aligned to the *movie.* The Pranksters' odyssey was conceived in part as a free-form film shoot for a feature to be titled "The Merry Pranksters Search for the Cool Place." In his conviction that film would replace fiction, Kesey equipped the Pranksters with cameras in order to document their journey. While the resulting footage is chaotic and the movie was never edited into final form, the significance of film to Kesey's understanding of a trip is indexed by his twin, and virtually identical, metaphors of being "on the bus" (i.e., being in tune with the Pranksters' unprogrammatic program of letting it all hang out) and being "in one's movie" (i.e., absorbed in the experience of a trip, whether this is literally an acid trip or merely the automatic flow of consciousness). This paradoxical position of the tripper—as both participant and witness of his or her own mental adventures—is probably at the root of all psychedelic media metaphors. As Prankster Ron Bevirt remembered, "The filming was all kind of connected to some of our evolved philosophy, which was simply trying to 'be in the now.' We were trying to be spontaneous and record things as they spontaneously occurred."[61] Like the feedback loops at La Honda, recording footage for "The Merry Pranksters" served the paradoxical function of *preserving* spontaneous experience. Through such tactics, media compensates for (and witnesses) the *unconsciousness* of "being in the now." Put another way, machine vision takes the place of consciousness. Indeed, as Kesey himself remarked to journalists in New York about the media apparatus on the bus, "Those tape recorders and

cameras have gone a long way toward making us *responsible*. Able to respond. Able to see."[62]

The second model for the intersection of media and psychedelic consciousness is in many ways an extension of the first. The Pranksters' bus trip preceded and helped to inspire the widespread popularization of psychedelia. But even when this fringe phenomenon began to be packaged and promoted to mass audiences at rock festivals, film continued to play an essential role. As Robert Santelli writes in *Aquarius Rising: The Rock Festival Years*, the Woodstock movie both validated and completed the 1969 Woodstock festival: "Those young people who did not attend Woodstock but felt a spiritual bond with those who did needed to see the movie to confirm their belief in the power of the event. Those who were at Woodstock wanted to see the movie to recall memorable moments and see if their faces could be spotted in the crowd . . . as veritable proof that they were really part of the Woodstock legend."[63] This account parallels Bevirt's declaration that in the Prankster movie, "We were trying to be spontaneous and record things as they spontaneously occurred." In both instances the process of filming an experience allowed for a belated moment of *watching* that seemed more real and legitimate than *living* it had been.

This paradoxical impulse to *replay* activities whose ostensible purpose was to embody an *unmediated* experience "in the now" is given optical expression in the third model of psychedelic media consciousness I wish to propose: Stan Brakhage's films. Brakhage's unique abstract idiom is explicitly directed toward simultaneously representing the automatic imagery of an inner eye (analogous to a trip) and the "normal" vision and representation of an outer eye. In his 1963 text *Metaphors of Vision*, Brakhage makes this point in describing a series of perceptual experiments undertaken with his wife: "My wife, thru the needling eye of extreme concentration, has been able to retain the fabric of shut eye patterns with her lids wide open and thread her sight thru both sensory worlds at once, moving toward the sense of their interrelatedness. . . . My wife waits, receives, inspires my vision, as always, yet receives her source of inspiration in my art. . . ."[64] Inner and outer vision, the heterosexual union of husband and wife, and the shifting priority of art versus life all percolate through this rich passage, but by 1967 in Brakhage's article "Hypnagogically Seeing America," published in the *Los Angeles Free Press*, such doubling shifts from the realm of lyricism into the domain of politics. I will quote this dense text at length:

FIGURE **2.14**
Stan Brakhage, *Dog Star Man*, 1961–1964.
Film stills. Courtesy of the Estate of Stan Brakhage
and Fred Camper (www.fredcamper.com).

SPELL "Vietnam" backwards and you do get "ManT(ei)V"—and it does seem like that: that "the medium IS" McLuhan's apologetic "message" . . . that the optic war-of-nerves occurs in anybody's very real 'living room as a feed-back to/fro the fat Spartans that American-'middles' must take themselves to be. . . . The T.V. viewer becomes center-of-the-universe 1st time thru medium because the image-carrying-light comes directly at him . . . and comes enmeshed, or made-up-of, the television-scanning 'dots' which closely approximate his most private vision—his sense of his own optic nerve-end activity, seen as a grainy field of 'light'-particles when his eyes are closed, particles which seem to cluster into shapes in the act of memory and, thus, make-up the picture being remembered as if it were a slide cast from the brain against closed eye-lids, particles which seem to explode into brilliant coloration and, often, geo-/sym-metrical patterns when the closed-eyes are rubbed and/or the head struck (or—so they tell me—the brains are treated to that internal crisis L.S.D. is . . . mind banged inside-out, etc.).[65]

Brakhage seizes on the phenomenological contradiction embodied in television and recognizes its political significance. The same "television-scanning 'dots'" that carry the messages of commercial television to the "fat Spartans" of the American middle class also characterize their "most private vision—[their] sense of [their] own optic nerve-end activity." In other words, in television, the patterns of commercial broadcast that have always functioned as an unofficial form of political propaganda are absolutely enmeshed in the patterns of the inner eye. "ManT(ei)V" is where external and internal stimuli intersect, where public and private are absolutely scrambled. When, through tripping, the "mind [is] banged inside-out" by the youthful members of the first TV generation, the interwoven scan lines of public and private information are addressed in newly political ways. The children of the "fat Spartans" who flooded Haight-Ashbury in the Summer of Love were thus reversing the kind of viewing experience they were accustomed to in their living rooms. Instead of channeling networks into commodities, they allowed commodities to effloresce as new networks of consciousness.

III

In a text titled "Video Synthesizer Plus," Nam June Paik offers a perspective on what Timothy Leary had called the "politics of ecstasy":[66]

> In the drug experience, all three parties are united into one. A kid who smokes a joint or so is at the same time, creator, audience and critic. There is no room for comparison and grading, such as "first class drug taker" or "second rated pot smoker" etc. . . . This ontological analysis demonstrates to us once again that drug is a short cut effort to recover the sense of participation . . . and basic cause lies in our passive state of mind, such as TV watching, etc.
>
> Can we transplant this strange "ontology" of drug experience to the "safer" and more "authentic" art medium, without transplanting the inherent danger of drug overdose???
>
> Participation TV (the one-ness of creator, audience, and critic) is surely one probable way for this goal . . . and it is not a small virtue . . . not at all. . . .[67]

Paik undoubtedly regarded his distorted video images, such as the "dancing patterns" generated by viewers in *Participation TV 1* (1963) by speaking into a microphone, as an analogue to psychedelic vision. In responding to an interviewer's query about the movement from synthesized to realistic images in his single-channel videotape, *Global Groove* (1973), for instance, the artist remarked, "That's right. You can't be on LSD every day. . . ."[68] But Paik also acknowledged that drugs are a "short cut"— that, in using them, the public realm shrinks to the contours of a single mind, absorbing into itself the functions of creator, audience, and critic. His solution is to externalize the inner "scanning 'dots'" of the tripper as a "dancing pattern" parasitically derived from commercial television, and resituated in the gallery or museum for viewers to manipulate. Media, as the "mind banged inside-out," could be used to facilitate genuine participation.

Paik's acknowledgement of the limits of personal liberation captures the same contradiction of lifestyle-oriented politics that Alan Watts had identified at the Houseboat Summit: How can an individual's personal choice to "drop out" serve as the building block for collective action? In fact, the counterculture (not to mention all other sectors of American culture) found itself with few feasible choices for action.[69] Hannah Arendt saw this crisis clearly in her famous essay "On Violence," and she attributed it to the modern tyranny of bureaucracy:

> Bureaucracy [is] . . . the rule of an intricate system of bureaus in which no men, neither one nor the best, neither the few nor the many, can be held responsible, and which could be properly called rule by Nobody. (If, in accord with traditional political thought, we identify tyranny as government that is not held to give account of itself, rule by Nobody is clearly the most tyrannical of all, since there is no one left who could even be asked to answer for what is being done. It is this state of affairs, making it impossible to localize responsibility and to identify the enemy, that is among the most potent causes of the current world-wide rebellious unrest, its chaotic nature, and its dangerous tendency to get out of control and to run amuck.)[70]

Under rule by Nobody, the absence of public space must be masked by its simulation, and this is the function of American television, which invades individual minds with electronic emanations while concentrating the ownership and control of public airwaves in a tiny corporate minority. Deploying a form of liberated vision across disparate social sites, artists like Paik and psychedelic activists ranging from Leary to the Diggers practiced a genuinely viral politics in which commodities are obliterated in the same moment that new images (soon to be commodified in turn) proliferate. As a cultural sign, the hippie was almost instantaneously commercialized, but this figure nonetheless remains virulent to this day when, experiencing revivals of various degrees of nostalgia and seriousness, it continues to serve as a catalytic force in shaping political discourse. On the one hand, the lifestyle activism produced by hippies has provided a blueprint for much progressive politics of the late twentieth century in the United States—especially among the white middle classes—while on the other, it has shaped the policies of the radical right, whose objective has been to "roll back" the sixties just as Wal-Mart rolls back its prices at the expense of its labor force.

Those who wield images—including "their own"—cannot know what effects they will have in either the present or the future. As George Kubler understood, it is the job of the critic and historian to scan the patterns traced by objects in the course of their "social lives." But this does not mean that manipulation of images is without agency. Paik, Leary, the Diggers, and the hippies themselves were well aware of the viral process of obliterating and proliferating objects and images that their aesthetic projects, sometimes including their blatant self-spectacularization, entailed. To acknowledge and evaluate the force of this politics, we must retire judgments of success and failure, for a viral aesthetics can neither succeed nor fail, but can only reconfigure an ecology of images.[71] As movements devoted to assailing the commodity at its roots, both video art and psychedelia, in all their excesses and often "unproductive" pleasures, provoked an ecological event that might be called, whether in delight or dismay, a disaster.

3 FEEDBACK

FIGURE **3.1**
Front cover of *Guerrilla Television* by Michael Shamberg and Rain-
dance Corporation (New York: Holt, Rinehart and Winston, 1971).
Courtesy Henry Holt Publishing, New York.

I

In his 1971 book *Guerrilla Television*, Michael Shamberg linked television to national identity with the hyphenated term "Media-America."[1] Marking the convergence of corporate oligarchies and democratic procedures, "Media-America" denotes a form of sovereignty constituted from the massive accumulation and concentration of information in private hands. *Guerrilla Television* sought to assault this sovereignty by transforming passive video consumers into active video *producers* and by establishing alternate community-oriented networks through cable access television (CATV). It intended to facilitate dialogue through a politics of feedback. In one passage Shamberg writes:

> A more genuine radical strategy for middle-America would be to build a base at the actual level of repression, which for whites is mostly psychic, not physical. This means developing a base of indigenous information to work from. It might include tactics like going out to the suburbs with video cameras and taping commuters. The playback could be in people's homes through their normal TV sets. The result might be that businessmen would see how wasted they look from buying the suburban myth.[2]

Shamberg's recommendation that white middle-class businessmen examine their alienation through videotape is premised on the conclusion that, in the United States, "repression . . . for whites is mostly psychic, not physical." He thus implicitly acknowledges that for people of color, alienation in and from television is not exclusively psychological but inherent in the structure of the industry.

Whereas the values and traumas of the white middle classes are endlessly dramatized in commercial television programming, African Americans and other ethnic minorities were barely present on the screen in 1971.[3] Indeed, claiming territory in Media-America constituted one of many political demands made by proponents of Black Power during the mid and late 1960s. In calling for a kind of culture revolution in 1968, for instance, Harold Cruse analyzed the situation in the following terms:

we must locate the weakest sector of the American capitalist "free enterprise" front and strike there. Where is that weak front in the free-enterprise armor? It is in the cultural front. Or better, it is that part of the American economic system that has to do with the ownership and administration of cultural communication in America, i.e., film, theater, radio and television, music, performing and publishing, popular entertainment booking, management, etc. In short, it is that part of the system devoted to the economics and aesthetic ideology involved in the cultural arts of America.[4]

Indeed, the Black Panthers, who were among the most image-conscious African American radicals during this period, explicitly called for community control of television, and particularly cable television, in two articles published in their newspaper in 1972. In one of these, "All Black People Got to Seize the Time for Unity!" the demand for media access is one plank of a complex political platform, while the other, "Cable Television: A Signal for Change," focuses exclusively on CATV. In the first article, which outlines a broad agenda for the National Black Political Convention in Gary, Indiana, an eleven-point strategy on communications is introduced with the declaration, "From the beginning, those who enslaved and coloured us understood that by controlling communications they could control our minds."[5] Quoting a National Advisory Commission Report on Civil Disorders which stated four years earlier that white-controlled media had failed blacks,[6] the authors made three sorts of demands: for greater representation of black life and culture on the screen, for black ownership of media, and for black participation in government regulation through appointments to such bodies as the Federal Communications Commission (FCC). One communications demand focuses directly on cable: "Cable television offers a relatively low cost way both to control information coming into our communities, and to channel what would have been white profits into community development. We must see to it that no cable television comes into our communities unless we control it. Our minds and the minds of our children are at stake."[7] The Panthers were well aware that for African Americans psychic repression—the primary locus of white anomie, according to Shamberg—is directly linked to the ownership of broadcast facilities. Like Harold Cruse, they understood that the question of property—the possession of means of production—must precede any ameliorative or radical assault on televisual content. But by the circular logic through which oppression is maintained, it is impossible to appropriate power without understanding its structure, and this understanding

FIGURE **3.2**
"Cable Television: A Signal for Change," cover image of *The Black Panther*, December 7, 1972. © Huey P. Newton Foundation. Courtesy Alternative Press Collection, Thomas J. Dodd Research Center, University of Connecticut Libraries.

requires access. Despite its limitations, Shamberg's career therefore serves as a useful diagnostic tool. His itinerary through Media-America is exemplary simply because he participated in so many episodes of television's social life during the 1970s. I track his viral progress not to identify and ratify an individual "genius," but to provide an introduction to the possible tactics and trade-offs that can be exploited by all "informationally disenfranchised" groups (which include virtually all Americans, to differing degrees). Against such a ground of "white" guerrilla television, I conclude this chapter with a discussion of one African American artist—Melvin Van Peebles—who simultaneously appropriated media space and transformed its licit messages.

II

Cable's current commercialization suggests erroneously that its depoliti-
cization was inevitable. However, in 1970, just before *Guerrilla Television*
appeared, and soon after Shamberg's engagement with Media-America
began, Ralph Lee Smith published "The Wired Nation," an influential ar-
ticle on the future of cable access television in which he heralded the new
broadcast technology as a kind of revolution:

> As cable systems are installed in major U.S. cities and metropolitan
> areas, the stage is being set for a communications revolution—a
> revolution that some experts call "The Wired Nation." In addition to
> the telephone and to the radio and television programs now avail-
> able, there can come into homes and into business places audio,
> video and facsimile transmissions that will provide newspapers,
> mail service, banking and shopping facilities, data from libraries and
> other storage centers, school curricula and other forms of informa-
> tion too numerous to specify. In short, every home and office will
> contain a communications center of a breadth and flexibility to
> influence every aspect of private and community life.[8]

In 1970, hopes for the progressive democratic potential of CATV were
virtually identical to claims made for the Internet around 1993. In order
to garner FCC support in the face of network opposition, cable operators
professed a commitment to community programming in the years
between 1968 and 1972.[9] This openness to unconventional television was
seized upon by a raucous community of video artists and activists equipped
with a new and relatively affordable technology—the portapak—and
underwritten by funding from the New York State Council on the Arts as
well as private foundations.

In 1969, in the midst of this buoyant atmosphere, Shamberg, then a writer
for *Time* magazine, published an unsigned review of the first video exhibi-
tion to take place in the United States, "TV as a Creative Medium" at the
Howard Wise Gallery in New York. In his opening paragraph, Shamberg
perhaps unwittingly summarized his media program for the next decade:
"The younger generation has rebelled against its elders in the home. It

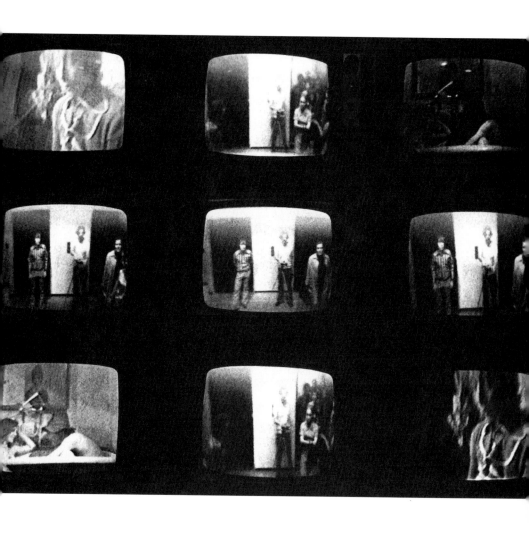

FIGURE **3.3**
Frank Gillette and Ira Schneider, *Wipe Cycle*, 1968–1969.
Video installation with real-time, delay-time, and prerecorded video.
Courtesy Howard Wise Estate.

has stormed the campuses. About the only target remaining in loco parentis is that preoccupier of youth, television. Last week the television generation struck there too, but the rebellion was half in fun: an art exhibition at Manhattan's Howard Wise Gallery entitled 'TV as a Creative Medium.'"[10] Included in "TV as a Creative Medium" was Wipe Cycle (1969), a work by Frank Gillette and Ira Schneider that particularly interested Shamberg. Wipe Cycle consisted of a bank of nine monitors and a closed-circuit video camera that recorded live images of viewers as they approached the work. These fragments of footage were played on eight- and sixteen-second delays, jumping from monitor to monitor and intercut with pre-recorded segments. Periodically all of the screens would be wiped clean. Gillette's description of the work links it explicitly to an ethics of televisual communication: "The intent of this [image] overloading . . . is to escape the automatic 'information' experience of commercial television without totally divesting it of its usual content."[11] In other words, Wipe Cycle, like a whole range of closed-circuit video works of the late 1960s and 1970s, was meant both to represent and to pluralize the monolithic "information" of network TV through a spectator's unexpected encounter with her or his own act of viewing.

Shamberg was so impressed by Wipe Cycle that he joined with Gillette and Schneider to form the Raindance Corporation, a video collective intended to function as an alternative think tank—a progressive version of the RAND Corporation. The activities of Raindance proceeded on two tracks—videomaking and publishing—but all of its work emerged from the group's fascination with the kind of media ecology theorized by such figures as Marshall McLuhan, Buckminster Fuller, and Gregory Bateson. Raindance sought to redress the imbalance of power between video producers and video consumers, in part by executing a number of informal videotapes in which ordinary people on the street were given the time and space to communicate. The group attempted to institutionalize its alternative vision of media communication in an unrealized Center of Decentralized Television that would have been housed at the Jewish Museum where the watershed exhibition "Software" took place in 1970. But perhaps its most significant legacy was its publication, Radical Software (1970–1974), whose founding editors were Beryl Korot and Phyllis Gershuny (now Segura). On the face of it, Radical Software appears a chaotic mix, both in its eclectic design and its editorial shifts. In the first volume, published as a large-format tabloid, funky figurative illustrations reminiscent of underground comics rub shoulders with technical charts, and dynamic compositions of

FIGURE **3.4**
Radical Software, number 1, 1970, front cover and page 19.
Alternative Press Collection, Thomas J. Dodd Research Center,
University of Connecticut Libraries. Courtesy Beryl Korot & Phyllis
Gershuny, editors.

FEEDBACK

ANT FARM

ANT FARM designs and constructs inflatables, mostly in California. They have some tape of themselves and are putting together a tape on how to do your own inflatable.

HOMESKIN

HOMESKIN is a city-country communal information news using 1/2 inch equipment. It seems we should begin exchanging tapes. People in Amsterdam and London are putting together similar numbers. Couldn't we all just get it on without waiting for a more formal distribution set-up? Local planet network. — San Francisco

SAN FRANCISCO

VIDEOFREEX

The VIDEOFREEX are involved in television technically and artistically, intellectually and emotionally. Technical ideas bring us together. We are as a web of video/audio energy flows. We are caught in the act of electronic fucking. And we sure like to fuck. Contact us at 98 Prince Street, NYC.

NYC

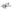

Raindance Corporation

RAINDANCE CORPORATION is setting up a video information network which will be so highly accessible as possible i.e. Alternate Television: runaway, interactive, decentralized.

We believe the culture needs new information structures, not just improved content pumped through existing ones. NYC

NYC

C.T. Lui of CTL Electronics
86 West Broadway
NYC, NY 10007
212-233-0764
offers free technical information
on video & technical innovation in video.
He has designed & built colorizers,
gen-lock systems & has modified effects
generators for specialized use.

CHARLES BENSINGER

Videotech Lab
7280 Hollywood Blvd
Los Angeles, Calif. 90028

LOS ANGELES

TVX—LONDON VIDEO CO-OP

TVX-LONDON VIDEO CO-OP. Membership has now grown to about 40 people. Recent activities include recordings of The Incredible String Band in "U" at the Roundhouse, an interview with William Burroughs, Community TV at Goldsmiths College, CCTV, and experimental pilot programs for BBC's "Line Up" and "Disco 2". In the near future we hope to be co-producing colour videotape with BBC TV, and an election night TVX special at the Arts Lab. Contact us through the London New Arts Lab, 1 Robert Street, London N.W.1.

PEOPLE'S VIDEO THEATRE

PEOPLE'S VIDEO THEATRE, an alternative news media, has six objectives:

1) to become a model for other community video theatres,
2) to provide the people of the community a medium for exposing their goods, services and ideas,
3) to introduce and develop video journalism,
4) to provide a public video archive which can be used by acting groups, dancers, therapists, political groups, etc.,
5) to stimulate community dialogue through the LiveForum,
6) to establish a video library for use by videologists.

Our weekly shows will touch on local, "neighborhood", city and national news and include features on cultural and scientific activities.

The Live-Forum will register and involve our audiences in controversial issues viewing them by registering their views on tape. Contact us at (212) 691-3254, NYC.

ELLIOT GLASS
KEN MARSH

DIAL ACCESS VIDEOTAPE TV

Dial Access Videotape TV—West Hartford, Conn. School System—Van Flaregiotis

ENVIRONMENTAL CINEMAS

730 Yonge St., Suite 717
Toronto, Canada

TORONTO

EAT

EAT wants to set up a videolab for people experimenting with videotape — to generate video inter-communications. Contact Robert Whitman. EAT, 235 Park Ave. So., NYC.

Sony ECM-22 cardiod condenser
(directional) microphone $100.00
being used expressly by Nam June Paik,
Raindance and Videofreex with
portable video equipment

GLOBAL VILLAGE

Global Village is developing the electronics of shared experiences by creating a total video environment. We use videotaping relevant political events and people and kinetic compositions and presenting them in a visual counterpoint on 9 TV monitors. What emerges is a matrix of politics, morals and sounds of a generation. A refracted image of our time is created: Nixon on 3 monitors, Abbie Hoffman on 5 monitors and Mick Jagger singing "You Can't Always Get What You Want" on 1 monitor; and where—an implosion and you are actually feeling the ambiance of a great or time. Technically, this is achieved through the use of 14 possible output channels in contrast to commercial TV's single output channel.

Global Village is instantaneous feedback — it becomes the visual counterpart to the underground newspapers in one sense and yet goes beyond that. The Global Village generation is always changing and moving forward. We move through time and space to chronicle the assassination of RFK, Woodstock, Nixon's Vietnamization speech, the Chicago Conspiracy, the Panther march to Queens, the LA police riots, the student strikes and demonstrations in Washington. We orchestrate these actual reports from performance to performance to give a sense of the ongoing violence, waste, pollution, and tensions of this society. We hope to come to a point where Global Village is open 24 hours a day, 7 days a week to offer people a continuous video ambiency of news and kinetics.

The low cost and portability of the 1/2 inch TV equipment gives the necessary freedom to break the hold of the large and expensive networks and studios. We can send out people to tape these events that may remain unnoticed by commercial TV but are necessary pieces to catalogue the radical movement. Censorship has not yet touched this medium. When the power of the medium is realized, undoubtedly new and expensive laws will be enacted. This kind of communication will have to be illegal in the present order of things.

We would have a medium that would not only unite us from coast to coast, but from continent to continent. This possibility is becoming a reality. A second Global Village will open in NYC in the beginning of June; a third Global Village will open in Boston at the end of August...

The radicalization of the television image requires pushing the present comic book medium we know as broadcast TV in America. Through a multichannel, multi-sensory experience of video and kinetics we are triggering an overload. Energy can be transmitted in many ways and in many yet-to-be discovered forms: sci-telling how far it can travel. JOHN REILLY and RUDI STERN. Contact us at 454 Broome St., NYC 10012.

STUDENTS

Students at the State University of New York in Binghamton are receiving requests money to document their environment with portable VT cameras. The program is less than a half-year old and will expand to a university network in the fall. Tapes produced include anti-war demonstrations in Washington and Buffalo, and a portrait of two teenage junkies shooting up in New York City while implicating the consortium not to do likewise.

BINGHAMTON, NY
RALPH HOCKING

VIDEO WORKSHOP AMSTERDAM

I have started a video workshop in Amsterdam, having turned Sony on enough to set us through the last month with tons of equipment, which will allow us to earn enough money to get a basic workable set of videorecorder, playback, etc.

We are working on the bread line for the time being, but seem to be getting many video heads together ... VPRO television is very interested in our work and experiments, they is an independent TV company have to put out tons for making an evening's programming although the state-owned companies of the mother company.

By the twenty-ninth of May we shall have two to three tapes for the beginning of an exchange engine with other video people ... Would you please be kind enough to let people know of us ... we are working on 620 "c", which could be copied to your systems.

video workshop offers an alternative work/viewing situation to that of modern television. The techniques might be evolved under the same technical limitations, but the concept is that of a new movement of "video heads." One of its ambitions is to decentralize and have a re-birth of television from its accepted form, to a more communicative sense of the medium.

That sense which will give us the realm of experience which can only be achieved through "seeing" not only in one's mind's eye, but on the feedback of the television screen. The accepted form of television is far too padded within entertainment which feeds the masses, not as a communication, but as a passive entertainment ... why be indoctrinated by broadcasts which feed you what they think you ought to see with no alternative ...

We need you, because we want to know you

Contact JOE PAT GJALT WALSTRA, tel. 270013, Workshop Keizers-gracht 717, tel. 65417.

MINERVA

MINERVA, a participatory technology system—multiple input network for evaluating reaction, votes, and attitudes—Amitai Etzioni, Center for Policy Research, 423 West 118th St., New York, N.Y. 10027.

RICHARD KLETTER
SHELLEY SURPIN
ALLEN RUCKER

...organizing a high school video project for the Portola Institute.

PALO ALTO, CALIFORNIA

Remember I was a battery of tape recorders at the door—Departed have left spectators involved—Good night under surges of silence since the recorders and movies in this point have failed—It will readily be seen beside you a man walks through screen—The exhibition reflected dominion dwindling—Photo flakes fell in swirls on our ticket—sound silently fading out—light travel—In this point messy a one has failed—courage to go deeper and deeper into the blue—ebbing carbon dioxide—last terrace of the garden—Isn't time is there left? halves of the human organism to give you?

WILLIAM BURROUGHS, *The Ticket that Exploded*

text boxes are frequently linked together by vectors, transforming pages into flow charts reminiscent of early computer code. The journal's free-wheeling editorial policy is epitomized by the "Feedback" section at the end of each number of the first volume, where blurbs from various video groups or individuals are crudely pasted together on a skewed grid. The juxtaposition of feature articles was equally unconventional. In the first issue, for instance, texts ranged from Thea Sklover's highly technical account of a cable operator's conference in Chicago to Marco Vassi's "Zen Tubes," which opens with the following declaration:

> To write about . . . to write . . . about . . .
>
> Tape is explaining a trip to someone who's never dropped acid. You have to say, it's *like* this.[12]

This wild veer from the intricacies of CATV to acid video captures the flavor of *Radical Software* (and it affirms the connection between psychedelia and video art that I traced in chapter 2). But underwriting such exuberant heterogeneity was a consistent and reasoned advocacy of *feedback* in the double sense of meaningful communication and the willful jamming of communication through feedback *noise*. These two dimensions of feedback were expressed formally and aesthetically by the Raindance Corporation (as well as many early video artists including Les Levine, Peter Campus, and Dan Graham) in the structural organization of closed-circuit installations like *Wipe Cycle*, where viewers are captured in a feedback loop of video playback on time delay. What distinguished the editorial policy of *Radical Software* from other accounts of video in the 1970s—whose positions have been progressively balkanized—was its demonstration that closed-circuit works of video art are structurally identical to cable access TV and particularly to its activist documentary tradition developed by Raindance and others, like the Videofreex or Global Village.[13] In *Radical Software*, art and activism were drawn as structural equivalents on account of their shared closed-circuit form. This homology was articulated in a 1969 interview of Frank Gillette and Ira Schneider, reprinted in the first number of *Radical Software* (1970):

> **Frank:** . . . Now, television is usually understood in terms of a receiver. Our idea is to render that void. Television is something you feedback with as much as you receive with—which is a symbiosis—

which works both ways. That's the vast potential of cable TV hooking up with portable equipment. . . .

Ira: Perhaps we should quickly run through these different television notions: CATV, CCTV (Closed Circuit TV), and UHF. The notion is that closed circuit TV is akin to cable TV in that closed circuit, if we're talking about videotape or storage of information and playback, plays back from the recorder into a wire that runs into the monitor. CATV is an extension of this in that the wire-cable between the playback and the monitor is much longer.[14]

Two points deserve emphasis in this interchange. First, on a technological level, CATV and CCTV are identical—they are both closed circuits composed of cameras and monitors. As Schneider declares, the only difference between them is the length of the cable required to form the loop. But second, the "software" recommended for CCTV and CATV is as closely related as the hardware. Although *Wipe Cycle* and other closed-circuit video installations were intended to introduce circuits of video feedback within the controlled environment of the gallery, they also served as a blueprint for guerrilla television's response to the centralization of commercial television through the production of politically engaged documentaries on cable, or what Gillette describes as a symbiotic feedback between receiving and broadcasting. It is consistent with the editorial program of *Radical Software,* then, that Nam June Paik, who is sometimes criticized for his assiduous efforts to establish video as an art medium, contributed a text to the journal's first issue that proposed an expansive pedagogical role for video well beyond the art world. In "Expanded Education for the Paperless Society," he recommends a complete rethinking of higher education, including a systematic effort to record great thinkers on tape before they die. As Paik charmingly describes the virtues of interviewing great philosophers, "The interviewer should be a qualified philosopher himself . . . so that Jaspers or Heidegger can talk as naturally as [Andy Warhol's] 'Chelsea Girls.'"[15]

Schneider and Gillette's conclusion, that television and video art share the structure of closed-circuit TV, signals a recurrence of one of the most fundamental crises of twentieth-century art: the readymade's elision of commercial and aesthetic form. As I argued in chapter 2, the emergence of video in art, as Paik recognized, carried the readymade tradition from

its focus on singular objects to a concentration on how networks transform (and become) commodities. The Raindance Corporation recognized the genuinely political opportunity opened up by the homology between commerce and art: rather than practicing art per se, Shamberg, Schneider, Gillette, and many others chose to enter a televisual media ecology from one portal (which might in one context be labeled "art" or in another "activism"), but their ambition was to leverage the entire ecology of Media-America. In other words, they dwelled on the political potential of video rather than on its personal or narcissistic dimension.[16] As they saw it, one aspect of the ecological crisis occasioned by the centralization of network TV was a psychic blockage—a kind of media tumor—in which information flowed in one direction only—from TV to viewer—leaving the spectator few if any means of responding in kind. In *Guerrilla Television,* Shamberg assesses the situation:

> In Media-America, our information structures are so designed as to minimize feedback. . . .
>
> This makes for incredible cultural tension because on the one hand people cannot ignore media evolution, while on the other they require feedback for psychological balance. The result was the 1960s: every conceivable special interest group, which was informationally disenfranchised, indulged in a sort of "mass media therapy" where they created events to get coverage, and then rushed home to see the verification of their experience on TV.[17]

This passage theorizes a kind of media activism that eschews the avant-garde's fantasy of negation, its all-or-nothing prescriptions for revolution or subversion. Shamberg's recommendation is that video art and media activism (which share a form as CCTV or CATV) each address the same system—the system of which they are both a part, "Media-America," or the informational ecology—in order to redress a social imbalance caused by the massive capitalization of television. Unlike histories of video art, which dwell on the recursive nature of the closed-circuit medium as a form of narcissism, or histories of media activism, which tend to be content-driven, Shamberg's account treats form *as* content: the imbalance of the commercial closed circuit must be operated upon to reopen its pathways. This operation may occur (and does occur) at many sites within the system, but that does not mean that any particular intervention is equivalent to all others. Indeed, the story of Shamberg's career is exemplary precisely

because he chose to address the "informationally disenfranchised" from many different positions, each with its own costs and opportunities.

The next project Shamberg was involved with, Top Value Television (TVTV), was consequently directed toward the broader audience available through cable television. TVTV was an open-ended video collective that produced a variety of programs throughout the seventies. The group originally included Megan Williams and the media activist Allen Rucker, as well as members of the flamboyant San Francisco artists' collective Ant Farm (famous for upending a row of Cadillacs in Amarillo, Texas). It was initiated to produce alternate coverage of the 1972 Democratic and Republican conventions in Miami. After succeeding against the odds in acquiring press credentials for the conventions as well as raising a modest budget of a few thousand dollars contributed by four cable TV stations, TVTV rented a house together in Miami like a commune or a rock band. Unencumbered by the heavy equipment the networks needed at that time to make broadcast-quality footage, TVTV members gained greater access to the intrigue of the convention floor with their portable portapak cameras, capturing stories that more experienced journalists missed. Most significant was TVTV's policy of turning its cameras on the conventions of network coverage—the feedback loop of television news— in part by interviewing celebrity correspondents like Dan Rather and Mike Wallace about the limits and practices of legitimate network reporting. This informational ecology—or feedback—was further acknowledged by the informal nature of TVTV interviews themselves, in which no effort was made to hide the interviewer or the intrusiveness of the interview, shattering both the neutrality of the questioner and the questioned. In other words, these tapes and others produced by TVTV during the seventies applied to documentary video the interference, or feedback noise, between viewer and viewed which Gillette and Schneider had presented as an aesthetic strategy in *Wipe Cycle.*

Despite receiving significant critical praise, TVTV had trouble sustaining itself economically. Cable and public television stations hired them on a project-by-project basis, making survival nearly impossible and always precarious. Ultimately, in the late 1970s the group underwent two shifts: it moved away from documentary and toward fictionalized programming reminiscent of *Saturday Night Live,* and it began to pitch projects to the networks. Like his earlier activities in Raindance and TVTV, Shamberg's concept for the *TVTV Show,* which had a brief, unsuccessful run on NBC in

FIGURE **3.5**
TVTV, *Four More Years*, 1972. Video stills. Courtesy Electronic
Arts Intermix (EAI), New York.

1977, satirized what he had called "Media-America"—but in the context of entertainment. As Deirdre Boyle recounts in her excellent history of TVTV, Shamberg told a *Village Voice* critic in 1976: "When you create a really effective fictional character, you have a much bigger impact than with a documentary. There have been plenty of documentaries of the working class which have been forgotten, but Archie Bunker is on every T-shirt in America. So we've decided that we're going to do fiction TV as well."[18] Given Shamberg's rather startling nomination of the television character Archie Bunker as a working-class hero, it is not surprising that in the next and current phase of his career he has moved entirely into the realm of fiction as a producer of Hollywood films. His first hit—and for my purposes, the most interesting of his many credits, which include *Pulp Fiction* (1994), *Gattaca* (1997), and *Erin Brockovich* (2000)—was *The Big Chill* of 1983, a paean to the lost hope of the sixties generation. In this movie, a group of former college radicals—now mostly prosperous professionals— reunite for a weekend in the comfortable country house of married class- mates Harold (Kevin Kline) and Sarah (Glenn Close) after the suicide of their mutual friend Alex. *The Big Chill* is a sophisticated and nuanced story about the vulnerability of idealism that, like Shamberg's earlier work, prominently features therapeutic uses of video. In the film, Nick (William Hurt), who is one of the few of his cohort not to "evolve" into yuppiedom, interviews himself and some of his friends with a home video camera, and later they watch their confessions on the television screen in a mo- ment of "family room feedback." In a painful scene in which Nick questions himself on camera about his career failures and the impotence he suffered as a result of a Vietnam war injury, the closed-circuit video apparatus, which had been used to explore philosophical and phenomenological issues in Gillette and Schneider's *Wipe Cycle* and to undertake social analysis in TVTV, degenerates into a kind of parody of pop psychology— indeed, in the same interview, Nick expresses his shame at having worked as a radio psychologist in San Francisco. The once democratizing potential of inexpensive video equipment has evaporated, like the student radicalism of the characters, leaving in its place the parlor games of the upper middle class. And the advice Shamberg had once offered to subur- ban commuters—to videotape and play back their own alienation— is here realized as a feature of Hollywood entertainment.[19]

In *Guerrilla Television*, Shamberg wrote, "True cybernetic guerrilla warfare means re-structuring communications channels, not capturing existing ones."[20] And yet, despite this declaration (and the efforts of a decade to

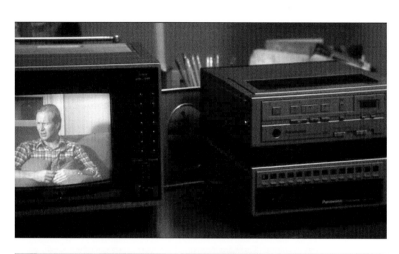

realize its stated goal), he ended up a powerful figure in one of the most venerable commercial "communications channels" in existence: Hollywood film. Like a character in *The Big Chill,* Shamberg yielded to market forces, moving from a "radical" mode of communication to a "conservative" one. This shift inevitably inspires accusations of selling out, but such dismissive judgments fail to capture the significance of Shamberg's career. For in a society whose public sphere is colonized by commercial media, an inverse relationship obtains between audience and message: increasing one's audience requires both greater financial investment and a more politically constrained message. If, instead of judging Shamberg's move to Hollywood as a moral failure, one were to regard it as an effort to address a broader public, albeit with a blander message, then a different lesson might be drawn from his career. From the perspective of feedback, in which form is partly determined by its degree and conditions of capitalization, Shamberg simply positioned himself in a different location within the same media ecology, and in doing so he knowingly sacrificed political piquancy for access to a broader platform.

The capitalization of form thus generates a third variable: *community,* which is neither an ostensibly "natural" affinity group like a "people," nor the result of an institutional structure like the nation-state.[21] Such communities, founded in a shared identification, like the "black community" or the "gay community," arise in response to myriad cultural and commercial interpellations, including those of television, which aims to transform its viewers into market segments whose collective identification inspires customized sales strategies.[22] "Communities" are the semicommodified constituencies of Media-America. As the historian Lizabeth Cohen argues:

> While network television was, of course, a mass medium aimed at a mass market, its need to sell bred almost from the start a receptivity to "narrowcasting," or targeting programs at demographically specific audiences. Once the very early years of limited programming had passed, advertisers and broadcasters lost no time conceiving of future profitability in terms of market segmentation. . . . This was necessary if television was to expand beyond evening prime time, as the rest of the day and week was most profitably programmed with distinctive audiences in mind: children in the early mornings and on weekends, homemakers during the day, teenagers in the late afternoons, various adult audiences in the evenings, families on Sunday nights.[23]

FIGURE **3.7**
Richard Serra, *Television Delivers People*, 1973. Video still. © 2006
Richard Serra/Artists Rights Society (ARS), New York.

As Cohen asserts, television's packaging of its public is not monolithic: it sorts viewers into "demographically specific audiences." The lesson of Shamberg's career is that video and video activism not only *deliver audiences*—as Richard Serra proclaimed in a famous 1973 videotape titled *Television Delivers People*—but delivers *particular* audiences by fostering the self-conscious if also market-driven identification as communities or constituencies. In a very literal sense, video's medium is community.[24]

Dan Graham's projects for closed-circuit video installations of the mid 1970s diagram the constitution of communities from the feedback loop of television. In the never-realized *Time Delay Room 5* (1974), for instance, two chambers equipped with monitors and closed-circuit cameras were planned to hold two audiences, A and B, who could walk from room to room or watch themselves (A on time delay; B live) or the audience in the next room (audience A would see audience B live and itself in real time; audience B would see itself live and audience A on time delay). In a third room, closed off from the other two, a "performer" would track both audiences A and B, on time delay, via monitors connected to the cameras in each audience room and would narrate live descriptions of these groups, carried back to them via speakers. Because of the eight-second time delays in some of the video feeds in this complex network, the performer's "soundtrack" for the two audiences' behavior would be strangely disarticulated from either their actual or videotaped behavior. Graham thus proposes rigorously interrupting the sync between broadcast content and the viewer's experience, while simultaneously dramatizing the line between witnessing a spectacle, as audience members do when they watch one of the monitors, and *becoming* a spectacle, which is their fate when captured by the closed-circuit cameras. Graham characterizes the disorientation in this way: "As the description by the performer will in part refer to audience A's hearing and responding to the performer's own depictions, made before audience A is able to view for itself this behavior, a feedback interference or tautology (of effect to cause) is created."[25] Whereas commercial television establishes "communities" through identification, Graham's proposed installation (and many like it in the mid 1970s, some of which were realized and others not) invents a video circuit where individual audience members would be alienated not only from their own image but from each other (as the two separate audience rooms suggest spatially). The feedback loop of commercial television, in which an imagined nation, Media-America, is simulated through the consolidation

of communities, is here countered by "feedback interference" founded in disidentification. Graham brilliantly maps commercial television in reverse by acknowledging the political atomization and impotence it masks. If Shamberg's itinerary through the info-nation demonstrates the economic impediments to addressing a mass audience and Graham shatters the myth of coherence in communities interpellated by television, what options exist for producing an oppositional media public? This is the question to which I now turn.

AUDIENCE A AUDIENCE B PERFORMER

FIGURE **3.8**
Dan Graham, *Time Delay Room 5*, 1974. Concept diagram.
Courtesy Marian Goodman Gallery, New York.

III

In his 1968 manifesto *Revolution for the Hell of It,* Yippie activist Abbie Hoffman made the following comments:

> Did you ever hear Andy Warhol talk? . . . Well, I would like to com-
> bine his style and that of Castro's. Warhol understands modern
> media. Castro has the passion for social change. It's not easy. One's
> a fag and the other is the epitome of virility. If I was forced to make
> the choice I would choose Castro, but right now in this period of
> change in the country the styles of the two can be blended. It's not
> guerilla warfare but, well, maybe a good term is monkey warfare.
> If the country becomes more repressive we must become Castros.
> If it becomes more tolerant we must become Warhols.[26]

A hybrid of Fidel Castro and Andy Warhol strains the imagination.[27] But for the Yippie leader who built a movement by capturing free publicity on TV,[28] this genealogical fantasy is strikingly appropriate. In their combination of radical politics and media savvy, Yippies were indeed the legitimate progeny of Castro and Warhol. What is puzzling and exhilarating in Hoffman's pairing is the distinction he draws between his two forefathers: "If the country becomes more repressive we must become Castros. If it becomes more tolerant we must become Warhols." The first half of this prescription is conventional enough: when political repression is intractable, radicals make revolution. But Hoffman's second recommendation is startling. Warhol—the paragon of indifference and passivity, the celebrity groupie and ambitious art world operator—is held up as a model of politics appropriate for "tolerant times."

Before defining Warholian activism, we must establish Hoffman's own understanding of media politics and, for this, there is no better source than Hoffman himself. Yippie actions were premised on soliciting and addressing the media through what Daniel Boorstin famously called "pseudo-events." The pseudo-event, as Boorstin put it in 1961, "is planted primarily . . . for the immediate purpose of being reported or reproduced. Therefore, its occurrence is arranged for the convenience of the reporting or reproducing media. Its success is measured by how widely it is reported."[29] Yippie leaders

FIGURE **3.10**
Yippies launch their presidential candidate, a pig named Pigasus, at the
Democratic convention, Chicago, August 23, 1968. © Bettmann/CORBIS.

consolidated their movement primarily by producing outrageous events that would parasitically capture time on the network news in order to attract potential participants or fellow travelers. Hoffman's notorious 1967 action of dropping money onto the trading floor of the New York Stock Exchange from the visitor's balcony, for instance, caused a paroxysm of greed among the traders, who snatched up dollar bills hungrily.[30] In other words, Hoffman conjured a mediagenic *image* of capitalist greed from the involuntary performances of what the Diggers would call "life-actors." Profoundly influenced by the grassroots agitation of the Diggers (though incapable of maintaining their disciplined anonymity), Hoffman orchestrated a flamboyant street theater whose objective was not to galvanize a neighborhood but to attract the television cameras that feed Media-America. The apogee of this strategy was Yippie agitation at the 1968 Democratic convention in Chicago, where the nation's media had assembled alongside its political parties, eager for dramatic stories. The Yippies did not disappoint, orchestrating a variety of high jinks including the nomination Pigasus, a pig, as their candidate for the presidency. In Hoffman's ensuing conspiracy trial,[31] he used his own body to provoke media attention, notoriously "desecrating" the American flag by wearing a shirt with its pattern during congressional hearings following the protests. Here is his brilliant analysis of Yippie media activism, drawn from *Revolution for the Hell of It*:

> The commercial is information. The program is rhetoric. The commercial is the figure. The program is the ground. What happens at the end of the program? Do you think any one of the millions of people watching the show switched from being a liberal to a conservative or vice versa? I doubt it. One thing is certain though . . . a lot of people are going to buy that fuckin' soap or whatever else they were pushing in the commercial.
>
> What would happen if a whole hour were filled with a soap commercial? That's a very interesting question and I will speculate that it would not work as well, which means that not as much information would be conveyed, that not much soap would be sold. It's only when you establish a figure-ground relationship that you can convey information. It is the only perceptual dynamic that involves the spectator.

Our actions in Chicago established a brilliant figure-ground rela-
tionship. The rhetoric of the Convention was allotted the fifty
minutes of the hour, we were given the ten or less usually reserved
for the commercials. *We were an advertisement for revolution.*[32]

Hoffman articulates a contradiction almost as startling as the association
of Castro and Warhol. By embracing the television commercial as a model
for radical politics, he recommends assimilating the rhetoric of the
very corporate structures that his movement was devoted to challenging.
Indeed, Hoffman is emphatic in linking activism with advertising, as
when he writes in *Revolution for the Hell of It,* "We are living TV ads, movies.
Yippee! There is no program. Program would make our movement sterile."[33]
This declaration translates the Diggers' concept of the life-actor into
a persona appropriate to the info-nation of Media-America, but in this
world, in which a human agent is also an image, the limits of circulation
are even stricter than those on the street. "Living TV ads" must obey the
logic of figure-ground reversal and, as I will shortly argue, they also must
suffer the strictures of celebrity.

Hoffman's understanding of information as an opposition between figure
and ground is undoubtedly indebted to the cybernetic theories of Norbert
Wiener, widely popularized during the 1960s. According to information
theory, a message emerges as a *pattern,* which stands out from the entropic
noise of unmediated experience.[34] An analogous structure underlies
perceptual psychology's discovery that visual form is perceived through
an optical distinction between a figure (a pattern) that is discernible only
against a ground. Such a synthesis of informational and aesthetic theo-
ries is certainly appropriate to the Yippies' program of image-centered
agitation. They concluded that in order to convey information—as a
fundamentally political act—they must resort to the commercial. This
strategy accords well with my analysis in chapter 1 of the emergence of
commercial network programming as an oscillation between network
and commodity whose dilations and contractions are themselves part of
a figure-ground opposition in which the network sometimes serves as
ground for the commodity and sometimes as figure to the commodity's
ground (as in Paik's manipulated TV sets).

Hoffman's conclusion that commercials are the carriers of televisual
information is therefore perfectly accurate. It is obvious that the Yippies'
pseudo-events functioned as viral images, circulating through their

host—commercial television—and undermining its pieties. In bringing repressed messages (and normally invisible "life-actors") into view, such coverage could help to redress the condition of informational blockage that Shamberg diagnosed in *Guerrilla Television*. While the specifically human, or psychological, dimension of feedback—the need for two-way communication—is interrupted or blocked in Media-America through the centralization of television networks, commercials for revolution could offer the "informationally disenfranchised . . . a sort of 'mass media therapy.'"[35] Just as industrial psychologists like Ernst Dichter argued that social tensions could be released or resolved imaginatively through rituals of consumption, *commercials for revolution* offer a form of "mass media therapy" in which those communities whose opinions or experiences are repressed by commercial television are made visible in a kind of figure-ground reversal.

Shamberg's phrase "informationally disenfranchised" captures the political innovation of Yippie media theory. Perhaps the central contribution of Hoffman and his cohort in this realm is their theorization of what counts as disenfranchisement in revolutionary struggles. During the 1960s economic and political oppression were refigured as *informational poverty* within a media economy. This shift has transformed politics to this day, but it is important to be cautious about eliding too easily economies of survival and economies of information: the overlap between them is significant, but they are not congruent to one another. Indeed, the gap between producing outrageous pseudo-events and accomplishing significant social change, or even something as basic as the Diggers' efforts to feed hordes of hippies in San Francisco's Golden Gate Park, is suggested by Shamberg in another passage from *Guerrilla Television*: "The last thing you want to do is get a lot of publicity every which way. Abbie Hoffman thinks he's getting his message across by going on the Dick Cavett show, but as somebody (John Brockman actually) once said: 'The revolution ended when Abbie Hoffman shut up for the first commercial.'"[36] This last phrase, in juxtaposition with Hoffman's advocacy of "commercials for revolution," suggests a tension fundamental to the Yippie program between affecting media content on the one hand and its form on the other.[37] Even if the Yippies changed the message of the commercial by selling revolution instead of soap or automobiles, they nonetheless risked leaving the structure of network TV intact. This is what was meant by criticizing Hoffman for "shut[ting] up for the first commercial." As the Yippie leader himself understood, to be part of the program instead

of making oneself a commercial for change was to risk losing one's message altogether.

Hoffman thus faced a dilemma: the success of his media interventions brought him from the margins of public attention to the center—to the Dick Cavett show, where he was able to address a broad constituency within Media-America. But exploiting this platform comes at a price, since the public space of television forces those who would occupy it into a kind of celebrity, which Hoffman, in any event, was never disposed to resist. In his important book *The Whole World Is Watching,* Todd Gitlin traces an analogous dynamic in the media coverage of the Students for a Democratic Society (SDS) during the sixties. Gitlin argues that mainstream media always attempt to defuse the force of oppositional politics by reducing radical leaders to stereotypes like the raving drug addict or the starry-eyed hippie, which serve to invalidate their substantive messages.[38] The challenge of media activism is thus the nearly impossible task of producing telegenic but oppositional content capable of capturing a mass audience, while resisting absorption within the institutional framework of TV's cast of stock characters.

Andy Warhol's media projects emerge precisely from this dilemma. Warhol's art adopted the *content* of commerce through its appropriation of commodities and celebrities, but it simultaneously dismantled the institutional *forms* through which these objectified products circulate. It did so by scrambling the stable figure-ground relationships—between commercial and program, for instance—that Hoffman's media activism merely reversed. A simple example is his early pop painting *TV $199* (1960), in which a television set is rendered within the partially obscured field of an advertisement for itself. As the painting's title implies, the ties between television and money are impossible to dissolve. And yet, by veiling the reproduced ad with brushy fields of white paint, Warhol recodes it as an aesthetic object, suggesting an alternating current of commerce and art. Here the figure-ground relationship between the analytical content promised by art and the commercial language of advertising is not allowed to settle down into stable oppositions, and this rhetorical instability is mirrored by the optical instability of the painting, in which no one element is allowed to emerge as primary. The issue, as modernist critics have argued to other ends, lies in the charged undecidability between figure and ground.

There's nothing accidental in Warhol's choosing to represent a television set. He had strong and prescient opinions about TV, many of which accord well with Hoffman's. Before considering how these attitudes manifested themselves in certain of Warhol's projects of the mid sixties, like his multimedia Exploding Plastic Inevitable and his book *a: a novel,* I wish to survey the artist's writings on TV, and particularly his amusing and sometimes withering remarks in *The Philosophy of Andy Warhol (From A to B and Back Again)* which, although published in 1975, is rooted in attitudes developed in the sixties. Abbie Hoffman declared in 1968 that Yippies were "living TV ads, [or] movies,"[39] and for Warhol the confusion of such a condition, between experience and spectatorship—between *being* a movie and *watching* a movie—was axiomatic. On the first page of *The Philosophy,* he states, "A whole day of life is like a whole day of television. TV never goes off the air once it starts for the day, and I don't either. At the end of the day the whole day will be a movie. A movie made for TV."[40] This confusion between mediated and unmediated experience is pushed further in his famous description of waking up after being shot in 1968:

> Before I was shot, I always thought that I was more half-there than all-there—I always suspected that I was watching TV instead of living life. People sometimes say that the way things happen in the movies is unreal, but actually it's the way things happen to you in life that's unreal. The movies make emotions look so strong and real, whereas when things really do happen to you, it's like watching television—you don't feel anything.

> Right when I was being shot and ever since, I knew that I was watching television. The channels switch, but it's all television. When you're really really involved with something, you're usually thinking of something else. When something's happening, you fantasize about other things. When I woke up somewhere—I didn't know it was at the hospital and that Bobby Kennedy had been shot the day after I was—I heard fantasy words about thousands of people being in St. Patrick's Cathedral praying and carrying on, and then I heard the word "Kennedy" and that brought me back to the television world again because then I realized, well, here I was, in pain.[41]

This extraordinary passage contains two important reflections on experience in a media culture. The first is Warhol's conviction that "TV" and "life"

mutually de-realize one another. The shifts in this passage are dizzying. At one moment Warhol asserts that mediated perceptions are more real than lived ones, more emotionally powerful and vivid, and a moment later he declares that, on the contrary, it is the media that exemplify the deadening of affect to which he is so morbidly sensitive. This contradiction fractures a single sentence: "The movies make emotions look so strong and real, whereas when things really do happen to you, it's like watching television—you don't feel anything." Perhaps Warhol is drawing a fine distinction here between movies and television (a possibility well worth entertaining),[42] but in a larger context he suggests a kind of infinite regress where emotional dissociation is both produced and reproduced in rebounding reflections between media and life, life and media. His 1968 "novel," *a,* is a brilliant demonstration of this de-realizing effect.[43]

a was one result of Warhol's infatuation with his tape recorder, a machine he referred to as his "wife."[44] The concept was to record the adventures of Factory habitué and superstar Ondine over the course of a speed-induced twenty-four-hour binge of talking and partying. (In actuality, more than one session was required.) The text, some 450 pages long and exactly transcribed from the tapes by two teenage typists, is astoundingly incoherent, like listening to the soundtrack of a television show without seeing the picture. Here's a brief excerpt from a heart-to-heart conversation between Ondine and Edie Sedgwick, who is identified by the letter T.

> T—And y'know. And I have to start again. And each time it, it's a little harder. But each time you have more equipment. *(Pause.)* Each time there's more equipment. T—But Ondine, you're such uh . . . I'm just the opposite of it too. T—But . . . I'm just the opposite of it. As as nice as I am, there's a stupid and unbelieving . . . T—I know. Do you know I don't believe in things.[45]

This is one of the more dramatic passages. Drugs certainly disorganized these conversations, but the brilliant accomplishment of *a* is its demonstration that experience escapes mechanical reproduction. In the novel, the aural surface of life is detached and allowed to float free: the transcription of experience suffocates it. And this leads to the second important point in Warhol's description of being shot. For Warhol, the exit from the wonderland of televisual disorientation was through the insistent physicality of the body, through pain. He concludes his meditation by stating, "and then I heard the word 'Kennedy' and that brought me

FIGURE **3.12**
Nico and the Velvet Underground perform at Andy Warhol's Exploding
Plastic Inevitable at the Dom on St. Marks Place in the East Village,
New York, 1967. Photo: Billy Name/OvoWorks, Inc. © 2006 The Andy
Warhol Foundation for the Visual Arts/Artists Rights Society (ARS),
New York.

FIGURE **3.13**
Andy Warhol's Exploding Plastic Inevitable featuring the Velvet Under-
ground at the Dom, New York, 1966. Photo: Billy Name/OvoWorks,
Inc. © 2006 The Andy Warhol Foundation for the Visual Arts/Artists
Rights Society (ARS), New York.

back to the television world again because then I realized, well, here I was, in pain."

The body as a site of kinesthetic experience—of pain—and the body as an object of mechanical reproduction were deliriously confounded in Warhol's collaborations with Lou Reed and John Cale's band, the Velvet Underground. Warhol saw the Velvets for the first time in 1965, and through 1966 he promoted them in a series of raucous multimedia presentations eventually known as the Exploding Plastic Inevitable, or EPI.[46] The EPI was by all accounts a wildly disorienting palimpsest of feedback loops. Little remains of these events except for a few powerful photographs by Billy Name and others, a film by Ron Namuth, and the vivid accounts of those who were present. It was typical for two or three films to be projected at all times onto the band, and these often included footage of the performers themselves. There were strobe and light shows that included dancers onstage shining lights directly at the audience. In addition to the band, members of the Warhol retinue including Gerard Malanga and Ronnie Cutrone invented spontaneous S/M dramas on stage, and sometimes the filmmaker Barbara Rubin would plunge into the crowd with her own camera and lights, making the audience itself a spectacle. These practices established a circuit of media feedback in which the line between performing oneself and becoming an image was perpetually crossed and recrossed. In a beautiful metaphorical summation of this experience, Jonas Mekas suggested in 1966 that strobe light could lead a dancer to perceive himself or herself transmogrified into film. He stated, "You become a particle, a grain of the movie. Maybe that's what it is. We are cut by strobe light into single frames, to eight frames per second or whatever the strobe frequency is, on and off. . . ."[47] This powerful experience of media feedback in which one may transit in and out of the "space" or "grain" of the film was mirrored by the Velvets' music, which was characterized by shrill and assaultive feedback noises that engulfed the listener in an environment of sound.

The Exploding Plastic Inevitable embodied Warhol's model of media spectatorship, in which television, film, and kinesthetic experience mutually de-realize one another. As Sterling Morrison, one of the Velvets, remembered of a performance in New Jersey: "At Rutger's [sic] we were all dressed entirely in white. The effect, with all of the films and lights projected on us, was invisibility."[48] Here is the converse of Abbie Hoffman's manipulations. Yippies sought the position of *figure* in their media interventions,

whereas in the Exploding Plastic Inevitable, the band served as a mobile *ground* for mechanically reproduced figments—sometimes of *themselves*—playing across their bodies. How can this contradiction be resolved with Hoffman's statement that in tolerant times "we must become Warhols"? We know from Hoffman's biographer, Jonah Raskin, that the Yippie activist saw the Exploding Plastic Inevitable at the Dom on St. Marks Place and that he "reveled" in its "total assault on the senses."[49] Hoffman knew that certain kinds of direct political action required the insertion of new messages—new figures—within conventional TV programming. But perhaps he also realized that John Brockman's accusation regarding his "good manners" on the Dick Cavett show cut to the heart of the political challenge of "tolerant times." Tolerance means allowing Abbie Hoffman on TV, but the price of his appearance there was the consolidation of a stereotypical persona crafted by the corporate media, whose avatar in this case is Dick Cavett. In other words, the political struggle with regard to tolerance lies not in destabilizing governments, but in destabilizing the forms of subjectivity that are the foundation of sovereignty—both public and personal.[50] This, of course, was a fundamental tenet of the New Left, and it is precisely what is at stake in Warhol's EPI. Jonas Mekas understood this in 1966 when he wrote:

> The strength of Plastic Inevitables, and where they differ from all the other intermedia shows and groups, is that they are dominated by the ego. Warhol has attracted toward himself the most egocentric personalities and artists. The auditorium, every aspect of it—singers, light throwers, strobe operators, dancers—at all times are screaming with screeching, piercing personality pain. . . . In any case, it is the last stand of the ego, before it either breaks down or goes to the other side.[51]

It couldn't be said any better. Andy Warhol is right for "tolerant times" because he calls forth and shatters the ego, because he stages its "last stand." One of the deepest and most unsettling legacies of the 1960s is the sometimes violent, sometimes ecstatic revelation that the ostensibly private arena of the self has become a public battleground. Warhol understood this condition not only in terms of psychology and politics but also in terms of form: the shattering of an ego is always a shattering of figure-ground relationships. What, after all, is an ego if not a figure standing against the ground of the unconscious, or alternately, the ground of socially constructed and media-generated identities? It is this profound

disruption of both the "content" of subjectivity and its form that Abbie Hoffman must have recognized as Warhol's political promise for "tolerant times."

Hoffman and Warhol called forth counterpublics by performing as "living TV ads" or as "a grain of the movie." Yippies captured a mass audience by starring in advertisements for revolution, but in maintaining television's opposition between figure and ground they failed to challenge the industry's structure, and consequently insured their own recuperation. Warhol's Exploding Plastic Inevitable kept figure and ground in flux by short-circuiting the interval that a participant (either performer or spectator) experienced between being a person and being a picture in an assault on the modern ontology of celebrity. It is such interference or feedback noise between self and image that Jonas Mekas identified as "the last stand of the ego," but the price of such subjective elasticity was quarantine in the discotheque. And while such communities of pleasure could serve as sites of genuine contact for various youth and subcultures during the late 1960s and 1970s, their political scope was necessarily limited.[52] Hoffman and Warhol thus delimit a territory of mid-sixties media activism that pivots on the construction or dismantling of media celebrity: Hoffman exploits celebrity in order to seize media parasitically, and in Warhol's EPI its unraveling is spectacularized. But the field of possibilities these figures define represents only a portion—albeit the most powerful and visible portion—of a Media-America whose racial practices at midcentury were akin to apartheid. Both Yippie actions and the EPI presume the possession of an intelligible identity—ranging from gadfly to superstar[53]—but in United States, such self-possession was not a universal privilege. A third option might well have been added to the political genealogy Hoffman traced between Castro and Warhol: *If the country remains racist, we must become Black Panthers.*

In *Revolution for the Hell of It,* Hoffman made an offensive, if sincere, association between his role models, the Diggers, and African Americans: "Spades and Diggers are one. Diggersareniggers. Both stand for the destruction of property."[54] Black Americans did share something with the Diggers—a lack of media visibility. This exclusion was acknowledged by virtually everyone, including the authors of an official report published by Lyndon Johnson's Advisory Commission on Civil Disorders in 1968:

most newspaper articles and most television programming ignore the fact that an appreciable part of their audience is black. The world that television and newspapers offer to their black audience is almost totally white, in both appearance and attitude. . . . Far too often, the press acts and talks about Negroes as if Negroes do not read the newspapers or watch television, give birth, marry, die, and go to PTA meetings.

. . . . By failing to portray the Negro as a matter of routine and in the context of the total society, the news media have, we believe, contributed to the black-white schism in this country.[55]

Years earlier, in 1964, LeRoi Jones (who later changed his name to Amiri Baraka) had presented the negligible black participation in Media-America as a badge of honor—a moral triumph. Not surprisingly, his tone contrasts sharply with the well-intentioned but condescending rhetoric of the Commission's report:

Turn on a television, what do you see? Who is responsible for it? They are the people who have something to lose, and are already damned by their lives.

But there are people in America not responsible for the filth of its image. (What is that image? Ask any Latin American.) Most Negroes, for instance, are not responsible for, nor are they represented by, the consistent insipidity and vapidness, and again, the denials of reality, flashed at us constantly through the mass media of the society. Those messages are from the owners' minds—Negroes are not owners . . . no, not even those flashy tokens of the missionary mentality, one of whom might even be lucky enough to be The First Negro To Push The Button For An Atomic Murder, as *Ebony* magazine might say—they are just liberals' gibberish. So that now most Negroes can say of that mass media, "That's Whitie doing that stupid thing . . . not me," and be right, essentially.[56]

In raising the issue of *responsibility* for television, Jones begs the question of how one belongs to a media public, either by owning its means of production or by appearing within its representations. On either ground, African Americans lacked full citizenship in Media-America. And while Jones tries to turn this condition to advantage by dismissing TV as Whitie's

"stupid thing," he nonetheless acknowledges the price to be paid for media apartheid. Later in the same passage he declares: "any honest man in America is separate, or separates himself, from the gloss of its image. But by being separate from that image a man is also setting himself up to be murdered, one way or another."[57] Separation from the info-nation leads to a media lynching.

Jones's striking assertion—that existing outside the official images of Media-America results in annihilation—allows for two kinds of interpretations: first, that invisibility within a media public sphere is itself a kind of death, and second, that the failure to conform to representational norms is a capital crime (a lesson familiar to civil rights and Black Power activists alike). In other words, African Americans found themselves in the impossible position of being shut out of the televisual public sphere while compelled to identify with it. Such a paradoxical closed circuit was well described by Lerone Bennett Jr. in 1971:

> In the pre-black days [i.e., before the Black Power movement of the mid 1960s], Negroes generally reacted to the white image by defining themselves as counter-contrast conceptions. They tried, in other words, to become opposite Negroes, the opposite, that is, of what white people said Negroes were. This symbolic strategy is being abandoned by post-Watts blacks who are defining themselves as counter-counter-contrast conceptions, as the opposite, in short, of what Negroes said Negroes were. As you can see, there are dangers in that strategy. The danger, put bluntly, is that blacks will go around and around in circles and end up in an old harbor of white clichés, with the mistaken impression that they are discovering new land. . . . [The way out] is to redefine the black image from a perspective free of the pressures of white influences.[58]

A 1958 television documentary "The Hate That Hate Produced," whose subject was the Nation of Islam and other so-called "black extremists," vividly illustrates the endless feedback loop of racial mirroring that Bennett describes. Over and over Louis Lomax, the African American reporter who conducted most of the interviews, returned to instances of black-white hostility as opposed to other pertinent themes, posing questions like, "Is there any good white man?" or "Can a white man join your temple?" In this way the documentary functioned as a distorted mirror, reflecting white racism back to its (white) viewers as black extremism in

order to simultaneously exonerate and alarm them (hence the aptness of the title: "The Hate That Hate Produced").[59] The ideological logic of these reversals is epitomized by the nauseating hypocrisy of host Mike Wallace, who declares at one point, "Thus the story is told: a small but growing segment of the American Negro population has learned to hate before the Christian white man has learned to love." As a representative of "Whitie's TV," Wallace assumes that the place of blacks is to wait, while that of whites is to learn.[60] Indeed, frustration with "waiting" for the love of Christian white men fueled the challenge launched by the Nation of Islam, Malcolm X, and later the Black Panthers to the nonviolent form of protest epitomized by Martin Luther King. Black Power was an effort to combat the actual and symbolic violence directed toward African Americans, and it included an attempt to "redefine the black image from a perspective free of white influences."[61]

"The Hate That Hate Produced" functioned as a media virus, helping to publicize the Nation of Islam and particularly Malcolm X rather than (or in addition to) mobilizing a reaction against them. William Strickland has claimed that the documentary "launched Malcolm and the Nation into national and international orbit, bringing them to the awareness of white America and the world," and historian Jeffrey O. G. Ogbar reports that "Within months after the show aired, NOI [Nation of Islam] membership doubled."[62] Ten years before Abbie Hoffman theorized guerrilla television's reversals of figure and ground, its effects were thus apparent in the reception of "The Hate That Hate Produced," where an unintended and "invisible" African American audience saw through the bankrupt message of the program to the magnetism of Malcolm X, a brilliant and disciplined manipulator of media. As Malcolm reports in his *Autobiography*, "The program hosts would start with some kind of dice-loading, non-religious introduction for me. It would be something like '—and we have with us today the fiery, angry chief Malcolm X of the New York Muslims. . . .' I made up my own introduction. At home, or driving my car, I practiced until I could interrupt a radio or television host and introduce myself."[63] Like the Yippies, Malcolm X exploited his own celebrity, and he did so by producing an image of disciplined resolve that was later made both para-military and glamorous in the informal dress code of the Black Panthers: natural hair, leather jackets, sunglasses, and often a beret.

Proponents of Black Power, as personified by Malcolm X and the Panthers, challenged the television apartheid of African Americans caught between

invisibility and forced identification in Media-America. Under such conditions, neither the exploitation nor dismantling of celebrity that Hoffman and Warhol had pursued were sufficient. It is no coincidence that Malcolm X self-consciously learned what Hoffman would not—how *not* to shut up for commercials—because *new icons* were needed and Malcolm X was one of the first. As LeRoi Jones declared in 1965, "What a culture produces, is, and refers to, is an image—a picture of a process, since it is a form of a process: movement seen. . . . The Black artist, in this context, is desperately needed to change the images his people identify with, by asserting Black feeling, Black mind, Black judgment."[64] Lerone Bennett called such new representations "directive images," which he defined as "large and dynamizing images that shape and mold behavior in desired directions. We mean images that point, command, and bind. We mean images that present tasks, make demands, and pull individuals out of themselves."[65] These are not images whose purpose is to facilitate narcissistic identification or ecstatic modes of oblivion, but an arsenal of tools for inciting political agitation, such as Emory Douglas's famous caricatures of police as pigs for the paper *The Black Panther.*[66] Amiri Baraka (no longer LeRoi Jones) called such images "Assassin Poems, Poems that shoot/guns."[67]

One such "Assassin Poem" was Melvin Van Peebles's feature film *Sweet Sweetback's Baadasssss Song* (1971), which was produced on a modest budget of $500,000 and grossed approximately $10,000,000, making it one of the most successful independent films in history.[68] *Sweetback* did not "find" an audience ready-made, but *constituted* one, largely through Van Peebles's independent publicity and word of mouth, drawing from the same so-called lumpenproletariat of black youth who were the typical recruits and supporters of the Black Panther Party founded by Huey Newton and Bobby Seale in 1966. Sweetback, who became the paradigm for commercialized blaxploitation heroes like Shaft (1971) and Superfly (1972), is a hypervirile dandy who, in the course of the film, makes his way from childhood as an orphan in a whorehouse to an unpremeditated (and largely apolitical) murderous assault on two corrupt white cops. Taken into custody by these policemen for the sake of appearances (Beatle, the proprietor of the whorehouse, handed him over as a dummy suspect for another crime), Sweetback witnesses the beating of a black activist, Moo-Moo, and the cops' savagery spontaneously inspires him to bludgeon them with his handcuffs. After this initial quasi-sacramental act of violence, Sweetback undertakes a journey as fantastic as any picaresque

FIGURE **3.14**
Cover of *The Black Panther*, November 8, 1969, with an illustration by Emory
Douglas. © Huey P. Newton Foundation. Courtesy Alternative Press Collection,
Thomas J. Dodd Research Center, University of Connecticut Libraries.

drama, ultimately making his way across the Mexican border to triumphant freedom. To a black community that had been terrorized by police brutality from the time of its arrival in the United States as slaves, this story of liberation was profoundly gratifying, and the movie was a hit.

But *Sweetback*'s success is not due solely to its narrative of revenge and liberation. Van Peebles (who acted in the starring role as well as directing, editing, and scoring the film) constructed a new outlaw image—a new kind of icon. The film is both the representation of an outlaw (Sweetback) and an outlaw mode of representation (pornography).[69] Its sexuality is explicit and perverse, from the opening scene in which an adult prostitute seduces the young Sweetback in early puberty, and proceeding through a lesbian sex pageant at which the Good Dyke Fairy Godmother accomplishes a sex change in one of two female lovers. Sweetback's escape is punctuated by a series of flamboyant conquests, including his visit to a resentful but lascivious former girlfriend and a sexual triumph over a large and boisterous white biker known to her male buddies as the "Pres." As a modality of insurgent power, the sex in *Sweetback* shares some of the piquancy of Jack Smith's or Andy Warhol's queer spectacles of sexual difference, but its blurring of genres, between pornography and action/adventure, represents a further sort of power play rooted in the economics of the film industry. Van Peebles has stated that the sexuality of *Sweetback* arises in part from a strategic shift in genre by which he sought to avoid the costly pay scales and intense regulation exerted by powerful Hollywood unions. As he wrote shortly after the film was released, "The Unions don't trouble themselves over smut films, that is, pornographic films, which I suppose they consider beneath their dignity, and there is even an entire parallel distribution circuit for these films. So I went to Nutsville to cover my project and told everyone I was making a beaver film. (Beaver is Californese for vagina.)"[70] In a notorious contretemps, the film was given an X rating, which Van Peebles challenged as an inappropriate white judgment on a black film, making T-shirts that read, "Rated X by an all white jury."

Sweetback's status as an outlaw operating within an outlaw genre is conveyed structurally through his nature as an image cipher. His character seldom speaks, and when he does, his remarks are terse and clipped. He communicates through his image—through a face that is paradoxically both vacant and eloquent, that serves as a screen of projection for its audiences. When the young Sweetback is instructed in the ways of sex

by the prostitute who deflowers him, she exhorts, "You ain't at the photographer's. You ain't gettin' your picture taken. . . . Move." And throughout the movie, the taciturn but utterly photogenic Sweetback, not unlike one of Warhol's glamorous superstars, takes this advice and circulates as a *moving picture:* as both a picture in motion and a picture capable of *moving its audience* by functioning as an "Assassin poem." There was a great deal of controversy over *Sweet Sweetback's Baadasssss Song,* both among African Americans who resisted its seamy rendering of black life and among whites whom it shocked or disgusted. But the work's seriousness—its intent to instruct while entertaining[71]—was recognized by no less a figure than Huey Newton, cofounder of the Black Panthers and unofficial ideologue of the movement, who wrote a long analytic essay on the revolutionary qualities of *Sweetback.* Newton pays close attention to the iconicity of Van Peebles's character and identifies it as a revolutionary technique:

> The film also demonstrates the value of unity among the entire Black community. . . .
>
> This unity is . . . demonstrated by the fact that Sweetback has almost no dialogue in the entire movie. He says hardly anything at all. Why? Because the movie is not starring Sweetback, it is starring the Black community. Most of the audiences at the movie are Black and they talk to the screen. They supply the dialogue because all of us are Sweetback; we are all in the same predicament of being victims. . . . This happens throughout the film. So the thing to do is not just see the film, but also to recognize how you the viewer are also an actor in the film, for you are as much a victim of this oppressive system as Sweetback.[72]

In Newton's analysis, the spectator of *Sweetback,* like the participant in Warhol's EPI, *is an actor in the film,* and it is through feedback—by "talk[ing] to the screen"—that strangers in a theater cohere as a public, cementing the "unity among the entire Black community." Unlike Hoffman's cult of personality or the collapsed egos of the EPI, Sweetback is available for appropriation as an "Assassin poem" or a "directive image." As opposed to a stereotype, Sweetback is a type, an open cipher, and this is why Van Peebles's assertion in the opening credits that *Sweetback* stars the "Black Community" is no exaggeration. It is worth remarking that both Warhol's and Van Peebles's assaults on the television system are conducted through

FIGURE **3.15**
Melvin Van Peebles, film stills from *Sweet Sweetback's
Baadasssss Song*, 1971. Courtesy of the artist.

130 ○ CHAPTER THREE

independent film where access to a mass audience is possible, if hardly easy or assured. As Van Peebles wrote, "'Where is Brer?' I asked me [sic], he was digging TV, movies and the sounds. But TV was out; television at this stage of the game, as it is practiced in America at least, is not a feasible tool for carrying really relevant ideas to the minds of the disenfranchised."[73] Van Peebles not only deployed a viral image—the character Sweetback— which experienced a robust afterlife in blaxploitation films and as a generalized folk hero, but he shrewdly diagnosed and exploited the economic structures of the film industry parasitically: "[Sweetback] must be able to sustain itself as a viable commercial product or there is no power base. The Man has an Achilles pocket and he might go along with you if at least there is some bread in it for him. But he ain't about to go carrying no messages for you, especially a relevant one, for free."[74] The profitable pathway Van Peebles opened up was quickly seized upon by Hollywood, and like Shamberg's commercial features, the progeny of *Sweetback,* such as *Shaft* or *Superfly,* had little of its political force. But guerrilla action should not be evaluated in terms of permanency. Van Peebles, like Hoffman and Warhol, caused a public to flash into being through feedback—by making pictures move.

4 AVATAR

ictory—but the fumes
of battle fill the air

by SUSANNA
McBEE

FIGURE 4.1

Susanna McBee, "Victory—But the Fumes of Battle Fill the Air," *Life*, September 6, 1968. McBee's article © 1968 LIFE Inc. Reprinted with permission. All rights reserved. Photos: LIFE Magazine. © 2006 Time, Inc.

I

On the eve of his nomination as the Democratic candidate for president in 1968, Hubert Humphrey kissed a television screen, and *Life* magazine was there. *Life*'s essay "Victory—But the Fumes of Battle Fill the Air" included commentary by Susanna McBee and a photo layout positioning Humphrey between two opposing images: the youthful insurgency taking place across the street from his Hilton Hotel room, and political business-as-usual. Humphrey described his view of demonstrators under attack by the Chicago police as "a terrible mark on what could have been a beautiful picture." But, for *Life,* he rebutted this blighted image by performing his own "beautiful picture." Following political tradition, the candidate had monitored the convention's proceedings via television from his hotel. When it became clear that his nomination was assured,

> He sprang from his chair, "That's it," he shouted. "Boy, I really feel like jumping." He thought of his wife Muriel, who was at the convention hall. "Mom," he said, "I wish you were here." Just then, as if summoned, her picture appeared on the screen. "How pretty she looks—I'm going to give her a big kiss."

> And, walking over to one of the television sets, Hubert Humphrey kissed the screen.

Humphrey's television kiss was certainly intended for the camera. Not only did *Life* record it in the most prominent photo of its essay, which filled two-thirds of the right page and crossed the gutter into the left, but this picture shows at least four other photographers aiming cameras at the kiss. In fact, Humphrey was acutely conscious of the press surrounding him at the Hilton. Earlier in her text, McBee describes him "Shooing off a covey of aides and photographers . . . [grumbling], 'This place is sometimes like Grand Central Station.'"[1]

Humphrey's kiss is a powerful registration of the *vivacity* of human presence on television, whose sinister dimension had been captured by Lee Friedlander in a 1963 photographic essay, "The Little Screens."[2] In these pictures, desolate crepuscular rooms are emptied of human occupants,

FIGURE **4.2**
Lee Friedlander, *Philadelphia,
PA*, 1961. Gelatin-silver print.
Digital image © The Museum of
Modern Art/Licensed by SCALA/
Art Resource, New York.
Courtesy Fraenkel Gallery,
San Francisco.

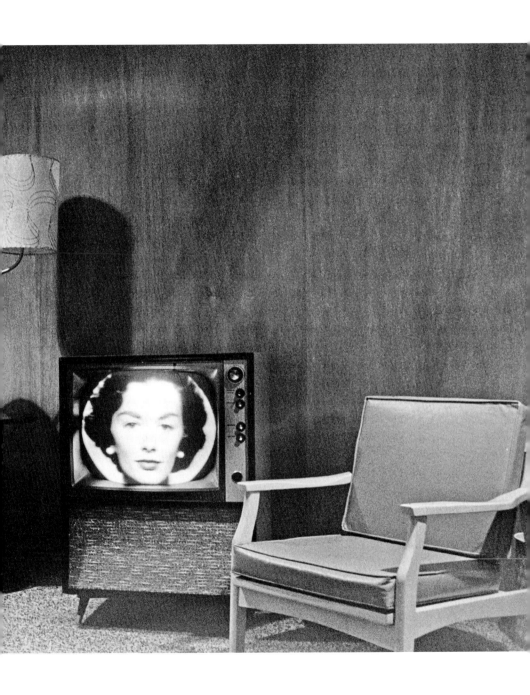

who return as faces on television screens. Walker Evans described these televisual totems as "spanking little poems of hate" and attributed them with an implicitly political power: "The human denizens of the rooms are purposely left out. In this atmosphere of eclipse, the sense of citizen presence is actually increased."[3] Evans's use of the term "citizen" may or may not have been purposeful, but citizens were undoubtedly on Humphrey's mind when he placed a kiss on his wife's electronic image. This highly self-conscious gesture goes beyond an acknowledgment of televisual presence: it encompasses two dimensions of *character* that structure both fiction and nonfiction television. On the one hand, in acting as he did, Humphrey *assumed a character*—the exuberant sitcom husband and father, kissing his wife (whom he affectionately calls "Mom"!) like Dick van Dyke returning home from the office. But on the other hand, Humphrey was *showing character* through his ostensibly impromptu and impulsive gesture. In the course of her essay, McBee notes criticism leveled at Humphrey for allowing himself to be overshadowed by President Johnson, particularly with regard to Johnson's unpopular Vietnam policies, and she quotes the candidate's defensive response: "Everyone has said, 'Be your own man.' Well, I thought I had done that long ago. I never felt the President was laying down the line to me." But, as McBee goes on to explain, the facts seem to undermine this assertion of independence:

> He had certainly been talking to Johnson about Vietnam policy over the previous weeks—and was sensitive to criticism that the greatest mistake in his campaign was his failure to issue a comprehensive policy statement all his own. He had wanted to, friends said, and in late July he went over a statement with his campaign coordinator, Lawrence O'Brien. He put it in his pocket, carried it around—and never gave it out. He considered at least four more drafts of the statement. But every time he got ready to release it, the President reminded him that the Paris peace talks were at a crucial stage.[4]

The cautious candidate who carried a crucial policy draft in his pocket without mustering the courage to pull it out is belied by the man so oblivious to conventional opinion that he will jump up to kiss a television screen in full view of the press corps. It was precisely such gestures, capable of demonstrating sincerity by giving an extemporaneous glimpse into the character of the man behind the politician, that could make or break a political career in the age of television.

In chapter 3, I described how media publics are established in feedback loops of identification (or disidentification) with celebrities, as in the complementary strategies of Abbie Hoffman and Andy Warhol, who respectively deployed celebrity for insurgent goals and deconstructed its mechanisms as an assault on ego. I further argued that media icons like Melvin Van Peebles's Sweetback operated as political vehicles for disenfranchised audiences. In every case, public life was *personified:* characters stand for, or more frequently displace, rational debate under television's regime. While oppositional or subcultural movements have generally been credited with establishing an equivalence between the *personal* and *political,* it was, in fact, mainstream politicians at midcentury like Dwight Eisenhower, Richard Nixon, and John F. Kennedy who pioneered the personalization of public discourse as a tool for consolidating power. Television's intimacy and serial mode of broadcasting enabled a new kind of personal authority that historically precedes identity politics and establishes its conditions of possibility. This form of power is almost unprecedented in its reach and stability, but, as Humphrey's television kiss demonstrates, it emerges out of a bifurcation: the necessity of *assuming a character,* or adopting a role, is distinct from the exigency of *showing character* by behaving in a spontaneously ethical manner. The interaction of these two qualities, character-as- role and character-as-conviction, is volatile, for while a successful political outcome requires that they be harmonized, their reconciliation is not always possible. This is Margaret Morse's point in theorizing the role of network news anchors (who, in presiding over national events, occupy a position analogous to that of the president). For Morse the degree of congruency between assuming a character and showing character is indexed by an anchor's degree of perceived *sincerity:* "Sincerity then is the unification of social role and personal belief, as well as the unification of the speaking subject and the subject in the sentence. . . . But these subjects of knowledge and belief, of speaker and language, and of person and a social role are not only different—they can never coincide. Even the most successful socialization is incomplete; social roles are never exactly equivalent to personal identities."[5] Character as social role and character as the locus of personal belief *never coincide,* and yet their smooth superimposition has been the anxious objective of every American politician since the rise of television.

Eisenhower's invention of the television news conference in 1955 was the first major step toward bypassing the traditional role of the press as an interlocutor whose questions might challenge or interfere with a

president's message. The explicit goal of his advisors was to deliver information directly from the president to the public via the edited film or transcription.[6] But television offered more than a neutral conduit to a mass audience incapable either technologically or financially of answering back. In a memo of November 23, 1953, Eisenhower wrote, "We have a task that is not unlike the advertising and sales activity of a great organization," and he likened his administration to a "good product to sell."[7]

In order to market this product on television, the sales medium par excellence, he enlisted the same experts and advertising agencies that sold consumer goods. Their strategy was to focus on the politician's *character*—branding him, as it were, with slogans such as "I like Ike." Instead of selling policies, the administration sought to sell the values supposedly embodied by the president. As media historian Craig Allen puts it, "Believing that Americans were more alike than they were different, the binding factors Eisenhower conceived were patriotism, personal prosperity, security, and the hope for an ever-brighter future. It was logical to Eisenhower that these simple themes be assembled in package form and promoted to the public through mass communication."[8] Indeed, the emphasis politicians place on selling unobjectionable values like patriotism, personal prosperity, and security on TV has been both consistent and bipartisan since the mid 1950s. Kennedy, for instance, in an extraordinarily prescient account of television and politics published in *TV Guide* in 1959, acknowledged that the television candidate's need to produce an image that was both widely palatable and "sincere" meant the extinction of a rougher kind of statesman who might not be welcome in viewer's living rooms:

> The slick or bombastic orator, pounding the table and ringing the rafters, is not as welcome in the family living room as he was in the town square or party hall. In the old days, many a seasoned politician counted among his most highly developed and useful talents his ability to dodge a reporter's question, evade a "hot" issue and avoid a definite stand. But today a vast viewing public is able to detect such deception and, in my opinion, willing to respect political honesty.[9]

As Kennedy enumerates with breathless optimism, a new "public" sphere had taken root in the family living room, causing the viewer's instincts to replace the reporter's inquiries and requiring politicians to behave like the fond but authoritative television fathers who were already welcomed

there nightly.[10] But Kennedy was equally alert to the peril inherent in this new political arena. For all its artifice, television is, in his account, a machine for detecting insincerity: the viewing public can recognize old-fashioned sophism and they will reject it. Transmitting sincerity depends upon a politician's *image*:

> Honesty, vigor, compassion, intelligence—the presence or lack of these and other qualities make up what is called the candidate's "image." While some intellectuals and politicians may scoff at these "images"—and while they may in fact be based only on a candidate's TV impression, ignoring his record, views and other appearances— my own conviction is that these images or impressions are likely to be uncannily correct.[11]

Kennedy's conviction—or wish—that the *sincerity* of television images might eclipse such legitimate concerns as assessing a politician's record or his views on specific issues is as blithely Machiavellian as it is accurate. To this day, American politicians, especially but not exclusively at the national level, labor to deliver personal images directly to the public, without undue interference from the press or too much compunction regarding the exchange of ideas. To reach this public directly requires enormous expenditures of cash, as the millionaire Kennedy himself acknowledged. ("The other great problem TV presents for politics is the item of financial cost. It is no small item.")[12] Consequently, the televisualization of presidential politics constitutes a serious threat to democracy.

Here is the paradox that every politician of the television era has had to confront: he or she must adopt a familiar and even ready-made role, and yet such characterizations must avoid striking viewers as artificial. The politician's challenge is to carefully engineer a market-tested image that will appear natural, honest, and above all, sincere. This double bind explains why so many politicians, including Eisenhower and Nixon, who made extensive use of media consultants, tended to disavow or at least to downplay them. The actor Robert Montgomery was enlisted to transform Ike's performance style, brilliantly accentuating his homey diction rather than masking it, while giving him a crisper and more appealing look through darker suits and new eyeglasses.[13] But as Allen recounts, Eisenhower resisted the reputation of a slick politician, and wanted his retooled persona to appear natural.[14] In the Nixon presidential campaign of 1968, an impressive media team, including the notorious Republican operative

Roger Ailes, met resistance at times from traditional political advisors who were averse to political uses of television and its inevitable aura of "showmanship." But as Joe McGinniss demonstrates in *The Selling of the President*, rebuilding Nixon's image, which had suffered significant damage in the 1960 television debates with Kennedy, was a high priority, causing his camp to consult the writings of no less a figure than media guru Marshall McLuhan. In an appendix to *The Selling of the President*, McGinniss published a series of quotations from McLuhan's *Understanding Media* that were distributed to Nixon's staff. One of these perfectly sums up the nature of personification in politics: "With TV came the end of bloc voting in politics, a form of specialism and fragmentation that won't work since TV. Instead of the voting bloc, we have the icon, the inclusive image. Instead of a political viewpoint or platform, the inclusive political posture or stance."[15] Ailes, a former producer for the *Mike Douglas Show*, might have taken these remarks literally in producing a series of television specials for Nixon based on what he called the "arena concept," which placed the candidate alone, standing on a central platform to face questions from a "representative" panel of citizens. As McGinniss recounts, it is not the content of Nixon's statements in these programs but his *political posture* that communicated most eloquently:

> He was alone, with not even a chair on the platform for company; ready to face, if not the nation, at least Illinois. To communicate, man to man, eye to eye, with that mass of the ordinary whose concerns he so deeply shared; whose values were so totally his own. All the subliminal effects sank in. Nixon stood alone, ringed by forces which, if not hostile, were at least—to the viewer—unpredictable.

> There was a rush of sympathy; a desire—a need, even—to root. Richard Nixon was suddenly human: facing a new and dangerous situation, alone, armed only with his wits. In image terms, he had won before he began.[16]

Such attention to posturing—to image—was equally apparent in a sequence of television ads made by the Nixon campaign from still photographs "through which Richard Nixon would seem to be contemporary, imaginative, involved—without having to say anything of substance."[17] In both strategies, the candidate was sold as an "inclusive image" whose purpose was to appeal to the largest possible market.

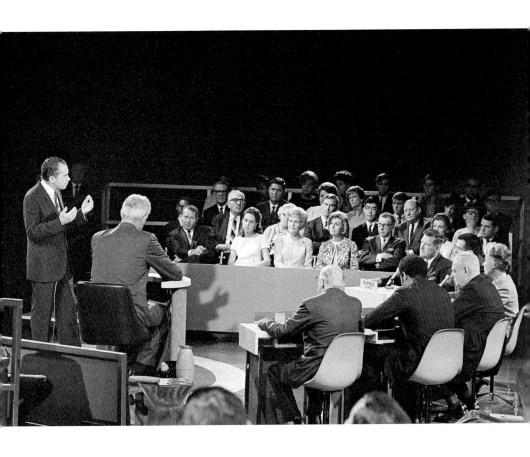

FIGURE **4.3**
Richard Nixon fields questions on statewide television in
Hollywood, September 18, 1968. © Bettmann/CORBIS.
Photo: David Hume Kennerly.

If McLuhan is correct—if the rise of television as a sphere of politics caused a change in the character of voting, as well as other political acts, from a putatively rational identification with the shared interests of blocs to an affirmation of "inclusive images" whose sincerity, or market appeal, is purposefully fashioned to attract consent—then an intractable problem arises. How can political opposition be organized against an icon, which by definition should be venerated rather than challenged? Politics is now conducted through images, but much of political science and popular commentary sustains the fantasy that its procedures are founded in logical debate. Beginning with the civil rights and liberation movements of the 1960s, it was identity politics that launched the most effective political countericons, including fictional personae like Sweetback that, functioning as a bloc might have done in earlier political movements, offer efficacious points of political identification. But inventing an icon is not the same as producing a movement, either in mainstream politics or from the counterculture. To succeed, an icon must proliferate, as a virus does. And in order to proliferate, an icon must overcome enormous inertia by capturing the imaginations of a wide media public, which requires financial investments of a magnitude that functionally excludes all but the largest corporations and mainstream political parties, or the boldest media activists, like the Yippies and Panthers, capable of hijacking expensive air time.

Images, then, are essential to politics, but their capacity to circulate is just as important—and such dissemination is unpredictable. In their studies of major televised political events such as the 1952 conventions and the Kennedy-Nixon debates of 1960, sociologists Kurt and Gladys Engel Lang confirmed that the mobility of the "inclusive image" is checked by inertia. Rather than dramatically changing minds, a candidate's image serves to crystallize preexisting formations of public opinion established almost geologically over a period of many years. Kennedy's impressive performance against Nixon on TV, for instance, did not lead to a landslide victory, but rather served to assuage the doubts of Democrats already disposed to support him that Kennedy was not too young and inexperienced to lead. The candidate's personal image therefore performs the relatively impersonal function of linking a voter's established views, based on the gradual accretions of public opinion, to the party representative who happens to be running in a particular election: "What our research did illustrate was a variety of ways in which perceptions were brought into line with electoral choices."[18] In other words, a politician's *sincerity* or, as I have defined

it following Margaret Morse, his or her reconciliation of social role and personal belief, functions to accomplish an analogous process of reconciliation for the citizen-viewer, whose social role as a Democrat or Republican is, as it were, brought into line with the personal characteristics of a Kennedy or a Nixon. The crux of the political process then, is a kind of focalization in which overlapping images—the personal and the conventional—are brought into alignment largely in the service of the status quo. This reconciliation of "pictures behind pictures" is well captured by the Langs in a passage analyzing Eisenhower's 1952 television campaign: "After each telecast, reporters asked and answered whether or not the *real* Eisenhower had come across. What was said during the press conference, speech, or interview was less remarked upon than how well the general had performed. Behind the picture itself there seemed to lurk a picture of the real Eisenhower and whether or not the telecast did justice to it."[19] What the Langs describe is an intensely social figure-ground relationship where a "real" picture may always be found behind a constructed one (in a relationship that is not only differential but reversible according to the prominence of personal belief or conformity to social role in a candidate's projected character). Even more striking is their observation that what was *said* by Ike was much less important than his performance; that is, the political efficacy of an image—its "sincerity" as a media effect in reconciling personality to political role—emerges as a fundamental test. And the mechanism of superimposition that makes for a good performance, whose ultimate goal is to make the pictures behind pictures congruent to one another and thus to neutralize the instability of their figure-ground relationship, may account for the inertia or stasis that the Langs observe in postwar American politics. For indeed, political change may occur only if new social roles are invented and adopted through the assertion of personal belief. Bringing the two sides of the equation between person and role into alignment is consequently a powerful means of establishing the steady state that any well-established network of power (including the two-party democracy of the United States) wishes to maintain. As the Langs acknowledge: "the preconceptions and impressions that enter into a vote decision are gradually built up throughout the years between elections, and television plays a large part in shaping that political imagery."[20] It should be noted, if only in passing, that just as televisual politics sought to abolish the flicker between figure and ground, the most advanced painters of the era, from Ad Reinhardt to Ellsworth Kelly and Frank Stella, accomplished something analogous through their play with the monochrome and deductive procedures of composition.[21]

Although politicians like Eisenhower, Kennedy, and Nixon understood the fundamental importance of producing themselves as icons, they may not have sufficiently acknowledged the corresponding inertial drag exerted on the "inclusive image" by the *longue durée* of public opinion. Such myopia is not surprising, given that character is primarily consolidated not through politics per se but in the constant flow of fictional entertainment on television, whose values rhyme perfectly with the politician's effort to reconcile personal behavior and social roles. As media theorist John Ellis has brilliantly recognized, there is little structural difference between "news" and entertainment: "the non-fiction and fiction modes of exposition of meanings seem to have converged within TV."[22] Indeed, the great accomplishment of commercial television is to *train Americans to maintain their proper places*—roles that they will reprise at election time through identification with spectacularized candidates. Each television genre articulates the relationship between personal behavior and social role in its own way: daytime talk shows by bullying their unconventional guests for failing to adopt normative behavior (and by demonstrating the ridicule they will suffer from such refusals); sports by glamorizing competition and insisting on the "rule of law" in physical competition;[23] the evening news by associating world events with the benign paternal figure of the anchorman; and documentaries by organizing investigative reporting around individual protagonists or characters.[24] But in their ostensibly apolitical character, entertainment genres are probably the most insidious sources of ideological persuasion. Television drama is besotted by the law, focusing relentlessly on the regulation of the body through narratives of the heroic doctor and the complementary regulation of social life through paeans to the detective, the lawyer, and the prosecutor. These dramas often pivot on a "renegade" professional who, like the politicians I have discussed, demonstrates her personal integrity by challenging the power structures she belongs to, only to redeem them in the end, leaving a dual impression of the unassailability of the disciplinary institutions of medicine and law, and of their laudable flexibility in accommodating the domesticated dissent of television's doctor-policeman-lawyer rebels.

It is, however, in situation comedy—where character arises as a by-product of family conflict—that television's ideological conditions as a medium rooted in the home are most explicit. Here, the figure-ground relationship that obtains between a politician's personal conviction and his or her social role is transposed as the opposition between a fictional character's

FIGURE **4.5**
Lucille Ball and Desi Arnaz portray Lucy Ricardo and Ricky Ricardo
in the CBS television series *I Love Lucy*, September 15, 1952.
CBS/Landov.

individual desire and the limits placed on it by the surrounding matrix of family ties that governs a particular TV series. In sitcoms, the relation between "real" and "constructed" images, which politicians seek to elide in their projection of a sincere character, is explored dramatically in a protagonist's comical divergence from and ultimate restoration to his or her "proper place." What the sitcom sells, in short, is the virtue of *remaining in character*. As Ellis has argued, the television series, and particularly the sitcom, establishes cycles of conflict and resolution that produce "a steady state to which audience and fiction return each week."[25] One might say that personal conviction—or desire—erupts in these plots only to be overcome by the exigencies of social roles, as when Lucy Ricardo, protagonist of the iconic 1950s series *I Love Lucy* (1951–1957), attempts and spectacularly fails to shake off her housewife's duties in order to become a star (often in competition with her bandleader husband, Ricky). By the episode's "happy ending," Lucy is always consigned again to the status of subordinate helpmate. As Ellis argues: "This is exactly the dilemma that situation comedy deals with: it presents conflicting forces or emotions that can never be resolved. Hence the series situation is highly suited to present a particular static vision of the family and of work relations. What is particularly marked about the situation series is that the characters lose all memory of the previous weeks' incidents. They never learn."[26] Or, one might amend Ellis's conclusion, they learn only too well that the consequence of dissent—of the desire to break out of character—is to be unceremoniously pushed back, restored to television's steady state. Here, the reconciliation of the figure-ground relationship between personal belief and social role that is fundamental to the optimization of "image" in politics is rendered as *comedy* in order to make its quasi-totalitarian disciplinary force palatable to the citizens of a democracy.[27] In its celebration of political victory through the gendered subordination of his wife, Humphrey's television kiss is thus an echo of the kisses Ricky bestows on Lucy to solemnize her wifely acquiescence.

Television, then, simultaneously *constructs* character and *maintains* it in a spectrum of proper social roles. This is why politics in Media-America can be both excessively "personal" and thoroughly bereft of individual agency, let alone dissent. Identities are sold as coherent stable properties on television, in its fiction and nonfiction genres alike. All day long and throughout the year, character is abstracted and quantified. Television teaches us our place and keeps us there. In this, as Avital Ronell has argued, it resembles the police: "The police become hallucinatory and spectral

because they haunt everything; they are everywhere, even where they are not. They are present in a way that does not coincide with presence: *they are television.*"[28] Television is equivalent to the police because it *polices character,* and it is in the realm of character that public conflict is negotiated. The philosopher Jacques Rancière has likewise called such conditions, in which citizens occupy the positions set out for them, the domain of the *police* or *policy.*[29] This is a form of social life where the distance between figure and ground, role and person, is minimized. Politics, in Rancière's theory, pertains not to its casual colloquial sense of governmental business, but to the rare and usually short-lived encounter of incommensurable worlds that meet through the agency of those who, like the poor, are powerless and hence invisible under a particular regime or "distribution of the sensible."[30] For Rancière, politics is inherently aesthetic because its mode is the articulation of an imaginary relation between a given social world and a new type of subject who comes into being by demanding equality in response to a wrong. Such a political subject, Rancière writes, "is never the simple assertion of an identity; it is always, at the same time, the denial of an identity given by an other, given by the ruling order of policy. Policy is about 'right' names, names that pin people down to their place and work. Politics is about 'wrong' names—misnomers that articulate a gap and connect with a wrong."[31] Such subjects, in occupying the impossible space of the "wrong name," exhibit what Rancière calls in-betweenness: "The place of a political subject is an interval or a gap; being *together* to the extent that we are *in-between*—between names, identities, cultures and so on."[32] Rancière thus provides a critical tool for fighting television's balkanization of character—its promotion of abstracted and commodified identities. The "wrong name" might break open the foreclosed figure-ground relationship between character-as-role and character-as-conviction, yielding new social spaces where we can be "*together* to the extent that we are *in-between*—between names, identities, cultures and so on."

Something of this in-betweenness has always been latent in the volatility of television's bifurcation of character. Fictionalized beings, whether politicians or sitcom protagonists, need to convey some sense of life in order to capture viewers, but life can never be thoroughly domesticated. As Lynn Spigel writes, such a strategy was already apparent in 1950s sitcoms: "'TV couples' such as Jane and Goodman Ace, Ozzie and Harriet, Burns and Allen, and Lucy and Desi were an ambiguous blend of fiction

and reality. By appealing to viewers' 'extratextual' knowledge (their famil-
iarity with television celebrities through fan magazines and other public-
ity materials), these programs collapsed distinctions between real life
and television."[33] The slippages between fictional and nonfiction roles
that Spigel notes were not necessarily oppositional—on the contrary, the
introduction of "reality" was intended to garner profit: "At the end of *I Love
Lucy*, Lucy and Ricky Ricardo returned to their star personae of Lucille Ball
and Desi Arnaz, inviting viewers to smoke Philip Morris cigarettes."[34] And
as *Newsweek* reported in 1953, the convergence of the fictional character
Lucy Ricardo and the glamorous star Lucille Ball was good not only for
commercials but for building new story lines as well:

> Lucille Ball . . . and Desi Arnaz discovered last June that they were
> going to have a second baby, and they were frightened for their TV
> health. The stars of the highest-rated show on American television,
> they didn't see how the pregnancy could be convenient for Lucille's
> figure or for their weekly filming of I Love Lucy. They delivered the
> news to Jess Oppenheimer, their producer and head writer. Unfazed,
> Oppenheimer immediately shouted: "Whatta gimmick! I've been
> wondering what we were going to do next season!" Lucille and Desi
> immediately saw what the real-life baby could do for their screen-
> life careers as Lucy Ricardo and her husband Ricky.[35]

The brisk optimism of this passage thinly masks a brute economic fact:
that "TV health" is enhanced by injecting "reality" into the repetitive and
recombinant plots of television sitcoms.[36] The success of this genre relies
heavily on the viewer's capacity to empathize with featured characters
and to grow sufficiently attached to them to tune in week after week.
To this purpose, some intimation of the star's off-screen character was
enormously effective and remains so. Although so-called reality television
is assumed to be a recent invention, successful sitcoms have always
contained or simulated quasi-documentary content. If, in the 1950s,
this quality was conveyed by the notoriety of celebrity couples like Lucille
Ball and Desi Arnaz, in the early 1970s it arose from the "relevance" of
countercultural struggles and corresponding concerns about identity and
difference such as those brashly addressed in Norman Lear's controversial
series *All in the Family*, or more ingratiatingly explored in proto-feminist
workplace sitcoms like *The Mary Tyler Moore Show*, in which family values
migrated to the office.[37]

Notwithstanding its primarily commercial justification, the introduction of "reality" into sitcoms often had a double edge. While intended to reap profits, it could enable readings by some viewers that went against the grain of television's ideological abstraction of character. As Patricia Mellencamp has argued, the slippage between a character's fictional and nonfiction dimensions, while certainly not attaining the political force of the "wrong name" that Rancière theorizes, may nevertheless destabilize social roles by holding two contradictory characters in suspension:

> If Lucy's plots for ambition and fame *narratively* failed, with the result that she was held, often gratefully, to domesticity, *performatively* they succeeded. In the elemental, repetitive narrative, Lucy never got what she wanted: a job and recognition. Weekly, for six years, she accepted domesticity, only to try to escape again the next week. During each program, however, she not only succeeded, but demolished Ricky's act, upstaged every other performer . . . and got exactly what she and the television audience wanted: Lucy the star, performing.[38]

In Mellencamp's account, the collapse of the social figure-ground relationship that politicians *perform* in their self-presentation and that fictional television *narrates* as entertainment is forestalled by the contradictory personae of Lucy Ricardo, who is perpetually defeated, and Lucille Ball, who is eternally triumphant. While it is tempting to make a judgment in favor of the triumphant Ball over the defeated Ricardo, such partisanship would only balkanize identity, reinscribing the "'right' names," at the expense of "in-betweenness." Commercial television either obsessively disavows or compulsively reenacts the resolution of a fractured character. But elsewhere in the video ecology—in works of art—the contradiction between a person and her image is not short-circuited, but openly exhibited.

II

Mellencamp's distinction between Lucy Ricardo as a function of narrative and Lucille Ball as a function of performance indicates a model of a critical spectatorship in which Ball's worldly celebrity may be read against her fictional role as a housewife. And yet as John Ellis has argued, commercial television works to foreclose this disruptive possibility. According to him, viewers are *complicit*—their perspective is "delegated" to the camera in its selective, if various, scansion of the world. The intimacy established by television's location in the home, its constant presence as a "companion," and its capacity to make highly structured segments seem like natural perception lure spectators into adopting its corporate point of view. Although this perspective is saturated with the values of domestic normativity, television leads viewers to disregard their own conditions through its conspiratorial insinuation of uniqueness or superiority. As Ellis puts it: "'Housewives' are designated as a 'they' whose actions are scrutinised by the TV institution and its viewers together. This effectively prevents the recognition by women in that audience of themselves as 'housewives.'. . . [T]he 'housewife' is presumed to be everywhere, blindly devoted to the maintenance of her little family, but no one recognises themselves in that designation."[39] In other words, a general identification with "television" masks a more potentially efficacious and even potentially political acknowledgment of what one shares with a class or bloc, such as women who work in the home. Television establishes its complicity with the viewer, then, not only to create a certain kind of identification but also to negate other types of social bond. The ideal spectator identifies with the institutional values of television *in general* while disavowing *specific* connections that might challenge its power. As Ellis argues:

> Broadcast TV positions its viewers as citizens through the double distance from events that it installs by complicity with the viewer and delegation of the look. The viewer-as-citizen is uninvolved in the events portrayed, yet can manifest (as a result) a generalised concern and vague sense of scandal by turns. Citizenship is a position from which the outside, the "theys" of various kinds that TV constitutes, are recognized as problems. Citizenship recognises problems outside the self, outside the immediate realm of responsibility

FIGURE **4.6**
Bruce Nauman, *Live-Taped Video Corridor,* 1970. Wallboard, video camera, two video monitors, videotape player, and videotape, dimensions variable. Solomon R. Guggenheim Museum, New York, Panza Collection, Gift 1992 92.4165. Photo: Paul Rocheleau, courtesy of the Whitney Museum of American Art, New York. © 2006 Bruce Nauman/Artists Rights Society (ARS), New York.

and power of the individual citizen. The citizen is at ease with the world, but is not in the world. Citizenship therefore constitutes the TV viewer as someone powerless to do anything about the events portrayed other than sympathise or become angry.[40]

Television fosters a generalized identification with the values promoted in all its genres, fiction and nonfiction alike, while short-circuiting the establishment of actual collective action among citizens. One might say that TV alienates viewers from their own images (or images through which they might make common cause with others) by aligning them with corporate personifications of commerce and law. Here, then, is television's fundamental ideological accomplishment. It replaces human beings with *characters* and thus transposes politics and public debate into privately owned and operated simulations. The spectator is subjected to the same superimposition of personal belief and social role that is dramatized on TV: in absorbing television's point of view, individual viewers are transformed into characters in their own living rooms.

Video installations of the early and mid 1970s diagram this process—but in reverse—by spatializing the divergence between persons and their images as a social encounter. In Bruce Nauman's *Live-Taped Video Corridor* (1970), for instance, viewers are invited to enter a narrow passageway leading to two stacked monitors. On the bottom monitor, a prerecorded view of the empty corridor is played, while the one above carries a live image from the same angle. Since the live camera is mounted just inside the entrance, any viewer who walks into the corridor sees only an image of the *back* of her head and body that diminishes as she moves closer to the monitors. In other words, as the viewer advances, her image withdraws, and yet the restricted width of the passageway makes visitors acutely aware of their own bodies. Nauman's piece shatters the complacency of what Ellis calls television's "complicit viewer" by simultaneously frustrating the uncritical consumption of character (in part by foreclosing identification with a face) and making the act of viewing self-conscious through the spectator's heightened physical awareness. In this chapter I have argued that TV wields power by superimposing or reconciling images of personal conviction and "proper" social roles. As a fundamental condition in producing a commercial public sphere, such figure-ground collapse leads, as Michael Fried has argued in the realm of painting, to a kind of stasis, or what he calls "presentness."[41] The product of commercial television is precisely such presentness, which, constantly refreshed,

FIGURE **4.7**
Peter Campus, *cir*, 1976. Video installation, Castelli Gallery, 1976,
size site-specific. Photo: Bevan Davies. Courtesy Paula Cooper Gallery,
New York.

renders corporate ideology as "breaking news." But in video art, the correspondence between figure and ground, or between person and picture, is explicitly brought out of alignment. In place of presentness is the dilated moment of the feedback loop.

In Nauman's works and others, like *cir* (1976) by Peter Campus in which a viewer steps into the field of a camera mounted in a darkened gallery only to see his image projected at an angle from that point, feedback establishes a mechanism by which a person's distorted picture is abstracted before his eyes. In both *Live-Taped Video Corridor* and *cir*, the image places the viewer as much as the viewer projects an image: in Nauman's work, the corridor channels movement, and in Campus's, the apparatus hugs the wall, encouraging spectators to maneuver into the proper place in order to generate a picture. The coercive quality of this reciprocal positioning maps the disciplinary conditions of television spectatorship, but it also establishes a different sort of relation between a person and his image, premised on proximity and touch. As Campus himself describes the effect of *sev*, a work in the same series: "My image and I stand perpendicular to each other. The image is alive. The equation between matter and light energy formed. Photons of light penetrate the wall. I feel the emptiness around me. I let myself go into this extension of self. For a brief moment I am at the same time this image and this self."[42] If, as Campus proposes, the image is alive, one's relationship to it is more charged than the calculated elision fundamental to television's production of character. Indeed, the experience of works like *cir* and *sev* is decidedly intimate: one must nearly press against one's picture in order to maintain its continued projection. Such coexistence of "this image and this self," which is reminiscent of the co-presence of Lucy Ricardo and Lucille Ball, is thus imagined as a quasi-erotic encounter—a kind of video embrace. It might be tempting to call such an interaction narcissistic, but in fact it is the contrary: instead of collapsing the viewer into her picture, the projection appears as an external object, soliciting a response.[43]

Video feedback, then, can exhibit its own form of duality: it mingles alienation with intimacy. A viewer encounters an image—of himself or another—in a scene of primal sociality between persons and pictures. In certain of their single-channel videotapes, Vito Acconci and Joan Jonas have established such contact *face-to-face*. In Acconci's *Pryings* (1971), for example, a videotaped performance in which the artist attempted to pry open the eyes of his collaborator, Kathy Dillon, television's attenuation

FIGURE **4.8**
Vito Acconci, *Pryings*, 1971. Video still. Courtesy Electronic Arts
Intermix (EAI), New York.

FIGURE **4.9**
Joan Jonas, *Left Side Right Side*, 1972. Video still. Courtesy Electronic
Arts Intermix (EAI), New York.

of person-to-person communication is desublimated as an eroticized physical struggle. In 1972 Acconci described the work as follows:

> Camera focus on Kathy's eyes: her goal is to keep her eyes shut—my goal is to force them open.

> Ground for interaction: television (close-up, performer confronting viewer face to face). Here the performer will not come to terms, she shuts herself off, inside the box (monitor); my attempt is to force her to face out, fit into the performer's role, come out in the open.[44]

This grueling video, in which Acconci produces a long, sadistic "close-up," literalizes and reverses the coercive position of television's spectator by projecting it back onto the televised character.[45] Dillon's refusal to open her eyes both manifests and contradicts the behavior of television personalities who, as industrial products, are sealed tight despite their simulation of an ingratiating accessibility. But Dillon's closure is that of an actual body, and Acconci's assault on this condition is an effort to transform a mute face into a face that "faces out" as an image.

Acconci's pryings are thus in the service of the viewer's desire for character. But Dillon's recalcitrance restores the violence that underlies any appropriation of images from human subjects. Joan Jonas demonstrates the false social contract of the close-up from a different angle, by manifesting its instability rather than its violence. In the single-channel tape *Left Side Right Side* (1972), Jonas positioned herself between two cameras, one in front and the other behind her; she sat opposite a monitor and a mirror placed side by side, so that her video reflection, which is "true," was paired or alternated with a mirror image that is reversed. This ostensibly simple situation becomes dazzlingly complex through various shifts that reveal components of the apparatus to the viewer: monitor, mirror, performance space, or all at once. In the opening sequence Jonas initiates an extended incantation by pointing to her right eye, proclaiming, "This is my right eye," and to her left, performing the complementary speech act, "This is my left eye," but the contradiction, for the viewer, between true and reversed reflections (one to the viewer's left and one to her right) renders such definitive statements groundless, as though Jonas's face had been lost in a vertiginous crosscurrent of opposing representations. This lack of spatial coordination, which is only increased during moments when Jonas's body moves into the frame along with mirror and monitor,

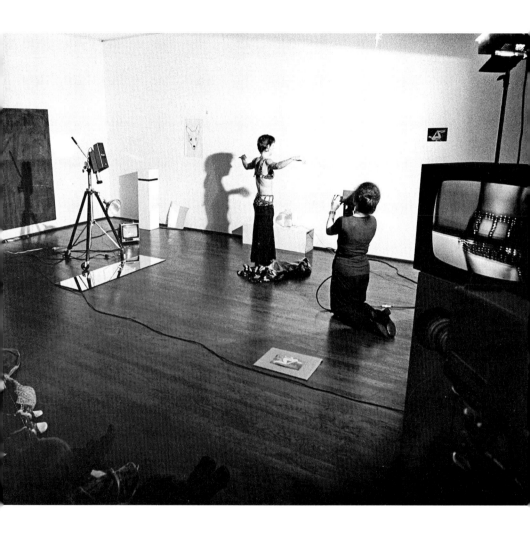

4.10
Joan Jonas, *Organic Honey's Vertical Roll*, 1973. Video performance,
Castelli Gallery, New York. Performer: Joan Jonas; camerawoman:
Babette Mangolte. Photo: James Patrick. Courtesy of the artist.

is distinct from Acconci's insistent touch on Dillon's face. Jonas gestures toward her eyes in order to claim her own presence and sovereignty over vision, and yet her "self-possession" is shattered into fragmentary facets in the monitor's infinite regress.[46] Acconci describes an analogous invagination of the body through representation in his discussion of a series of audiotape or photographic works in which he recorded actions like slapping a microphone, or photographing the *effects* of somatic movements (such as stretching and taking a photograph from an extended position): "Tape was a way to space my body, let it drift, cut it into intervals. Photographs, then provided a point; a way to locate myself in space: connect my body with its surroundings."[47] Such bodies, "cut . . . into intervals," represent the erosion of figure-ground relationships. Either with violence or through disorientation, they bring character out of register.

In Jonas's important video performances *Organic Honey's Visual Telepathy* (1972) and *Organic Honey's Vertical Roll* (1972), the "spacing out" of bodies is only one component of a thoroughgoing unraveling of the television apparatus. These works disentangle and reshuffle three closely interconnected video systems I have discussed in this book: feedback, scan lines, and character. Feedback loops are established by training a video camera on performers, including the title character Organic Honey, who was "played" by Jonas, exotically dressed and wearing a lewd, translucent mask purchased in a sex shop. Live tape was simultaneously fed to monitors in the same space so that viewers could see the character alongside her image performing various ordinary if mysterious actions, such as dropping coins into a large jug of water. Television's scan lines appear as *drawn lines* through Jonas's practice of drawing during her performance for the benefit of both the audience and the monitor. Her drawings are not meant as autonomous art objects but rather as dynamic icons or vectors, often repeated again and again in an enactment by hand of television's constant refreshing of its phosphorescent surface. In one section of *Organic Honey's Visual Telepathy,* the published script of the performance reads: "Honey kneels, removes mask, places objects one by one on paper, and draws, watching drawing materialize on monitor." The accompanying account of simultaneous video images elaborates: "Hand places object on paper, traces a line around it. As each object is delineated, it disappears. Lines collect, making image on the monitor and in projection."[48] In the imaginary space of the monitor, Jonas transmogrifies images as handmade scansions; they disappear into a thatch of outlines reminiscent of television noise. Following this sequence (which recalls a commercial's

presentation of objects to viewers), the drawing is torn away to reveal a mirror, as though reflecting the person behind the commodity (and behind the commodified character more generally) in the form of Jonas's face (without Organic Honey's mask). As the script recounts:

> [Performance] Honey hits mirror obsessively with large silver spoon, trying to break her image. Loud sound echoes in the space.

> [Video and Film Images] Silver spoon striking Jonas's image—inward and outward blurred silver hitting itself. Face removed. Spoon continues to bang. Mirror does not break.[49]

The image of a character divided against itself arises in conjunction with the presentation of anticommercials. But here, the two Joans, unlike the two Lucys in I Love Lucy, appear in open combat: Honey strikes Jonas in an attempt "to break her image."

Indeed, fundamental to Jonas's unraveling of television is a pluralization of her represented identity. As Constance De Jong beautifully expressed it in a 1973 essay on Organic Honey's Vertical Roll: "As a means of constituting, the monitor supplied an opposite: oneself given back. An intrinsic quality of the media—feedback—was taken metaphorically. It suggested one who could become a multiple identity."[50] Feedback's multiplication of identity establishes a theater of the "wrong name"—Joan Jonas is temporarily eclipsed by Organic Honey, only to shine through as "herself" again later on. Although Organic Honey is an intentionally vulgar interpretation of a feminine stereotype—a kind of showgirl or stripper—she is not placed in opposition to Joan Jonas as an artist, but rather in dynamic equilibrium with her in an instance of what Rancière called "in-betweenness."[51] And such "in-betweenness," as De Jong understood, results from feedback. The encounters between persons and images staged by Nauman, Campus, Acconci, and Jonas represent identity as a process, not a televisual presence. By calling forth animate images, these artists produced avatars whose purpose is to navigate media ecologies as "wrong names," storing potential power in the fissures of commercial character.

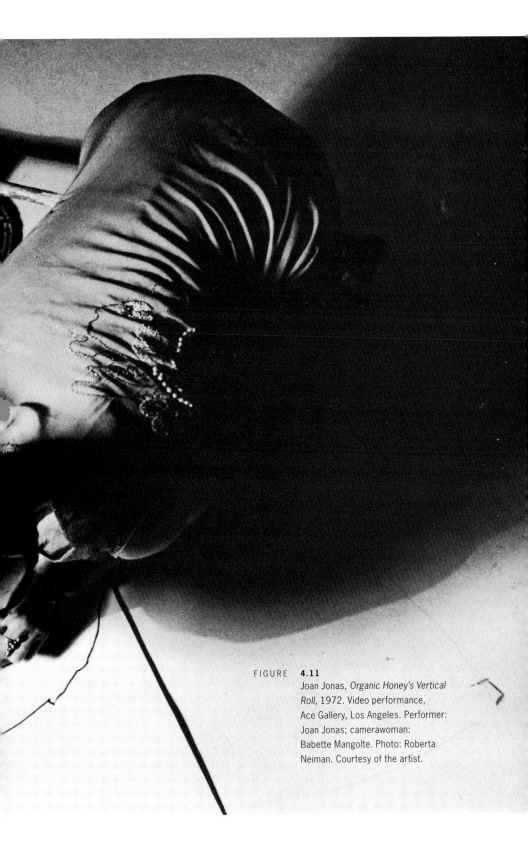

FIGURE **4.11**
Joan Jonas, *Organic Honey's Vertical Roll*, 1972. Video performance, Ace Gallery, Los Angeles. Performer: Joan Jonas; camerawoman: Babette Mangolte. Photo: Roberta Neiman. Courtesy of the artist.

III

Avatars circulate at the behest of an individual or group without being identical to any particular person. In this way they challenge television's presumption that citizens should *consume* and *possess* identities like private property—an assumption shared across the political spectrum from conservative advocates of family values to the proponents of progressive identity politics. Avatars arise under the conditions of Media-America where, in order to address a large public, one must assume (or be forced into) the position of an intelligible character, often closely associated with stereotyped identities like "gay," "conservative," or "African American."[52] As I argued in chapter 3, image feedback produces celebrity and, as semi-autonomous entities composed of images, celebrities (as distinct from the biological persons legally warranted to them) may under certain circumstances function as avatars. If television alienates viewers from their own representations through a skewed identification with commodified norms, avatars both acknowledge this alienation and attempt to combat it by inventing new "social lives" for such readymade characters. Avatars function as political agents by bringing persons and pictures face-to-face to produce publics.

Typically, celebrity is wielded conservatively to consolidate and promote the normative spectrum of character, but when Yoko Ono and John Lennon were married in 1969, they exploited their potential status as avatars by redirecting the widespread media attention their wedding attracted for purposes other than enhancing personal fame. In *Bed-In for Peace,* initially performed in Amsterdam,[53] they spent a weeklong honeymoon in a hotel suite, inviting reporters to interview them while they were in bed. Instead of providing fodder for celebrity gossip by offering "private" details to feed their public image, Lennon and Ono used their personal intimacy as a media platform for promoting peace.[54] Like Abbie Hoffman, they forced a figure-ground reversal between television programming and the commercials that interrupt it. According to Lennon: "We sat in bed and talked to reporters for seven days. It was hilarious. In effect, we were doing a commercial for peace instead of a commercial for war. The reporters were going 'uh-huh, yeah, sure,' but it didn't matter because our commercial went out irrespective. As I've said, everybody puts down TV commercials,

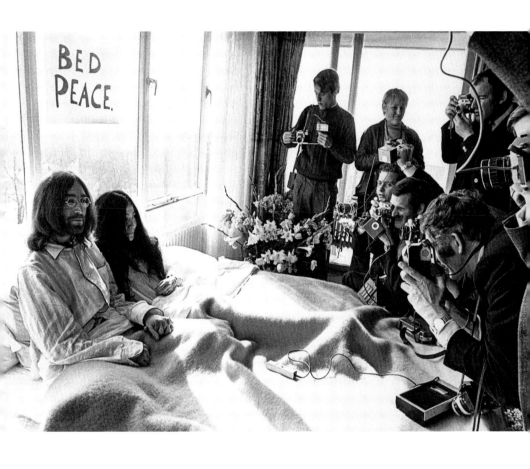

FIGURE **4.12**
John Lennon and Yoko Ono, *Bed-In for Peace*, Amsterdam,
March 1969. © Bettmann/CORBIS.

but they go around singing them."[55] The default position for a celebrity's media presence is to produce commercials for *themselves,* but Lennon and Ono used their status as icons to offer their public a political message. That this action occurred under the aegis of art indicates how rare it is to use celebrity as an avatar, since it risks compromising the value of one's identity as property.[56] Lennon and Ono were prepared to deploy their image as distinct, and even unappealing, personae. As Lennon declared: "Yoko and I are quite willing to be the world's clowns."[57]

The Beatle's celebrity functioned as a readymade because it was achieved outside the realm of art. But for Andy Warhol, the pursuit of celebrity was a lifelong process—a kind of "medium." Although Warhol explicitly thematized media icons in his paintings of celebrities like Marilyn Monroe, Liz Taylor, and Jackie Kennedy and destabilized them in the Exploding Plastic Inevitable, his more significant, if less recognized, contribution to mid-twentieth-century art was his prolific production of alternate publics, including the distinctive social milieu of the Factory (as his studio was known), the pop art world in which art events functioned as media events, and subcultural audiences for his underground films, not to mention the readership for his publishing enterprises like *Interview* magazine. Warhol was the only artist of the twentieth century to simultaneously represent and *manufacture* celebrity, and he did so by practicing an art of the avatar. His desire to produce himself as an icon, indexed in the 1960s by his wistful hope that Picasso would have heard of him, was notorious. But Warhol's pursuit of fame paradoxically forced a wedge between celebrity and self-possession rather than exploiting their elision. He functioned as a "blank" celebrity, lending his name to the diverse and often collaborative activities of the Factory, and allowing others to speak for him in interviews and even, in one notorious case, in a public lecture.[58] As he famously put it: "A lot of people thought that it was me everyone at the Factory was hanging around, that I was some kind of big attraction that everyone came to see, but that's absolutely backward: it was me who was hanging around everyone else. I just paid the rent, and the crowds came simply because the door was open. People weren't particularly interested in seeing me, they were interested in seeing each other. They came to see who came."[59] Warhol allowed the Factory to develop into a public where people came to *see each other,* without laying down its contours in advance. It was a space of possibility and outrageousness where the gay demimonde met the Ivy League, and camp encountered old wealth. Of this perpetual party, Warhol wrote: "It was a constant open house, like the format of a children's TV

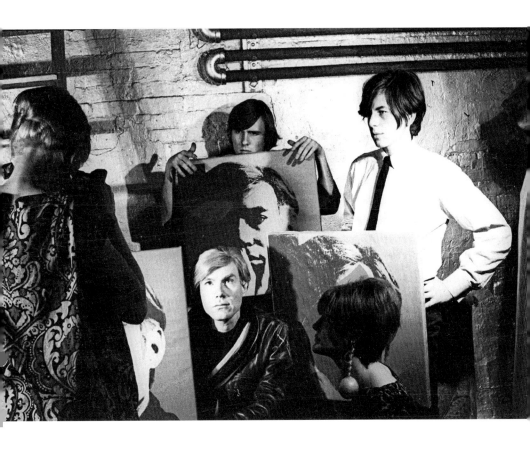

FIGURE **4.13**
Andy Warhol and others with silk-screen self-portraits at the
Factory, New York, 1965. Photo: Billy Name/OvoWorks, Inc.
© 2006 The Andy Warhol Foundation for the Visual Arts/
Artists Rights Society (ARS), New York.

program—you just hung around and characters you knew dropped in."[60] But the Factory reversed the values of commercial TV, causing character to blur rather than consolidate.

The name *Andy Warhol* functioned as a corporate umbrella, sheltering and promoting countercultural publics and a constellation of enterprises operating under its aegis.[61] And yet, as an avatar, the Warhol name had the opposite effect from television's elaboration of character: instead of bringing personal belief into alignment with social role, the Warhol system *caused them to diverge and proliferate*. This divergence between person and role (or image) is thematized everywhere in his art and life, from the uneven inking of successive silkscreens in gridded paintings of Liz or Jackie to the casting of "actors" in his films whose performances are always out of kilter. In what seems like a confirmation of Rancière's account of politics as an eruption of the "wrong name," Warhol wrote in 1975: "If I ever have to cast an acting role, I want the wrong person for the part. I can never visualize the right person in a part. The right person for the right part would be too much. Besides, no person is ever completely right for any part, because a part is a role is never real, so if you can't get someone who's perfectly right, it's more satisfying to get someone who's perfectly wrong. Then you know you've really got something."[62] Warhol devoted his life to parties, in which he apparently recognized the last remnants of a public sphere: "Sex and parties are the two things that you still have to actually be there for," he said.[63] All through the sixties, seventies, and eighties he was invited everywhere, recording everything with his camera and tape recorder.[64] He was a celebrity who was also a paparazzo: an avatar whose fame wrapped around the blankness of its own pursuit.

The death of the author, as influentially theorized by Roland Barthes and Michel Foucault, has too often been interpreted as an erasure of agency, rather than a shift in the nature of agency from the singular creativity of an individual to the multifarious effects of a text in the world. As Barthes famously declared, the death of the author makes possible the birth of the reader, which is equally the birth of an avatar—a projected and provisional subjectivity that is simultaneously in, out, and of the text.[65] In their capacity to signify the "wrong name," avatars indicate a locus of politics in a world pacified by television's stabilization of character. It is a type of image—part fiction, part documentary—that need not be tied to balkanized interests, but may function as a social agent in the service of collective demands. *By liberating identity from the status of property, avatars build publics.*

Afterword: Manifesto

This book was written in a period of stunning reversals for democracy, sold to Media-America in the name of fear and patriotism. I am convinced that understanding the history of television, and its major influence over public discourse, is still acutely necessary today, even as its dominance is challenged by new and perhaps more egalitarian media like the Internet.[1] Artists can have a powerful role in such a project if they reach beyond the art market, whose booming economy is fueled by routinized and trivial novelty. As art marches in circles, politicians manipulate images more effectively than the legions of M.F.A. graduates from prestigious schools like Art Center, Cal Arts, Columbia, and Yale. For this reason, I conclude *Feedback* with a manifesto—a challenge to artists and art historians alike, including myself—to make use of the tactics developed during television's first or "network" era. Let's respond to a thirty-year-old call from Susan Sontag and take a stand *against interpretation* and in favor of *action*.[2] Let's put images in motion.

1. FEEDBACK. Don't produce art or art history by making a "new" move in the game of aesthetics you learned in school. Assess the image ecology you live in and respond to it. Learn the system and counter it—make *noise*. Practice eco-formalism.

2. CREATE A VIRUS. How is your image going to circulate? Use the resources of the "art world" as a base of operations, but don't remain there. Use images to build publics.

3. LOSE YOUR IDENTITY. Don't believe that you're a piece of property, a "gay man" or an "African American" whose "subject position" is the product of market research. Use icons opportunistically, and share them with like-minded people. Make an avatar!

4. Imagine modes of art and art history that function as political science. Stop pretending to subvert commodification by demonstrating what everyone knows—that capital is everywhere. SEIZE THE WORLD AS A READYMADE and BREAK OPEN ITS CIRCUITS.

Notes

INTRODUCTION: TELEVISION AGAINST DEMOCRACY

Epigraph: from Daniel Odier, *The Job: Interviews with William S. Burroughs* (New York: Penguin, 1974), p. 174.

1. I would date the initiation of an information-based art to the work of Jasper Johns and Robert Rauschenberg in the mid 1950s.

2. Hannah Arendt, "Lying in Politics: Reflections on the Pentagon Papers," in *Crises of the Republic* (San Diego: Harcourt Brace, 1972), pp. 17–18.

3. In attempting an apparatical study of television, I am inspired by the words of Oskar Negt and Alexander Kluge: **"Products can be attacked only with counterproducts. Television criticism must set out from the historical corpus of the medium, namely, television as an industrial enterprise. What is more, any self-determination of the viewers, as the foundation of a possible emancipatory development of television, must measure itself against this industrial dimension: that is, by what cannot automatically be detected within an individual broadcast. Television can be transformed not on the level of the individual program, but of its entire history, which determines that program"** (boldface in source). Oskar Negt and Alexander Kluge, *Public Sphere and Experience: Toward an Analysis of the Bourgeois and Proletarian Public Sphere,* trans. Peter Labanyi, Jamie Owen Daniel, and Assenka Oksiloff, with a foreword by Miriam Hansen (Minneapolis: University of Minnesota Press, 1993, p. 103. (Originally published in German in 1972.)

4. In his brilliant book *Talking Politics: The Substance of Style from Abe to "W"* (Chicago: Prickly Paradigm Press, 2003), Michael Silverstein demonstrates that language in politics has fallen under the sway of the image. In explaining why President George W. Bush's apparent incapacity to speak coherently in public has functioned not as a drawback but as an *asset* for him politically, he suggests that Bush's difficulty with language shows that he's "really trying" and that this effort creates empathy for him among citizens by establishing an aura of sincerity. But more importantly, Silverstein argues that persuasive language in the United States, which encompasses both advertising and politics, no longer functions in the grammatically correct units of sentences or paragraphs, but rather appears as charged image fragments, such as "Freedom's on the March!" Silverstein calls this idiom "corporatized language," which he argues is "composed by phrases and words as the units, not by sentences and paragraph-chunks of denotational exposition. It's a compositional 'language'—really, a code—of imagery" (116). This rendering of text as image is furthered by the Bush administration's famous use of banners above or on podiums in order to convey soundbites *visually* despite what the president might actually say.

1 OPEN CIRCUITS

1. The Coke ad is one of several produced by the D'Arcy advertising agency in 1953; it is preserved in the Motion Picture Archives of the Library of Congress. Memos describing the ads also exist in

the Coca-Cola Archives, but they may never have been broadcast. Ted Ryan, manager of the collections department at Coca-Cola, wrote of these memos:

> I became intrigued because I have not been able to locate any material which gives additional insight into the creation or selling intent. This is unusual. The Coca-Cola Company generally sponsored television programs and then created television ads and then provided them free of charge to our many bottlers around the country urging them to buy advertising time—particularly when our sponsored program came on in that particular market.
>
> In 1953, when these stop motion spots were created, we were sponsoring Coke Time with Eddie Fisher and the Kit Carson Show. The Kit Carson ads generally featured Bill Williams (actor who portrayed Kit Carson) or his wife, Barbara Hale, on the set of the program. The Coca-Cola Company communicated to our bottlers via a weekly or monthly mailing. I found mailings for all of our other commercials produced during this time period which gave the intent of the commercial and had an attached page describing the ad. I could not find the intent page for your spots. Each mailing was numbered (ie 53.1 for the first in 1953, etc.) and after organizing the mailings for 1953, I determined there was no mailing for the stop motion spots. Very odd to go to the trouble of creating the description sheet with the images and then not communicate it the same way as the other ads. (Ted Ryan, e-mail communication, May 20, 2005)

The other two ads I describe are documented in Lincoln Diamant, *Television's Classic Commercials: The Golden Years 1948–1958* (New York: Hastings House, 1971), pp. 105–107, 136–138. The Lucky Strike ad dates from 1948 and the Raid spot from 1956.

2. Saskia Sassen has demonstrated that the decentralization of certain economic functions, such as manufacturing, is paradoxically premised on the centralization of service-oriented business in "global cities." See Sassen, *The Global City: New York, London, Tokyo* (Princeton: Princeton University Press, 1991).

3. Paul Rutherford argues that after an initial phase in which live TV ads were focused around talking heads (in an extension of the textually oriented radio ad to a visual medium), film and (after 1956) video were used to let the product show itself. Paul Rutherford, *The New Icons? The Art of Television Advertising* (Toronto: University of Toronto Press, 1994), p. 11.

4. I am thinking primarily of Donna Haraway and N. Katherine Hayles, each of whom has explored a mode of subjectivity that is "distributed" across human/organic and technological elements. For Haraway, this figure is embodied in the cyborg, and for Hayles in the posthuman. I discuss these questions further below. See Donna J. Haraway, "A Cyborg Manifesto: Science, Technology, and Socialist-Feminism in the Late Twentieth Century," in *Simians, Cyborgs, and Women: The Reinvention of Nature* (New York: Routledge, 1991), pp. 149–181; and N. Katherine Hayles, *How We Became Posthuman: Virtual Bodies in Cybernetics, Literature, and Informatics* (Chicago: University of Chicago Press, 1999). There has also been an interesting body of cyberfeminist thinking, including the work of Allucquère Rosanne Stone, *The War of Desire and Technology at the Close of the Me-*

chanical Age (Cambridge: MIT Press, 1995), and Sadie Plant, *Zeroes and Ones: Digital Women and the New Technoculture* (London: Fourth Estate, 1997).

5. In fact, Adorno and Horkheimer, whose description of the culture industry has been the most influential theoretical touchstone for many modernist art historians' discussions of reification, offer a rather complex picture. In their classic argument in "The Culture Industry: Enlightenment as Mass Deception," the authors state repeatedly that "culture now impresses the same stamp on everything" (120) and "The culture industry as a whole has molded men as a type unfailingly reproduced in every product" (127). I believe there is a fault line in their breathtaking (and airless) analysis. Adorno and Horkheimer acknowledge that the unrelenting sameness of the culture industry requires constant reproduction: "For only the universal triumph of the rhythm of mechanical production and reproduction promises that nothing changes, and nothing unsuitable will appear" (134). The authors believe that constant motion (of reproduction) can efficiently maintain absolute stasis, a "constant reproduction of the same thing." But such a frictionless system defies both scientific and human laws: in every technological process there is some drag, some hidden entropic force. In *Feedback* I will argue that the channeled motion inherent in such a closed circuit of reification may be interrupted for pleasurable and political purposes. These interruptions may not be permanent, but that does not render them inefficacious.

 A similar argument can be made with regard to the most important and influential art historian to have discussed and diagnosed the culture industry, Benjamin H. D. Buchloh. Buchloh's subtle and learned analysis of the spectrum of tactics invented by twentieth-century artists to undermine or accommodate the culture industry is legendary. But I take exception to his habitual positing of an absolute *opposition* between "fine" art and commercial art. A passage in the introduction to his recent book of essays, *Neo-Avantgarde and Culture Industry,* is typical: "Rather than settling for the comfort that the left has traditionally taken in declaring these spaces and practices of neo-avantgarde production to be foreclosed or corrupted, commercial or contaminated, recuperative or complicit, the title of this collection of essays would signal to the reader that its author continues to see a dialectic in which the mutually exclusive forces of artistic production and of the culture industry as its utmost opposite can still be traced in their perpetual interactions" (xxiii). My disagreement here is with Buchloh's assumption that artistic production and the culture industry are utmost opposites and that the only alternative to such a view is "selling out" (recuperative or complicit). On the contrary, in *Feedback* I hope to displace the all-or-nothing dialectic with an *ecological* analysis in which fine and commercial art are part of a continuous system that may be disrupted and redirected (if not overturned, as Hegel or Marx would have liked) in new ways. For this reason, the goal of sublation appropriate to a dialectic process can only be a dream, or stated differently, we are already experiencing the sublation of artistic production and the culture industry. *Feedback* will acknowledge the imbrication of art practices with the culture industry and seek to recover and theorize political tactics appropriate to such a condition, such as viral modes of scansion and feedback. See Max Horkheimer and Theodor W. Adorno, "The Culture Industry," in *Dialectic of Enlightenment,* trans. John Cumming (New York: Continuum, 1989), pp. 120–167 (originally published in German in 1944); and Benjamin H. D. Buchloh, *Neo-Avantgarde and Culture Industry: Essays on European and American Art from 1955 to 1975* (Cambridge: MIT Press, 2000), pp. xvii–xxxiii.

6. Paul Virilio, *Open Sky*, trans. Julie Rose (London: Verso, 1997), p. 24.

7. Jack Gould, *All About Radio and Television*, illustrated by Bette J. Davis, 2d ed. (New York: Random House, 1958).

8. Indeed, Jeffrey Sconce has shown that the electronic public sphere of television has often been represented as a kind of alien world. See Jeffrey Sconce, *Haunted Media: Electronic Presence from Telegraphy to Television* (Durham: Duke University Press, 2000).

9. See Edith Decker-Phillips, *Paik Video* (Barrytown, NY: Barrytown, Ltd, 1988), pp. 36–39. (Originally published in German in 1988.) For an indispensable account of Paik's career, see John G. Hanhardt, *The Worlds of Nam June Paik* (New York: Guggenheim Museum Publications, dist. Harry N. Abrams, 2000).

10. Nam June Paik, "Afterlude to the Exposition of Experimental Television, 1963, Galerie Parnass," originally published in *Fluxus cc Five Three* (June 1964) and reprinted in *Videa 'n' Videology: Nam June Paik (1959–1973)*, ed. Judson Rosebush (Syracuse: Everson Museum of Art; New York: Galeria Bonino, 1974), unpaginated.

11. Ibid.

12. Ibid.

13. Decker-Phillips argues that there were twelve televisions in the exhibition rather than thirteen. See Decker-Phillips, *Paik Video*, p. 58, n. 117.

14. Paik, "Afterlude to the Exposition," unpaginated.

15. See Raymond Williams, *Television: Technology and Cultural Form*, with an introduction by Lynn Spigel (1974; reprint, Wesleyan University Press; Hanover: University Press of New England, 1992).

16. Inquiries to Callie Angell, author of the Andy Warhol film catalogue raisonné, the Warhol Museum archives in Pittsburgh, and the Museum of Radio and Television in New York yielded no leads. Moreover, Schrafft's is out of business and so is the William Free ad agency.

17. Joe D'Allesandro's Web page includes the following reminiscence from the actor: "The motherfucker's got absolutely no talent. No original idea in his head. So when we get there and the guy said, 'the camera can do this,' Andy said, 'Oh yeah, I like that. Do that. Do that.' Do you think he was gonna talk to the actors who were sitting in front of the camera in their bare chests getting their hair combed? No, it was like, 'yeah, okay Viva, sit in front of Joe. Okay, that's good. Let's shoot that thing with the thing.' It was the most boring piece of shit, but he was paid a lot of money to do it." The author of this interview, Michael Ferguson, recounts: "The commercial aired effectively as a publicity stunt, but descriptions of it indicate that the actors were completely clipped out"; http://www.joedallesandro.com/html/underground_sundae.htm.

18. Harold H. Brayman, "New Flavor at Old Favorite: Warhol and Underground Sundaes: Schrafft's Will Never Be the Same," *National Observer*, October 28, 1968, p. 8. I am grateful to Callie Angell for her help in locating accounts of *Underground Sundae*.

19. John Leonard, "The Return of Andy Warhol," *New York Times Magazine*, November 10, 1968, p. 144.

20. Brayman, "New Flavor at Old Favorite," p. 8.

21. Paul Carroll, "What's a Warhol?" *Playboy* 16, no. 9 (September 1969): 140.

22. See my discussion later in this chapter of Arjun Appadurai's concept of the social life of things.

23. William Boddy, *Fifties Television: The Industry and Its Critics* (Urbana: University of Illinois Press, 1990), p. 20.

24. Ibid., p. 45 (italics in source).

25. Lenox R. Lohr, *Television Broadcasting: Production, Economics, Technique* (New York: McGraw-Hill, 1940), p. 162.

26. Ernest Dichter, *The Strategy of Desire* (Garden City, NY: Doubleday, 1960), p. 181.

27. Ibid., p. 84.

28. Gilbert Seldes, *Writing for Television* (Garden City, NY: Doubleday, 1952), pp. 86–87.

29. Charles A. Siepmann, *Radio, Television, and Society* (New York: Oxford University Press, 1950), p. 320. For another, present-day analysis of the relationship between TV and the freeway system, see Margaret Morse, "An Ontology of Everyday Distraction: The Freeway, the Mall, and Television," in *Virtualities: Television, Media Art, and Cyberculture* (Bloomington: Indiana University Press, 1998), pp. 94–124.

30. Boddy, *Fifties Television*, p. 125.

31. James G. Webster and Lawrence W. Lichty, *Ratings Analysis: Theory and Practice* (Hillsdale, NJ: Lawrence Erlbaum Associates, 1991), pp. 3–4.

32. *Television Today: Its Impact on People and Products* (New York: National Broadcasting Company, 1951), p. 55.

33. Karen S. Buzzard, *Chains of Gold: Marketing the Ratings and Rating the Markets* (Metuchen, NJ: Scarecrow Press, 1990). Buzzard maps these complex shifts in "Part II: Shakedowns and Shake-outs (1950–1960)," pp. 29–79, especially p. 37.

34. Willard R. Simmons and Thomas E. Coffin, *How Television Changes Strangers into Customers* (New York: National Broadcasting Co., 1955), p. 9 (italics in source).

35. Ibid., p. 23.

36. Ibid., p. A-3.

37. There were lively debates among competing ratings services about the pros and cons of anecdotal versus quantitative methodologies. The Audimeter, for instance, was criticized for only measuring whether the television was turned on (and to what channel), not whether anyone was paying attention. For an excellent account of the industry's development including these controversies, see Buzzard, *Chains of Gold*.

38. Desmond Smith, "TV's Unnerving Numbers Game," *New York Times*, August 18, 1963, p. 40.

39. Ibid., p. 56.

40. See Stanley Cavell, "The Fact of Television" (1982), reprinted in John G. Hanhardt, ed., *Video Culture: A Critical Investigation* (Rochester: Visual Studies Workshop Press, dist. Gibbs M. Smith, Peregrine Smith Books, 1986), pp. 205–218.

41. Ibid., p. 206.

42. Ibid., p. 209.

43. Ibid., p. 217.

44. In the closing paragraphs of *The Order of Things*, Foucault famously writes, "As the archaeology of our thought easily shows, man is an invention of recent date. And one perhaps nearing its end." Michel Foucault, *The Order of Things: An Archaeology of the Human Sciences* (New York: Random House, 1970), p. 387.

45. Lynn Spigel gives an important account of television spectatorship in the home in its early period (1948–1955) in which she charts two contradictory discourses. On the one hand, television was understood as unifying the family (as an entertainment it could share), while on the other hand, it was seen as a force dividing family members (as a medium premised on individual reception). She sees the social world of television as one characterized by division *and* unity. See Spigel, "Television in the Family Circle," chap. 2 in *Make Room for TV: Television and the Family Ideal in Postwar America* (Chicago: University of Chicago Press, 1992), pp. 36–72.

46. See Marshall McLuhan, *Understanding Media: The Extensions of Man* (1964; reprint, Cambridge: MIT Press, 1996), and Donna J. Haraway, "A Cyborg Manifesto."

47. See Hayles, *How We Became Posthuman*.

48. My argument is clearly indebted to Foucault's theory of discourse. See especially Michel Foucault, *The Archaeology of Knowledge*, trans. A. M. Sheridan Smith (1972; reprint, New York: Harper & Row, 1980).

49. Homi K. Bhabha, "The Other Question: Stereotype, Discrimination and the Discourse of Colonialism," in *The Location of Culture* (London: Routledge, 1994), pp. 74–75.

50. Arjun Appadurai, "Introduction: Commodities and the Politics of Value," in Appadurai, ed., *The Social Life of Things: Commodities in Cultural Perspective* (Cambridge: Cambridge University Press, 1986), p. 5.

51. The term is of course that of Ernst Cassirer. For an introduction to the concept, see Cassirer, *An Essay on Man: An Introduction to a Philosophy of Human Culture* (New Haven: Yale University Press, 1944).

52. In defining television in terms of monitoring, Cavell identifies the bank of surveillance monitors as an emblem of TV aesthetics: "The bank of monitors at which a door guard glances from time to time—one fixed, say, on each of the empty corridors leading from the otherwise unattended points of entry to the building—emblematizes the mode of perception I am taking as the aesthetic access to television." Cavell, "The Fact of Television," p. 209.

53. For an account of this work, see Michael Asher, *Writings 1973–1983 on Works 1969–1979,* written in collaboration with Benjamin H. D. Buchloh (Halifax: Press of the Nova Scotia College of Art and Design; Los Angeles: Museum of Contemporary Art, 1983), pp. 112–117.

54. This term is Appadurai's. See Arjun Appadurai, *Modernity at Large: Cultural Dimensions of Globalization* (Minneapolis: University of Minnesota Press, 1996), especially pp. 33–43.

55. See Fredric Jameson, "The Cultural Logic of Late Capitalism" (1984), in *Postmodernism or, The Cultural Logic of Late Capitalism* (Durham: Duke University Press, 1991), especially pp. 51–54.

56. For a polemical statement of this case, see Hal Foster's "The Artist as Ethnographer," chap. 6 of *The Return of the Real* (Cambridge: MIT Press, 1996), pp. 171–203; and for a very different account of the relation of fine art to ritual, see Carol Duncan, *Civilizing Rituals: Inside Public Art Museums* (London: Routledge, 1995).

57. See Thomas Crow, *The Intelligence of Art* (Chapel Hill: University of North Carolina Press, 1999), and the special issue on visual culture of *October,* no. 77 (Summer 1996).

58. I regard the most important insight of visual culture studies as an acute awareness of how power invests the visual field. This recognition, however, represents not an entirely new methodology (since art history is almost constituently involved in visual power) but rather a new set of political and ethical commitments to diversify perspectives of analysis and objects of study. This assault on the Eurocentrism, sexism, and classism of mainstream art history is powerful and essential, but polarization of the debate among proponents of the two "disciplines" leads to troubling simplifications on each side. I am more comfortable thinking of visual culture as a mode of activism that moves through existing fields rather than as a field in and of itself. For very useful summaries of the theoretical and political stakes in visual culture, see the first three essays in Nicholas Mirzoeff, *The Visual Culture Reader,* 2d ed. (London: Routledge, 2002): Mirzoeff, "The Subject of Visual Culture," pp. 3–23; Irit Rogoff, "Studying Visual Culture," pp. 24–36; and Ella Shohat and Robert Stam, "Narrativizing Visual Culture: Towards a Polycentric Aesthetics," pp. 37–59.

59. Pamela Lee makes a similar association between *medium* and *new media.* See Pamela M. Lee, *Chronophobia: On Time in the Art of the 1960s* (Cambridge: MIT Press, 2004), pp. 69 ff.

60. Rosalind Krauss, *"A Voyage on the North Sea": Art in the Age of the Post-Medium Condition* (London: Thames and Hudson, 1999), pp. 6–7.

61. Ibid., p. 27.

62. Craig Owens, "The Allegorical Impulse: Toward a Theory of Postmodernism" (1980), reprinted in Owens, *Beyond Recognition: Representation, Power, and Culture,* ed. Scott Bryson, Barbara Kruger, Lynne Tillman, and Jane Weinstock; with an introduction by Simon Watney (Berkeley: University of California Press, 1992), p. 53. For another important and influential account of allegory and postmodern art that, like Owens's, relies heavily on Benjamin's *The Origin of German Tragic Drama,* see Benjamin H. D. Buchloh, "Allegorical Procedures: Appropriation and Montage in Contemporary Art," *Artforum* 21, no. 1 (September 1982): 43–56.

63. See Douglas Crimp, "Pictures," *October,* no. 8 (Spring 1979): 75–88.

64. McLuhan, *Understanding Media*, p. 8.

65. Ibid., p. 64.

66. Ibid., p. 42.

67. See David Riesman in collaboration with Reuel Denney and Nathan Glazer, *The Lonely Crowd: A Study of the Changing American Character* (New Haven: Yale University Press, 1950).

68. David Antin, "Video: The Distinctive Features of the Medium" (1976), reprinted in Hanhardt, ed., *Video Culture,* p. 149. Along these same lines, Fredric Jameson writes, "Commercial television is not an autonomous object of study; it can only be grasped for what it is by positioning it dialecti- cally over against that other signifying system which we have called experimental video, or video art." See Fredric Jameson, "Surrealism without the Unconscious," in *Postmodernism, or, The Cul- tural Logic of Late Capitalism,* pp. 76–77.

69. Talcott Parsons, "Social Structure and the Symbolic Media of Interchange" (1975), in Parsons, *Social Systems and the Evolution of Action Theory* (New York: Free Press, 1977), p. 206. Niklas Luhmann calls attention to Parsons in the context of medium in *Art as a Social System,* trans. Eva M. Knodt (Stanford: Stanford University Press, 2000), p. 129.

70. Parsons, "Social Structure and the Symbolic Media of Interchange," pp. 206–207.

71. Ibid., pp. 210–211.

72. For an explicit statement of this comparison, bringing mass communications into the mix, see Tal- cott Parsons and Winston White, "The Mass Media and the Structure of American Society" (1960), in Parsons, *Politics and Social Structure* (New York: Free Press, 1969), pp. 241–251.

73. Consumer credit did not start with credit cards—in fact, it had a long history in the nineteenth and early twentieth centuries, just as advertising preceded television. But both the credit card and the television accelerated this system to an unprecedented degree. For a history of credit before the credit card, see Lendol Calder, *Financing the American Dream: A Cultural History of Consumer Credit* (Princeton: Princeton University Press, 1999); and for a consideration of the role of credit cards in American life, see Robert D. Manning, *Credit Card Nation: The Consequences of America's Addiction to Credit* (New York: Basic Books, 2000).

74. See "The Thinner Life of Things," part 7, in Daniel J. Boorstin, *The Americans: The Democratic Experience* (New York: Vintage Books, 1973), pp. 411–447; esp. pp. 425–429.

75. Norbert Wiener, *The Human Use of Human Beings: Cybernetics and Society* (New York: Da Capo Press, 1950), pp. 26–27.

76. Bateson writes, "A 'bit' of information is definable as a difference which makes a difference." In Gregory Bateson, "The Cybernetics of 'Self': A Theory of Alcoholism" (1971), in Bateson, *Steps to an Ecology of Mind* (1972; reprint, Chicago: University of Chicago Press, 2000), p. 315.

2 VIRUS

1. The rise of television in the United States corresponded to a widespread shift in representational practices whereby works of art ceased to appear as singular objects carrying singular messages, and began to demonstrate their confinement within complex overlapping circuits. This is most obvious in so-called conceptual work of the 1960s and 1970s, as exemplified by figures such as Hans Haacke and Eleanor Antin who generate form by "mapping" various economic and subjective social relations. But, as I will argue in this chapter, long before the onset of art's "dematerialization," the imbrication of objects in a world beyond their boundaries—an ecology of things—was apparent in Jasper Johns's paintings of the mid 1950s. For recent art-historical studies that apply systems theory to postwar art, see Pamela M. Lee, *Chronophobia: On Time and the Art of the 1960s* (Cambridge: MIT Press, 2004); Branden W. Joseph, *Random Order: Robert Rauschenberg and the Neo-Avant-Garde* (Cambridge: MIT Press, 2003); and Reinhold Martin, *The Organizational Complex: Architecture, Media and Corporate Space* (Cambridge: MIT Press, 2003).

2. Later in this chapter I discuss Herbert Marcuse's analysis of a "second nature" of commodities.

3. Susan Sontag, "The Image-World," in *On Photography* (New York: Dell, 1977), p. 180.

4. I think Sontag is using this evocative metaphor rather loosely. Earlier in the same essay she comes closer to the kind of position I am advocating in speaking of recycling: "Photography does not simply reproduce the real, it recycles it—a key procedure of modern society. In the form of photographic images, things and events are put to new uses, assigned new meanings, which go beyond the distinctions between the beautiful and the ugly, the true and the false, the useful and the useless, good taste and bad." Ibid., p. 174. And in reflecting on *On Photography* in 2003, she acknowledged the impossibility of her earlier statement, declaring, "There isn't going to be an ecology of images." And yet I feel the concept of a media ecology remains worth interrogating. Susan Sontag, *Regarding the Pain of Others* (New York: Farrar, Straus and Giroux, 2003), p. 108.

5. Nam June Paik, "Media Planning for the Postindustrial Society," ed. Alan Marlin (1976), reprinted in *The Electronic Super Highway: Travels with Nam June Paik* (Courtesy Holly Solomon Gallery and Hyundai Gallery, dist. Carl Solway Gallery, published in conjunction with the Ft. Lauderdale Museum of Art, 1997), p. 45. This was one of three reports written for the Rockefeller Foundation.

6. As George Fifield recounts,

> Paik introduced Barzyk to Howard Klein at the Rockefeller Foundation, who had seen the importance of this new medium some time before. Klein had already worked with a number of artists and institutions, like Paik and KQED in San Francisco, funding video experimentation. When he added WGBH and later WNET in New York to the process, he was able to design an entire program, the Rockefeller Artists-in-Television Project, to cover the various grants. It was funded by the Rockefeller Foundation from 1967 through 1970. It was replaced by "The WGBH Project for New Television" and in 1974 it became the "WGBH New Television Workshop."

Barzyk produced works by many important artists during his long tenure at WGBH. See George Fifield, "The WGBH New Television Workshop," in *Fred Barzyk: The Search for a Personal Vision*

in Broadcast Television (Milwaukee: Patrick and Beatrice Haggerty Museum of Art, Marquette University, 2001), p. 64. The other essays in this catalogue are also useful in recounting the history of the Workshop. See also Fred Barzyk, "TV as Art as TV," *Print* 26, no. 1 (January/February 1972): 20–29.

7. In an untitled text, written in 1965 and published in 1966 by the Something Else Press, reprinted in *Videa 'n' Videology: Nam June Paik (1959–1973),* ed. Judson Rosebush (Syracuse: Everson Museum of Art, 1974), unpaginated, Paik concludes by proclaiming, "The Buddhists also say/ Karma is samsara/Relationship is metempsychosis/**We are in open circuits**" (boldface in source).

8. Nam June Paik, "Nam June Paik: The Cathode-Ray Canvas," interview in Douglas Davis, *Art and the Future: A History/Prophecy of the Collaboration between Science, Technology, and Art* (New York: Praeger, 1973), p. 150.

9. Marshall McLuhan, *Understanding Media: The Extensions of Man,* with an introduction by Lewis H. Lapham (1964; reprint, Cambridge: MIT Press, 1994), p. 64.

10. Adrian Piper made a series of works in the early 1970s that she referred to collectively as "Performance Catalysis on the Street and in the World," in which she sought to provoke reaction through a series of anonymous actions such as *"Catalysis 1,* in which I saturated a set of clothing in a mixture of vinegar, eggs, milk, and cod liver oil for a week, then wore it on the D train during evening rush hour, and while browsing in the Marlboro bookstore on Saturday night." Adrian Piper, *Out of Order, Out of Sight,* vol. 1, *Selected Writings in Meta-Art 1968–1992* (Cambridge: MIT Press, 1996), p. 42; see also pp. 25–156.

11. It may be that I have not sufficiently credited public television experiments like those of KQED, WGBH, and WNET in this book. If that is so, it is because I have been drawn to guerrilla efforts that challenge or undermine the television system or apparatus as a whole. As important as public TV programs were in helping artists to produce works, they kept video art in the already existing category of cultural programming, thus renovating while respecting the status quo. As Fred Barzyk himself symptomatically stated, "I got into an aesthetic argument with our senior producer/director about WGBH's coverage of the Boston Symphony concerts. Why couldn't the cameras paint pictures instead of showing old men blowing horns and bowing violin strings?" Fred Barzyk, "Paik and the Video Synthesizer," in *Fred Barzyk: The Search for a Personal Vision in Broadcast Television,* p. 73. And in "TV as Art as TV," published in 1972, he suggests that video's entry into television might correspond to its entry into the traditional role of the artwork: "it is quite conceivable that an abstract video-art composition may one day command as large a sum on the gallery auction block as a Jackson Pollock or a Jasper Johns. The Leo Castelli Galleries in New York has [*sic*] already sold several private videotapes to collectors. When one considers the reproduction rights advantages of an 'original' or master tape, the prospects for monetary gain become immensely appealing" (29).

12. Many of the earliest of these works, including *TV Sea* (1974), *TV Garden* (1974, first version), and *Video Fish* (1975–1977), made explicit reference to ecological systems.

13. This is a single-channel videotape made for broadcast on Boston's PBS station, WGBH.

14. Gregory Bateson, "Pathologies of Epistemology" (1969; 1972), in *Steps to an Ecology of Mind* (Chicago: University of Chicago Press, 1972), p. 490.

15. W. J. T. Mitchell implies such a project in passing: "Perhaps, then, there is a way in which we can speak of the value of images as evolutionary or at least coevolutionary entities, quasi life-forms (like viruses) that depend on a host organism (ourselves), and cannot reproduce themselves without human participation." W. J. T. Mitchell, *What Do Pictures Want? The Lives and Loves of Images* (Chicago: University of Chicago Press, 2005), p. 87. See also McKenzie Wark's discussion of the vector as a kind of information virus, McKenzie Wark, "Vector," *A Hacker Manifesto* (Cambridge: Harvard University Press, 2004), paragraphs 313–345, unpaginated.

16. Nam June Paik, "An Interview with Nam June Paik," interview by Nancy Miller, in *The Color of Time: Video Sculpture by Nam June Paik* (Waltham: Rose Art Museum, 1984), unpaginated.

17. Marcel Duchamp, "The Green Box," in *Salt Seller: The Writings of Marcel Duchamp*, ed. Michel Sanouillet and Elmer Peterson (New York: Oxford University Press, 1973), 32.

18. William S. Burroughs, *The Ticket That Exploded* (1962; reprint, New York: Grove Press, 1967), pp. 49–50.

19. I will discuss video and televisual techniques of feedback extensively in chapter 3.

20. Some of these audio experiments were collaborations with Ian Sommerville and Antony Balch. Burroughs, Balch, and Brion Gysin also made a series of films in the mid sixties, including *Towers Open Fire* (1964) and *The Cut Ups* (c. 1966), in which the audio playback model is realized in cinematic form. Burroughs always credited Brion Gysin with inventing the cut-up method. See Barry Miles, *El Hombre Invisible: William Burroughs, a Portrait* (London: Virgin Books, 2002). For texts related to the cut-ups, see William S. Burroughs and Brion Gysin, *The Third Mind* (New York: Seaver Books, 1978), a good deal of which was published much earlier, between 1960 and 1973.

21. This is one of Burroughs's and Gysin's objectives in the cut-up method. See for instance Gysin's prose poem in which the phrase is repeated over and over in different permutations, in Burroughs and Gysin, *The Third Mind*, p. 83.

22. William S. Burroughs, *Electronic Revolution*, 10th ed. (1970; Bonn: Expanded Media Editions, 1998), pp. 21–22.

23. Burroughs, *The Ticket That Exploded*, p. 215.

24. Jasper Johns, sketchbook entry, "Book B, c. 1967," in *Jasper Johns: Writings, Sketchbook Notes, Interviews,* ed. Kirk Varnedoe, compiled by Christel Hollevoet (New York: Museum of Modern Art; dist. Harry N. Abrams, 1996), p. 61.

25. For an excellent history of Duchamp's successive "re-issues" of *Fountain*, see William A. Camfield, *Marcel Duchamp Fountain* (Houston: Menil Collection; Houston Fine Art Press, 1989). I discuss this aspect of the readymade in my essay "Dada's Diagrams," in Leah Dickerman and Matthew S. Witkovsky, eds., *The Dada Seminars* (Washington, DC: Center for Advanced Study in the Visual Arts, National Gallery of Art, in association with D.A.P./Distributed Art Publishers, 2005).

26. Johns, sketchbook entry in *Jasper Johns: Writings*, p. 49.

27. Paik, "An Interview with Nam June Paik," n.p.

28. Paik, "Nam June Paik: The Cathode-Ray Canvas," p. 150.

29. Nam June Paik, "Experiments with Electronic Pictures," *Fylkingen International Bulletin 2* (1967): 38, 39.

30. "Marcel Duchamp a tout fait sauf la vidéo. Il a fait une grande porte d'entrée et une toute petite porte de sortie. Cette porte-là, c'est la vidéo. C'est par elle que vous pouvez sortir de Marcel Duchamp." "Entretien avec Nam June Paik," interview by Irmeline Leeber, *Chroniques de l'art vivant* 55 (February 1975): 33. For another account of the relationship between television and the post-war tradition of art, which traces the image of TV through various aesthetic manipulations, see John Alan Farmer, "Pop People," in Farmer, *The New Frontier: Art and Television 1960–65* (Austin: Austin Museum of Art, 2000), pp. 17–67.

31. "A Conversation with Nam June Paik," interview with David Ross, in Toni Stooss and Thomas Kellein, eds., *Nam June Paik: Video Time—Video Space* (New York: Harry N. Abrams, 1993), p. 58.

32. Gregory Battcock, "Disaster in New York," reprinted in Battcock, ed., *New Artists Video: A Critical Anthology* (New York: E. P. Dutton, 1978), p. 133.

33. Quoted in Nam June Paik, "Abstract Time," interview with Paul Schimmel, in Battcock, ed., *New Artist's Video*, p. 127.

34. "Ce qui était surtout intéressant c'étaient les rapports entre le corps de Charlotte Moorman et l'appareillage TV. Lorsque deux américains comme Moorman et la TV font l'amour ensemble, on ne peut pas rater ça." Paik, "Entretien avec Nam June Paik," p. 33.

35. Donna Haraway, "The Biopolitics of Postmodern Bodies: Determinations of Self in Immune System Discourse," *Differences: A Journal of Feminist Cultural Studies* 1, no. 1 (1988): 4. For a complementary argument about the relationship between immune systems, and new flexible models of subjectivity and economic production, see Emily Martin, *Flexible Bodies: The Role of Immunity in American Culture from the Days of Polio to the Age of AIDS* (Boston: Beacon Press, 1994).

36. Katherine Hayles correlates the shift from the human to the posthuman in the mid twentieth century with a shift in the nature of information from a presence to a pattern. As she writes, "The contemporary pressure toward dematerialization, understood as an epistemic shift toward pattern/randomness and away from presence/absence, affects human and textual bodies on two levels at once, as a change in the body (the material substrate) and as a change in the message (the codes of representation)." N. Katherine Hayles, *How We Became Posthuman: Virtual Bodies in Cybernetics, Literature, and Informatics* (Chicago: University of Chicago Press, 1999), p. 29.

37. George Kubler, *The Shape of Time: Remarks on the History of Things* (New Haven: Yale University Press, 1962), pp. 17–18.

38. My association of Kubler's passage with a media metaphor for history is reinforced by a later passage in which he imagines history as a kind of film: "Certain types of motion appear when we look

at time as an accumulation of nearly identical successive moments, drifting by minute changes towards large differences amassed over long periods. Motion is perhaps a misnomer for the changes occurring between early and later members of a series of replicas. Yet a series of objects, each made at a different time, and all related as replicas based upon the same original form, describe through time an appearance of motion like that of the frames of a film, recording the successive instants of an action, which produce the illusion of movement as they flicker past the beam of light." Ibid., pp. 75–76. See also Pamela M. Lee, "Ultramoderne: Or, How George Kubler Stole the Time in Sixties Art," chap. 4 of *Chronophobia*.

39. See Judith Butler, *Gender Trouble: Feminism and the Subversion of Identity* (New York: Routledge, 1990).

40. Duchamp famously called his *Large Glass* a "delay" in glass.

41. For historical accounts of the Summer of Love, see Charles Perry, *The Haight-Ashbury: A History* (New York: Random House, 1984); Joel Selvin, *Summer of Love* (New York: Cooper Square Press, 1994); Barney Hoskyns, *Beneath the Diamond Sky: Haight-Ashbury 1965–1970* (New York: Simon & Schuster, 1997); and Peter Braunstein and Michael William Doyle, eds., *Imagine Nation: The American Counterculture of the 1960s and '70s* (New York: Routledge, 2002). For important recent contributions to the visuality of psychedelia, see Cristoph Grunenberg, *Summer of Love: Art of the Psychedelic Era* (London: Tate Publishing, 2005).

42. Allen Ginsberg, Timothy Leary, Gary Snyder, and Alan Watts, "Changes," in Jesse Kornbluth, ed., *Notes from the New Underground* (New York: Viking Press, 1968), p. 121. (Originally published in *San Francisco Oracle*, February 1967.)

43. Ibid., pp. 123, 150.

44. "The Death of the Hippie," in Kornbluth, *Notes from the New Underground*, p. 266.

45. While I admire the Diggers' politics in most regards, their "primitivizing" association of African and tribal peoples with a virulent pre-imagistic world is jarring. It underlines the dearth of African Americans in the hippie subculture.

46. T. J. Clark, *Farewell to an Idea: Episodes from a History of Modernism* (New Haven: Yale University Press, 1999), p. 291.

47. Ibid., p. 257.

48. Herbert Marcuse, *An Essay on Liberation* (Boston: Beacon Press, 1969), p. 11.

49. Nam June Paik, "Expanded Education for the Paper-less Society," in *Videa 'n' Videology*, unpaginated.

50. See "The Decline and Fall of the Spectacle-Commodity Economy" (December 1965), in Ken Knabb, ed. and trans., *Situationist International Anthology* (Berkeley: Bureau of Public Secrets, 1981), pp. 153–166.

51. For an excellent general account of the Diggers' varied activities, see Bradford D. Martin, "The Diggers: Politicizing the Counterculture," chap. 3, *The Theater Is in the Street: Politics and Public Performance in Sixties America* (Amherst: University of Massachusetts Press, 2004), pp. 86–125. For

an important account of the Diggers in the context of guerrilla theater, see Michael William Doyle, "Staging the Revolution: Guerrilla Theater as a Countercultural Practice 1965–68," in Braunstein and Doyle, eds., *Imagine Nation,* pp. 71–97.

52. See Emmett Grogan, *Ringolevio* (Boston: Little, Brown, 1972, Edinburgh: Rebel Inc, 1999), pp. 311–313.

53. Thomas Frank, *The Conquest of Cool: Business Culture, Counterculture, and the Rise of Hip Consumerism* (Chicago: University of Chicago Press, 1997).

54. "Trip without a Ticket," www.diggers.org/digpaps68/twatdp.html.

55. Ibid.

56. Ibid.

57. Aldous Huxley, *The Doors of Perception* and *Heaven and Hell* (New York: Harper & Row, 1954), pp. 21–22.

58. Timothy Leary, Ralph Metzner, and Richard Alpert, *The Psychedelic Experience: A Manual Based on the Tibetan Book of the Dead* (Seacaucus, NJ: Citadel Press, 1964), p. 61.

59. The best account of expanded media in this period remains Gene Youngblood, *Expanded Cinema,* with an introduction by R. Buckminster Fuller (New York: E. P. Dutton, 1970).

60. Tom Wolfe, *The Electric Kool-Aid Acid Test* (New York: Bantam, 1969), 52.

61. Quoted in Paul Perry, *On the Bus: The Complete Guide to the Legendary Trip of Ken Kesey and the Merry Pranksters and the Birth of the Counterculture,* ed. Michael Schwartz and Neil Ortenberg (New York: Thunder's Mouth Press, 1990), p. 56.

62. Ibid., p. 102.

63. Robert Santelli, *Aquarius Rising: The Rock Festival Years* (New York: Dell Publishing, 1980), p. 149.

64. Stan Brakhage, *Essential Brakhage: Selected Writings on Filmmaking,* ed. Bruce R. McPherson (Kingston, NY: McPherson, 2001), p. 29.

65. Stan Brakhage, "Hypnagogically Seeing America," *Los Angeles Free Press* (February 3, 1967), in *Brakhage Scrapbook: Collected Writings 1964–1980,* ed. Robert A. Haller (New Paltz, NY: Documentext, 1982), p. 104.

66. See Timothy Leary, *The Politics of Ecstasy* (1965; reprint, New York: College Notes & Texts, 1968).

67. Nam June Paik, "Video Synthesizer Plus," in *Videa 'n' Videology,* unpaginated. In the anthology, the citation for this text indicates it was published in 1970 in *Radical Software* 2, but I have not found it in that journal, causing me to question the date as well. Since the anthology was published in 1974, this text must have been written before then, but I am unclear whether it was published elsewhere.

68. Nam June Paik, quoted in "GLOBAL GROOVE, an Interview with Nam June Paik on His TV Opera," *Cantrills Filmnotes,* no. 20 (December 1974): 8.

69. For the standard account of the counterculture as a response to technocratic society, see Theodore Roszak, *The Making of a Counter Culture: Reflections on the Technocratic Society and Its Youthful Opposition* (Berkeley: University of California Press, 1968).

70. Hannah Arendt, *Crises of the Republic* (1969; reprint, San Diego: Harcourt Brace, 1972), pp. 137–138.

71. In making this claim, I am inspired by conversations with Maria Gough about the persistence of the forms and ideals of Russian constructivism despite its ostensible political failure. For her beautiful accounting of this history, see her *The Artist as Producer: Russian Constructivism in Revolution* (Berkeley: University of California Press, 2005).

3 FEEDBACK

1. The term "Media-America" calls to mind Oskar Negt and Alexander Kluge's important work on television's commodification and alienation of public experience. They write,

> Whether intentionally or not, collective experience is organized in television. In the present situation [German TV c. 1972], contact with this experience, via the screen and programming, is not available. But even apart from the fact that there is as yet no medium for the playback of this experience, one essential organizational element is lacking: what can viewers do with the reproduction of their own experience when their immediate needs relate to the libidinal compensation of the alienated labor process and are not oriented by knowledge of the world?

In this subtle passage, Negt and Kluge assert that collective experience, as organized by television, is a misrepresentation to which access (or "playback") is blocked, in part because, as they explain in a footnote, it would require an impossible grasp on the entire history of television's abstraction of experience, available to no individual viewer. But they also suggest that even "authentic" experience is unavailable to representation (if indeed such a possibility existed) because it is distorted or negated by the primary alienation of capitalist labor. In other words, television results in a double alienation—that of labor in general and the labor of representation in particular. In Oskar Negt and Alexander Kluge, *Public Sphere and Experience: Toward an Analysis of the Bourgeois and Proletarian Public Sphere,* trans. Peter Labanyi, Jamie Owen Daniel, and Assenka Oksiloff, with a foreword by Miriam Hansen (Minneapolis: University of Minnesota Press, 1993), p. 127. Originally published in German in 1972.

2. Michael Shamberg and Raindance Corporation, *Guerrilla Television* (New York: Holt, Rinehart and Winston, 1971), p. 29.

3. Nor has this situation been adequately addressed in the present. See, for instance, Herman S. Gray, *Cultural Moves: African Americans and the Politics of Representation* (Berkeley: University of California Press, 2005), and Herman S. Gray, *Watching Race: Television and the Struggle for "Blackness"* (Minneapolis: University of Minnesota Press, 1995). Although I focus here on the case of African Americans, similar arguments can be made for other people of color, including Asian Americans and Latinos, as well as sexual minorities like lesbians and gay men. I narrow my perspective

not only out of practicality, but also because racial difference in the United States is habitually reduced to a black-white opposition, as I discuss in the concluding section of this chapter.

4. Harold Cruse, "Rebellion or Revolution? I," in *Rebellion or Revolution?* (New York: William Morrow, 1968), pp. 110–111.

5. "All Black People Got to Seize the Time for Unity!" *Black Panther* 8, no. 6 (April 29, 1972): 16.

6. I discuss this report in the last section of this chapter.

7. "All Black People," p. 17.

8. Ralph Lee Smith, "The Wired Nation," *Nation* 210, no. 19 (May 18, 1970): 582.

9. See, for example, Ralph Engelman, *Public Radio and Television in America: A Political History* (Thousand Oaks, CA: SAGE Publications, 1996), especially pp. 235–245.

10. [Michael Shamberg], "The Medium: Taking Waste Out of the Wasteland," *Time* 93, no. 22 (May 30, 1969): 74.

11. Frank Gillette and Ira Schneider, *"Wipe Cycle,"* in *TV as a Creative Medium,* exh. cat. (New York: Howard Wise Gallery, 1969), unpaginated.

12. Marco Vassi, "Zen Tubes," *Radical Software* 1, no. 1 (Summer 1970): 18.

13. These are both video collectives. For more on the Videofreex, see Parry D. Teasdale, *Videofreex: America's First Pirate TV Station & the Catskills Collective That Turned It On* (Hansonville, NY: Black Dome Press Corp., 1999), and Videofreex, *The Spaghetti City Video Manual: A Guide to Use, Repair, and Maintenance* (New York: Praeger, 1973).

14. Jud Yalkut, "Frank Gillette and Ira Schneider, Parts I and II of an interview," *Radical Software* 1, no. 1 (Summer 1970): 9.

15. Nam June Paik, "Expanded Education for the Paperless Society," *Radical Software* 1, no. 1 (Summer 1970): 7.

16. The Raindance or *Radical Software* perspective in which video may play a therapeutic role is the usually suppressed complement to Rosalind Krauss's still highly influential account of video as a pure form of (pathological) narcissism in her watershed essay of 1976, "Video: The Aesthetics of Narcissism," *October,* no. 1 (Spring 1976). In this essay Krauss suggests that Vito Acconci's *Centers* (1971), in which the artist videotapes himself pointing to the center of the screen by tracking himself in the "mirror" of the playback monitor, manifests "a narcissism so endemic to works of video that I find myself wanting to generalize it as *the* condition of the entire genre" (51). This rhetorical flourish has caused a thirty-year misrecognition of video as narcissistic. In Krauss's terms, narcissism emerges from the conditions of mirror-reflection as opposed to the critical self-reflexivity that characterizes painting by artists such as Jasper Johns: "Mirror-reflection . . . implies the vanquishing of separateness. Its inherent movement is toward fusion. The self and its reflected image are of course literally separate. But the agency of the reflection is a mode of appropriation, of illusionistically erasing the difference between subject and object" (pp. 56–57). In actuality, this condition is

quite rare in video art, as Krauss's own examples in the second half of her essay demonstrate. She adduces three critical practices of video: "1) tapes that exploit the medium in order to criticize it from within; 2) tapes that represent a physical assault on the video mechanism in order to break out of its psychological hold; and 3) installation forms of video which use the medium as a sub-species of painting or sculpture"—that exist outside the closed circuit of narcissism (59). The preponderance of her discussion of actual art objects thus demonstrates that, as I am arguing, video art heightens the difference between a person and her image rather than eliding them. Even her dismissal of Acconci is made on false grounds: in pointing at the monitor *in the course of producing the tape,* he creates an image in which he is pointing *out at the viewer.* Rather than performing a narcissistic elision, Acconci stages a very public interpellation of the viewer, who in occupying the position where the monitor would have been during the videotaping of the work, is pointed at by the artist in her act of viewing. It is time to recognize Krauss's seductive metaphor as inadequate, even to her own analysis. The artists and theorists associated with *Radical Software* emphasized this other dimension of the video mirror. They produced a reading of "narcissism" diametrically opposed to Krauss's.

17. Shamberg, *Guerrilla Television*, p. 12. The "mass media therapy" Shamberg recommends was enthusiastically embraced by several figures associated with *Radical Software*. Paul Ryan, for instance, advocated a process of "infolding" by which one could see and incorporate one's behavior objectively by watching it on videotape. In "Cable Television: The Raw and the Overcooked," an essay published in *Radical Software* 1, no. 1 (Summer 1970), Ryan explained his technique:

> Working with encounter group leader, Dennis Walsh, I videotaped while a girl stood in the middle of the group with her eyes closed and described how she thought people were re-acting to her then and there. The contrast between her negative description and the posi-tive responses to her that the playback revealed were both illuminating and encouraging for her. This was information infold. What she and the group put out was taken by the tape and given back to them. (12)

While a videotaped encounter group is far from being a work of art, Ryan's notion of infolding is useful as an alternative model of the relation between video and narcissism. Here the videotape *releases* a subject from the closed circuit of her self rather than causing her to collapse into it. Ryan's notion of infolding also sheds light on Marco Vassi's analogy between video and LSD that I quoted above. Like Ryan's therapeutic videotape, an acid trip both dissolves the boundaries of the self and offers it back as an object. Many of the writers who published in *Radical Software* saw video's capacity to mirror back and therefore objectify experience as the prelude to political action. Community video was praised as an organizing tool in Dorothy Henaut and Bonnie Kline's "In the Hands of Citizens: A Video Report," in the first number of the journal. Recounting the collaboration between the video group Challenge for Change and the Comité des Citoyens de Saint-Jacques in downtown Montreal, they declared, "Having seen people like themselves on the familiar TV screen, discussing their problems with utter frankness, removed much of the reticence and timidity people have in a group of strangers. They simply said, 'I guess this is the place where I can talk freely,' and talked at length of problems shared and possible collective solutions." (Dorothy Henaut and Bonnie Kline, "In the Hands of Citizens: A Video Report," *Radical Software* 1, no. 1 [1970]: 11.) *Radical*

Software's utopian embrace of video—the journal's discussion of art and activism under a single umbrella—offers a different perspective on the question of medium and media. Those Raindance members who were identified as artists have been sorted into one category and activists were put into another, whereas in reality they were deploying the same form—closed-circuit video—in different (and differently capitalized) social settings.

18. Quoted in Ingrid Wiegand, "TVTV Turns Its Camera on the Rest of Us," *Village Voice* (May 17, 1976), quoted in Deirdre Boyle, *Subject to Change: Guerrilla Television Revisited* (Oxford: Oxford University Press, 1997), p. 174.

19. Indeed, in *The Big Chill,* scenes of watching TV together—ranging from late-night movies to a University of Michigan football game (the group met in college at Michigan), as well as the more self-conscious use of home videos—structure and punctuate the social interactions of the weekend reunion.

20. Shamberg, *Guerrilla Television*, p. 29.

21. For a useful discussion of the difference between the more passive "audience" and the more active notion of a public constituted from some collective identification, see Martha Rosler, "On the Public Function of Art," in Hal Foster, ed., *Discussions in Contemporary Culture*, no. 1 (Seattle: Bay Press, 1987), pp. 9–15.

22. On the concept of the imagined community, see Benedict Anderson, *Imagined Communities: Reflections on the Origin and Spread of Nationalism,* 2d ed. (London: Verso, 1991); and on narrowcasting based on identity, see Gray, *Television and the Struggle for "Blackness."* For Jacques Rancière's cogent critique of what he calls "the identification of politics with the *self* of a community" (64), see Jacques Rancière, "Politics, Identification, and Subjectivization," in John Rajchman, ed., *The Identity in Question* (New York: Routledge, 1995), pp. 63–70.

23. Lizabeth Cohen, *A Consumer's Republic: The Politics of Mass Consumption in Postwar America* (New York: Vintage Books, 2003), p. 302.

24. My argument that video's medium might be understood as the public is in contrast to Rosalind Krauss's notion of narcissism as the medium of video. See note 16 for a more detailed discussion of her canonical text "Video: The Aesthetics of Narcissism." I would further argue that even ostensibly arcane practices like conceptual art are directed toward addressing new publics through their use of text and photography, the very "media" of public speech in a "society of the spectacle."

25. Dan Graham, "Time Delay Room 5 1974," first published in *Control Magazine*, no. 9 (1975): 7. Reprinted in *Dan Graham: Works 1965–2000,* ed. Marianne Brower (Düsseldorf: Richter Verlag, 2001), p. 153.

26. Free [Abbie Hoffman], *Revolution for the Hell of It* (New York: Dial Press, 1968), p. 59.

27. Hoffman's surprising conjunction of Warhol and Castro is not unprecedented. In 1965 Warhol, along with his collaborator, "screenwriter" Ronald Tavel, made a movie called *The Life of Juanita Castro,* loosely based on the diaries of the revolutionary's sister that had recently been published

in *Life* magazine. Later, in 1970, Gregory Battcock published an essay that compared Castro's stance toward democratizing education to the complex politics of Warhol's art. See Gregory Battcock, "The Warhol Generation," *Other Scenes* 4, no. 9 (November 1970), reprinted in Battcock, ed., *The New Art: A Critical Anthology* (New York: E. P. Dutton, 1973), pp. 21–28. I am indebted to Branden Joseph for suggesting the connection with *The Life of Juanita Castro*.

28. For an excellent account of Hoffman's media politics, see Aniko Bodroghkozy, "'Every Revolution-ary Needs a Color TV': The Yippies, Media Manipulation and Talk Shows," chap. 4 of *Groove Tube: Sixties Television and the Youth Rebellion* (Durham: Duke University Press, 2001), pp. 98–122. David Farber's account of the 1968 Democratic convention in Chicago provides one of the most exhaustive histories of the development of Yippie activism. See David Farber, *Chicago '68* (Chicago: University of Chicago Press, 1988).

29. Daniel J. Boorstin, *The Image: A Guide to Pseudo-Events in America* (New York: Vintage Books, 1961), p. 11.

30. This action took place in August of 1967, before the official birth of the Yippie movement in early 1968, but it is nonetheless exemplary of their subsequent strategies. For an account of the event, see Jonah Raskin, *For the Hell of It: The Life and Times of Abbie Hoffman* (Berkeley: University of California Press, 1996), pp. 114–115.

31. Hoffman was charged with conspiring to cause a riot along with Rennie Davis, Tom Hayden, David Dellinger, Bobby Seale, Jerry Rubin, Lee Weiner, and John Froines.

32. Hoffman, *Revolution for the Hell of It,* pp. 133–134.

33. Ibid., p. 80.

34. For a fascinating discussion of information patterning and subjectivity, see N. Katherine Hayles, "Virtual Bodies and Flickering Signifiers," chap. 2 of *How We Became Posthuman: Virtual Bodies in Cybernetics, Literature, and Informatics* (Chicago: University of Chicago Press, 1999), especially pp. 25–49. Norbert Wiener writes, "A pattern is a message, and may be transmitted as a mes-sage. How else do we employ our radio than to transmit patterns of sound, and our television set than to transmit patterns of light?" Norbert Wiener, *The Human Use of Human Beings: Cybernetics and Society* (New York: Da Capo Press, 1950), p. 96.

35. Shamberg, *Guerrilla Television,* p. 12.

36. Ibid., p. 27.

37. David Farber analyzes this contradiction in "Inside Yippie!," chap. 8 of *Chicago '68*, pp. 211–225.

38. See Todd Gitlin, *The Whole World Is Watching: Mass Media in the Making and Unmaking of the New Left* (Berkeley: University of California Press, 1980).

39. Hoffman, *Revolution for the Hell of It*, p. 80.

40. Andy Warhol, *The Philosophy of Andy Warhol (From A to B and Back Again)* (London: Cassell, 1975), p. 5.

41. Ibid., p. 91.

42. Indeed, I think Warhol was acutely aware of the differences between film and television, not only on account of their different visual characteristics, but also due to their distinct modes of presentation: theatrical on the one hand and domestic on the other. Some of these distinctions are elaborated in his double-screen film *Outer and Inner Space* (1965), in which Edie Sedgwick "performs" before a television monitor carrying videotape of her own image. For discussions of the relationship between film and television in Warhol's work, see Callie Angell, "Andy Warhol, Filmmaker," in *The Andy Warhol Museum* (Pittsburgh: Andy Warhol Museum, 1994), pp. 121–145; and Branden W. Joseph, "Nothing Special: Andy Warhol and the Rise of Surveillance," in Thomas Y. Levin, Ursula Frohne, and Peter Weibel, eds., *CTRL[SPACE]: Rhetorics of Surveillance from Bentham to Big Brother* (Cambridge: MIT Press, 2002), pp. 119–133. Angell discusses *Outer and Inner Space* in *CTRL[SPACE]*, pp. 278–281.

43. On *a: a novel*, see Liz Kotz, "An Aesthetics of the Index?" in *Dia's Andy* (New York: Dia Art Foundation, 2004), pp. 88–93; Michael Krapp, "Andy's Wedding: Reading Warhol," in Krapp, *Déjà Vu: Aberrations of Cultural Memory* (Minnesota: University of Minnesota Press, 2004), pp. 71–95; Lynne Tillman, "The Last Words Are Andy Warhol," *Grey Room* 21 (Fall 2005): 38–45; and Craig Dworkin, "Whereof One Cannot Speak," *Grey Room* 21 (Fall 2005): 46–69. This recent work on *a: a novel* proposes a number of interesting ways to see the book in terms of its manifestation of an intimate and even erotic relationship with technology; how it stages a very fragile emergence of signification from informational "noise"; how telephonic communication, to which Warhol was addicted, might be a model for *a*'s assault on narrative; and how one might make an analogy between this book and musical scores (or musical performance via the frequent discussion of opera and particularly Maria Callas in *a*).

44. Warhol, *The Philosophy of Andy Warhol*, p. 26.

45. Andy Warhol, *a: a novel* (New York: Grove Press, 1968), p. 116.

46. According to David Bourdon's clear account, the early chronology runs as follows. Warhol first appeared with the Velvet Underground and Nico at a meeting of the New York Society for Clinical Psychiatry in January 1966. In February, as ANDY WARHOL, UP-TIGHT, he presented the Velvet Underground and others in his circle at the Cinémathèque in New York. In March performances occurred at Rutgers in New Jersey and the University of Michigan. Then, in April the Exploding Plastic Inevitable emerged in its run at the Dom, a big meeting hall on St. Marks Place in New York. The EPI later traveled to Los Angeles and San Francisco. For the purpose of this discussion, I'm drawing accounts from different moments of the Velvet Underground/Warhol collaboration in order to describe its visual mechanisms. See David Bourdon, *Warhol* (New York: Harry N. Abrams, 1989), pp. 218–237. This argument is derived from my "Yippie Pop: Abbie Hoffman, Andy Warhol, and Sixties Media Politics," *Grey Room* 8 (Summer 2002): 62–79. See also Branden Joseph, "'My Mind Split Open': Andy Warhol's Exploding Plastic Inevitable," *Grey Room* 8 (Summer 2002), 80–107.

47. Jonas Mekas, "More on Strobe Light and Intermedia," June 16, 1966 reprinted in Jonas Mekas, *Movie Journal: The Rise of a New American Cinema, 1959–1971* (New York: Macmillan, 1972), p. 246.

48. Victor Bockris and Gerard Malanga, *Up-Tight: The Velvet Underground Story* (New York: Quill/ Omnibus Press, 1983), p. 28.

49. Raskin, *For the Hell of It,* p. 85. These are Raskin's characterizations.

50. Such a shift in the ground of sovereignty to the very substance of "bare life" is theorized by Giorgio Agamben in *Homo Sacer: Sovereign Power and Bare Life,* trans. Daniel Heller-Roazen (Stanford: Stanford University Press, 1998). (Originally published in Italian in 1995.)

51. Jonas Mekas, "On the Plastic Inevitables and the Strobe Light" (May 26, 1966), reprinted in Mekas, *Movie Journal,* p. 242.

52. Warhol said he had been asked to transport the EPI "scene" to a commercial disco on Long Island that was to be called Murray the K's World, after the famous New York disc jockey. See Andy Warhol and Pat Hackett, *Popism: The Warhol Sixties* (San Diego: Harcourt Brace, 1980), p. 144.

53. "Superstar" was Warhoi's term for the most favored subjects of his films, who did not so much act as "be" in the film as self-authorizing presences.

54. Hoffman, *Revolution for the Hell of It,* p. 28.

55. Otto Kerner et al., *Report of the National Advisory Commission on Civil Disorders* (Washington, DC: U.S. Government Printing Office, March 1, 1968), pp. 210–211.

56. LeRoi Jones, "LeRoi Jones Talking" (1964), in *Home: Social Essays* (New York: William Morrow, 1966), pp. 184–185.

57. Ibid., p. 185.

58. Lerone Bennett Jr., "The Emancipation Orgasm: Sweetback in Wonderland," *Ebony* 26 (September 1971): 108. Bennett took a very critical view of the film *Sweet Sweetback's Baadasssss Song,* which he interpreted as the antithesis of the kind of directive image I will describe the work as later in this chapter. He writes, "*Sweet Sweetback* is neither revolutionary nor black. Instead of giving us new images of black rebels, it carries us back to antiquated white stereotypes, subtly and invidiously identified with black reality" (112). I respectfully disagree with his judgment but wish to retain his concept—the directive image—in order to theorize *Sweetback*'s impact.

59. In Kerner et al., *Report of the National Advisory Commission on Civil Disorders,* the ideological tendency is to see the legitimate political claims for equality made by African Americans as little more than a black-white schism: "the coverage of the disorders—particularly on television—tended to define the events as black-white confrontations. In fact, almost all of the deaths, injuries, and property damage occurred in all-Negro neighborhoods, and thus the disorders were not 'race riots' as that term is generally understood" (202).

60. For Wallace's own account of the program, see Mike Wallace, with Gary Paul Gates, *Between You and Me: A Memoir* (New York: Hyperion, 2005), pp. 85–92.

61. On the history of the Black Power movement, see Jeffrey O. G. Ogbar, *Black Power: Radical Politics and African American Identity* (Baltimore: Johns Hopkins University Press, 2004), and Komozi Woodard, *A Nation within a Nation: Amiri Baraka (LeRoi Jones) & Black Power Politics* (Chapel Hill:

University of North Carolina Press, 1999). With regard to the civil rights movement and media, Sasha Torres makes the provocative argument that the rise of television and the rise of the civil rights movement are intimately linked. She writes, "There was much more connecting civil rights with television than the temporal coincidence between the rapid expansion of the southern movement and the similar growth in television's penetration and profits. One of [my] central arguments . . . is that from 1955 to 1965, both the civil rights movement and the television industry shared the urgent desire to forge a new, and newly *national*, consensus on the meanings and functions of racial difference." While I find this argument fascinating, Torres optimistically sidesteps television's tendency to treat any political claims by African Americans in terms of the black-white schism, as is abundantly clear in "The Hate That Hate Produced" (which, tellingly, Torres does not discuss) and which was still found egregiously present in coverage of civil disorders by the authors of the much later Kerner report. See Sasha Torres, *Black, White and in Color: Television and Black Civil Rights* (Princeton: Princeton University Press, 2003), p. 6.

62. William Strickland, *Malcolm X: Make it Plain* (New York: Viking, 1994), p. 84; and Ogbar, *Black Power,* p. 21.

63. *The Autobiography of Malcolm X,* as told to Alex Haley (New York: Ballantine, 1964), p. 249.

64. LeRoi Jones, "The Legacy of Malcolm X, and the Coming of the Black Nation" (1965), in *Home,* pp. 247–248

65. Bennett, "The Emancipation Orgasm," p. 110.

66. On Emory Douglas, see Erika Doss, "'Revolutionary Art Is a Tool for Liberation': Emory Douglas and Protest Aesthetics at the *Black Panther,*" in Kathleen Cleaver and George Katsiaficas, eds., *Liberation, Imagination, and the Black Panther Party: A New Look at the Panthers and Their Legacy* (New York: Routledge, 2001); and Elton C. Fax, "Emory Douglas," in *Black Artists of the New Generation* (New York: Dodd, Mead, 1977), pp. 256–278.

67. Amiri Baraka, "Black Art," in *Black Magic* (1969), reprinted in *Transbluesency: The Selected Poems of Amiri Baraka/LeRoi Jones (1961–1995),* ed. Paul Vangelisti (New York: Marsilio Publishers, 1995), p. 142.

68. These figures are quoted in one of the best accounts of *Sweet Sweetback* in the larger context of blaxploitation films: Ed Guerrero, "The Rise and Fall of Blaxploitation," chap. 3 of *Framing Blackness: The African American Image in Film* (Philadelphia: Temple University Press, 1993), pp. 69–111. The production costs and profits are mentioned on p. 86. Another excellent account of this genre is given by Mark A. Reid, "Black Action Film," chap. 4 of *Redefining Black Film* (Berkeley: University of California Press, 1993), pp. 69–91.

69. For an important account of outlaw modes of representation, see Richard Meyer, *Outlaw Representation: Censorship and Homosexuality in Twentieth-Century American Art* (Oxford: Oxford University Press, 2002). Meyer's premise throughout *Outlaw Representation* is that censorship must be viewed not as a zero-sum game where a particular artwork or series of works is absolutely repressed, but rather as a productive—if not always progressive—force for the generation of new images. He is acutely aware that in the act of suppressing an artwork, the censor causes it to

circulate in new ways—through, for instance, the newspaper, the courtroom slide show, or the agitprop brochure. This is a kind of involuntary or unintended media parasitism, as opposed to Van Peebles's intentional exploitation of differences in genre.

70. Melvin Van Peebles, *Sweet Sweetback's Baadasssss Song* (New York: Lancer Books, 1971), p. 20.

71. "If Brer is bored, he's bored. One of the problems we must face squarely is that to attract the mass we have to produce work that not only instructs but entertains." Ibid., p. 15.

72. Huey Newton, "He Won't Bleed Me: A Revolutionary Analysis of *Sweet Sweetback's Baadasssss Song*, with an Introduction by Bobby Seale," originally published in *The Black Panther,* June 19, 1971, reprinted in *To Die for the People: The Writings of Huey P. Newton,* with an introduction by Franz Schurmann (New York: Random House, 1972), p. 131.

73. Van Peebles, *Sweet Sweetback's Baadasssss Song,* pp. 12–13. Van Peebles continues that TV's resistance to progressive content is a result of its commercial dependence on sponsors. His criticism of the medium is informed by experience. In explaining how he put together the financing for *Sweetback,* he mentions that he thought to approach Bill Cosby for funds (which the actor offered) because "I had done one of Bill Cosby's television series" (64).

74. Ibid., p. 15.

4 AVATAR

1. All quotations are from Susanna McBee, "Victory—But the Fumes of Battle Fill the Air," *Life* 65, no. 10 (September 6, 1968): 26–27.

2. Samuel Weber writes of presence and transmission across distance, "What television transmits is not so much *images,* as is almost always argued. It does not transmit *representations* but rather *the semblance of presentation as such,* understood as the power not just to see and to hear but *to place before us.*" Samuel Weber, "Television: Set and Screen," in *Mass Mediauras: Form, Technics, Media,* ed. Alan Cholodenko (Sydney: Power Publications, 1996), p. 117.

3. Lee Friedlander, "The Little Screens," a photographic essay with a comment by Walker Evans, *Harper's Bazaar,* no. 3015 (February 1963): 126–129. All but one of the photos included showed only a face.

4. McBee, "Victory," p. 26.

5. Margaret Morse, "The Television News Personality and Credibility: Reflections on the News in Transition," in Tania Modleski, ed., *Studies in Entertainment: Critical Approaches to Mass Culture* (Bloomington: Indiana University Press, 1986), p. 64.

6. In my discussion of Eisenhower's use of television, I am greatly indebted to Craig Allen's excellent book *Eisenhower and the Mass Media: Peace, Prosperity, and Prime-Time TV* (Chapel Hill: University of North Carolina Press, 1993). In chap. 3, "Circumventing the Press, 1953–1955," Allen traces the development of the first televised press conference.

7. Quoted in Allen, *Eisenhower and the Mass Media,* p. 23.

8. Ibid., p. 65.

9. John F. Kennedy, "A Force That Has Changed the Political Scene," *TV Guide* 7, no. 46, issue 346 (November 14, 1959): 6.

10. The classic account of television's transformation of family space is Lynn Spigel, *Make Room for TV: Television and the Family Ideal in Postwar America* (Chicago: University of Chicago Press, 1992).

11. Kennedy, "A Force That Has Changed the Political Scene," pp. 6–7.

12. Ibid., p. 7. Allen also describes how the Republicans had a monetary advantage, heightened by their shrewd practice of buying airtime well in advance of election season, which greatly enhanced their use of television. See Allen, *Eisenhower and the Mass Media*, pp. 101–104.

13. Allen, *Eisenhower and the Mass Media*, pp. 33–34.

14. Ibid., p. 9

15. Marshall McLuhan, quoted in Joe McGinniss, *The Selling of the President* (New York: Penguin Books, 1969), pp. 184–185.

16. Ibid., p. 69.

17. Ibid., p. 85.

18. Kurt Lang and Gladys Engel Lang, *Politics and Television* (Chicago: Quadrangle Books, 1968), pp. 246–247.

19. Ibid., p. 209.

20. Ibid., p. 305.

21. Yve-Alain Bois has offered the most nuanced analysis of efforts and tactics for dissolving figure-ground distinctions in midcentury painting. See especially Bois, "The Limit of Almost," in *Ad Reinhardt* (Los Angeles: Museum of Contemporary Art; New York: Museum of Modern Art; New York: Rizzoli, 1991), and *Ellsworth Kelly: The Years in France, 1948–1954* (Washington, DC: National Gallery of Art, 1992).

22. John Ellis, *Visible Fictions: Cinema, Television, Video,* rev. ed. (London: Routledge, 1992), p. 145.

23. Of the sporting event, Samuel Weber writes, "No wonder that the sporting event has emerged, in the United States at least, as one of the central discursive paradigms for representing reality, be it political, economic or social. Ever since the Vietnam War, conflicts of all kinds, even the most brutal and violent, have been described—and televised—as though they were sporting events. If this age turns out to be that of American television—a conjecture, not a hope—then the televisual sporting event will undoubtedly stand as its allegorical emblem, leaving everything as open and shut as the instant replay with which the medium demonstrates its control of the event, if not of its outcome." Weber, "Television: Set and Screen," pp. 127–128.

24. Michael Curtin argues that cold war documentaries were structured around characterization. See Michael Curtin, *Redeeming the Wasteland: Television Documentary and Cold War Politics* (New Brunswick: Rutgers University Press, 1995), especially pp. 180–187.

25. Ellis, *Visible Fictions,* p. 156.

26. Ibid., pp. 155–156.

27. My argument here clearly echoes Max Horkheimer and Theodor W. Adorno's famous argument about Disney cartoons: "In so far as cartoons do any more than accustom the senses to the new tempo, they hammer into every brain the old lesson that continuous friction, the breaking down of all individual resistance, is the condition of life in this society. Donald Duck in the cartoons and the unfortunate in real life get their thrashing so that the audience can learn to take their own punishment." Adorno and Horkheimer, "The Culture Industry: Enlightenment as Mass Deception," in *Dialectic of Enlightenment,* trans. John Cumming (New York: Continuum, 1989), p. 138.

28. Avital Ronell, "Video/Television/Rodney King: Twelve Steps beyond the Pleasure Principle," in Gretchen Bender and Timothy Druckrey, eds., *Culture on the Brink: Ideologies of Technology* (Seattle: Bay Press, 1994), p. 286.

29. In Jacques Rancière's major work of political philosophy, *Dis-agreement: Politics and Philosophy,* trans. Julie Rose (Minneapolis: University of Minnesota Press, 1999), he elaborates the role of the police. For instance, he writes: "Politics is generally seen as the set of procedures whereby the aggregation and consent of collectivities is achieved, the organization of powers, the distribution of places and roles, and the systems for legitimizing this distribution. I propose to give this system of distribution and legitimization another name. I propose to call it *the police*" (28). But in his article "Politics, Identification, and Subjectivization," in John Rajchman, ed., *The Identity in Question* (London: Routledge, 1995), which I cite below, the term "policy" is used. This could derive from an ambiguity in French, where *la police* may signify either the police as a law enforcement organization or a kind of contract like an insurance policy. The term also explicitly engages with Michel Foucault's accounts of a systemic form of discipline that pervades modern societies. But the linguistic slippage may have been intentionally directed toward an American audience: in the opening lines of "Politics, Identification, and Subjectivization" (which is a published symposium paper), Rancière declares, "In a sense, the whole matter of my paper is involved in a preliminary question: In what language will it be uttered? Neither my language nor your language, but rather a dialect between French and English, a special one, a dialect that carries no identification with any group" (63). In correspondence with me, John Rajchman confirms that Rancière "came with his own peculiar language, not French, but not quite English either." E-mail correspondence, February 18, 2006.

30. This is Rancière's evocative description of the organization of a social world into intelligible identity positions. See Jacques Rancière, *The Politics of Aesthetics,* trans. and with an introduction by Gabriel Rockhill (London: Continuum, 2004), pp. 7–45. On the poor, Rancière writes in *Dis-agreement:* "There is politics when there is a part of those who have no part, a part or party of the poor. Politics does not happen just because the poor oppose the rich. It is the other way around: politics (that is, the interruption of the simple effects of domination by the rich) causes the poor to exist as an entity" (11).

31. Rancière, "Politics, Identification, and Subjectivization," p. 68.

32. Ibid.

33. Spigel, *Make Room for TV*, p. 158.

34. Ibid., pp. 162–163.

35. "Desilu Formula for Top TV: Brains, Beauty, Now a Baby," *Newsweek* 41, no. 3 (January 19, 1953): 56. Spigel also quotes from this text (*Make Room for TV*, p. 158).

36. Todd Gitlin uses the term "recombinant" to refer to certain television series that attempt to capitalize on proven formulas through minor variations. See Todd Gitlin, *Inside Prime Time*, rev. ed. (Berkeley: University of California Press, 2000), pp. 75–85.

37. As Aniko Bodroghkozy recounts, "relevance" in TV was an effort, largely driven by the desire to capture younger audiences, to address student and civil rights activism in TV narratives. As Bodroghkozy argues, however, this was often carried out through the rather unconvincing mouthpiece of an older, benevolent patriarch who *sympathizes* with youthful dissent while trying to bring it into the system. See "Make It Relevant: How Youth Rebellion Captured Prime Time in 1970 and 1971," in Aniko Bodroghkozy, *Groove Tube: Sixties Television and the Youth Rebellion* (Durham: Duke University Press, 2001), pp. 199–235. For a discussion of these developments, see Ella Taylor, *Prime Time Families: Television Culture in Postwar America* (Berkeley: University of California Press, 1989). In her analysis of these shows, Taylor makes a very interesting and important argument about how, on the one hand, characters come to represent social issues in series like *All in the Family* and, on the other, family intimacies migrate into the ostensibly public space of the workplace in series like the *Mary Tyler Moore Show.*

38. Patricia Mellencamp, "Situation Comedy, Feminism, and Freud: Discourses of Gracie and Lucy," in Joanne Morreale, *Critiquing the Sitcom: A Reader* (Syracuse: Syracuse University Press, 2003), p. 49.

39. Ellis, *Visible Fictions*, p. 140.

40. Ibid., pp. 169–170.

41. For a complex discussion of Michael Fried's notion of "presentness" and 1960s systems theory, see Pamela M. Lee, "Presentness Is Grace," chap. 1 of *Chronophobia: On Time in the Art of the 1960s* (Cambridge: MIT Press, 2004), pp. 36–81. In her nuanced analysis, Lee establishes an analogy between the instantaneity of perception that Fried associated with abstract painting in his canonical 1967 essay "Art and Objecthood" and the foreshortened or collapsed time of technological systems. This argument provides a context for my claim here that television may be understood as a form of "presentness."

42. Peter Campus, "sev" (1975), reprinted in *Peter Campus Video-Installationen, Foto-Installationen, Fotos, Videobänder* (Cologne: Kölnischer Kunstverein; Berlin: Neuer Berliner Kunstverein, 1979), p. 28.

43. For my discussion of Rosalind Krauss's influential account of video and narcissism, see chapter 3, note 16.

44. "Vito Acconci" (special issue), *Avalanche*, no. 6 (Fall 1972): 50.

45. Kathy O'Dell argues that masochistic performance art in the 1970s, including works by Vito Acconci, demonstrates a breach of the "social contract" during this era of the Vietnam War and iden-

tity-centered liberation movements. She suggests that such a breach is performed metaphorically through the traumatic psychic contract of masochism—what she calls a "contract with the skin." My argument about Acconci's violent and erotic rendering of the "contract with the viewer" through his manipulation of Dillon's "close-up" is indebted to O'Dell's analysis. See Kathy O'Dell, *Contract with the Skin: Masochism, Performance Art, and the 1970s* (Minneapolis: University of Minnesota Press, 1998), especially chap. 1, "He Got Shot," pp. 1–16.

46. Jonas sees the virtual "interior" of the monitor as a hybrid space that is both sculptural and theatrical:

> I saw the monitor as a box the monitor was a box I was always aware of a glass reflective surface and imagined a space behind it inside the box I worked with the illusion of space, constructing the illusion of depth or layers behind the surface this happened especially with vertical roll and then developed like the vertical roll bar as it flipped by referred or was on the surface with action was behind in space of the room when I put my face between the camera and the monitor the space changed and became more dimensional also revealed the space between the cam and the monitor." Joan Jonas, email communication to author, March 28, 2006.

47. "Vito Acconci," p. 6.

48. Douglas Crimp, ed., *Joan Jonas: Scripts and Descriptions, 1968–1982* (Berkeley: University Art Museum, 1983), p. 46.

49. Ibid.

50. Constance De Jong, "Joan Jonas: *Organic Honey's Vertical Roll*," *Arts Magazine* 47, no. 5 (March 1973): 28.

51. An important part of this fragmentation resulted from the live camera's frequent focus on parts of the performer's body instead of on a "whole self." In *Organic Honey's Vertical Roll* (1972), the use of vertical roll on the monitor to break the television image into pieces suggests that fragmentation in the apparatus corresponds to fragmentation of the body. At times the images above and below the horizontal bar of the roll are out of sync, and at others Jonas orchestrates a kind of reunion of the body's wholeness across the gap of the vertical roll, as when "Two hands clap the vertical-roll bar in time to the roll." Douglas Crimp, *Joan Jonas*, p. 57.

52. I hope it's clear in these comments that I do not mean to say that gay and lesbian rights and the struggles among people of color should be discounted—in fact I believe that the media's framing of such identities in reductive stereotypes is an impediment to this important political project. I am calling for a kind of identification that allows for mobility across categories.

53. Lennon and Ono repeated the performance in Montreal, two months after the Amsterdam Bed-In. Not allowed to enter the United States, they chose Montreal as a city convenient for North American media. See Anthony Fawcett, *John Lennon: One Day at a Time*, rev. ed. (New York: Grove Press, 1981), p. 53.

54. Ono said, "Everything is public. Whatever you're doing, even if you cough or sneeze or something, is going to affect the world. Even things you think you are doing in private. We're all sharing the

whole world together. There is no reason why you can't do these things publicly. On the contrary, you *have* to do it publicly." Quoted in G. Barry Golson, ed., *The Playboy Interviews with John Lennon and Yoko Ono*, conducted by David Sheff (New York: Playboy Press, 1981), p. 91.

55. Lennon, quoted in ibid.

56. Famous people often support causes publicly, but usually these efforts are meant as an extension of "commercials for themselves" by garnering positive public relations.

57. Quoted in Fawcett, *John Lennon: One Day at a Time*, p. 51.

58. Warhol tells the story of sending Allen Midgette, "a great-looking dancer we'd used in a few movies," to impersonate him for some college lectures in the West. The ruse was later found out. See Andy Warhol and Pat Hackett, *POPism: The Warhol '60s* (San Diego: Harcourt Brace, 1980), pp. 247–248.

59. Ibid., p. 74.

60. Ibid., p. 75.

61. Candice Breitz writes, "The various corporations that had structured Warhol's art business, including Andy Warhol Films and Lonesome Cowboys Inc., were formally consolidated under the umbrella of Andy Warhol Enterprises Inc. in the early 70s, at the very moment that Warhol's production of commissioned portraits accelerated dramatically." Breitz, "The Warhol Portrait: From Art to Business and Back Again," in *Andy Warhol Photography* (Pittsburgh: Andy Warhol Museum; Hamburg: Hamburg Kunsthalle; Zurich: Edition Stemmle, 1999), p. 198, n. 2. In 1966 Warhol had also famously offered himself for endorsements: "Meanwhile, the phone at the Factory was ringing more than usual because we'd just put an ad in the *Voice* that read: 'I'll endorse with my name any of the following: clothing, AC-DC, cigarettes, small tapes, sound equipment, ROCK 'N' ROLL RECORDS, anything, film, and film equipment, Food, Helium, Whips, MONEY; love and kisses Andy Warhol. EL 5-9941.'" Warhol, *POPism*, p. 152.

62. Andy Warhol, *The Philosophy of Andy Warhol (From A to B and Back Again)* (San Diego: Harcourt Brace, 1975), p. 83.

63. Andy Warhol and Pat Hackett, *Andy Warhol's Party Book* (New York: Crown Publishers, 1988), p. 6.

64. Mark Francis calls Warhol the "recording angel of his period" whose "enterprise in its entirety was directed towards accumulating a complete archival record of his observations, movements, and meetings. Just as he tape-recorded his telephone conversations, he took photographs in nightclubs, on journeys (even recording landscape images that are non-existent in his other work), and especially around New York City. He recorded graffiti, water swirling in a toilet bowl, shop windows, views from an airplane window—all insignificant details of modern life, but important enough to Warhol." Mark Francis, "Still Life: Andy Warhol's Photography as a Form of Metaphysics," in *Andy Warhol Photography*, p. 23.

65. Roland Barthes wrote, "We are now beginning to let ourselves be fooled no longer by the arrogant antiphrastical recriminations of good society in favour of the very thing it sets aside, ignores, smothers, or destroys; we know that to give writing its future, it is necessary to overthrow the

myth: the birth of the reader must be at the cost of the death of the Author." "The Death of the Author" (1968), in Roland Barthes, *Image-Music-Text,* trans. Stephen Heath (New York: Noonday Press, 1977), p. 148. See also Michel Foucault, "What Is an Author?" (1969), in Foucault, *Language, Counter-Memory, Practice: Selected Essays and Interviews,* ed. Donald F. Bouchard, trans. Donald F. Bouchard and Sherry Simon (Ithaca: Cornell University Press, 1977), pp. 113–138.

AFTERWORD: MANIFESTO

1. The Internet has been a more effective tool than I think television ever was, but TV remains a major source of information that may restrict the Web's flexibility if the two systems one day merge. It is important to note that the emergence of electronic media in the United States (radio, television, Internet) follow a similar pattern: technological development funded in large part by the government, and particularly the military; dissemination through "hobbyists" or ad hoc networks; and commercial consolidation by large corporate interests.

2. See Susan Sontag, "Against Interpretation" (1964), in *Against Interpretation* (New York: Farrar, Straus & Giroux, 1966), pp. 3–14.

Index

Boldface type indicates illustrations.